TACTILE

die gestalten verlag

- *Preface* -

Look around you, and you will notice a wealth of objects, collages, sculptures and installations firmly rooted in graphic design. Liberated from the fetters of page and screen, designers are starting to use the tools of their trade to translate signs and symbols to tangible space, to creations that promise a direct encounter and one-to-one experience.

Flitting between the dimensions, this book sets out to document how 2-D skills and styles are moving into the 3-D realm and charts their slow, but irreversible conquest of space.

Retracing the roots of this relatively recent phenomenon, it is worth turning back to the late 1960s, when pop art's celebration of serialisation and industrial reproduction sparked heated discussions in the art and design communities. And yet, the pivotal question of its time – what constitutes a work of art, its physical manifestation or the idea behind it? – has never been far from our minds since the early 20th century. When artists like Dali or Duchamps chose to separate the work from the artist, they contested the prevailing gospel that physical authorship was a virtue and reproduction would devalue its artistic premise.

Liberating the Material

In this spirit, digital technology, in particular, has helped to release the material from its traditional fetters, allowing artists and public alike to take the creative process and customisation to previously unimagined heights. And this process is not without precedent. Back in the 19th century, it was the advent of photog-

raphy which released painting from its traditional objective of depicting people and landscapes in a naturalistic manner – giving rise to a development that would pave the way for 20th century modern art.

It occurs to me that digital technology separates traditional written information from its physical carrier medium. Akin to photography's liberating effect on painting or art in general, the Internet, as a vessel for infinite and ubiquitous information, relieves matter and space from their function as carrier media or backdrop for information. And to an artist, there is nothing as tempting or frightening as a pristine, white canvas.

Liberating the Form

With the form-finding process no longer tied to traditional manufacturing methods, we find ourselves free to explore the apparent ease and flexibility of non-linear creation, the freedom of going back a few steps and clicking our way to an infinite potential for variation and replication.

And yet, while most of the exponents featured in these pages have a solid background in computer-aided creative techniques, Tactile also highlights their unique love-hate relationship with the irreversible advancement of digital ubiquity. For some, this liberation from the material, from the limits of the laws of physics and production within the confines of a high-end CPU, suggests a loss of connection, a disassociation from the work itself. In their quest for authenticity and new frontiers, they have started to return to their roots, towards limited, physical objects charged with non-verbal and non-linear content, imbued with sensory, even sensual

qualities, weight, personality and emotions. Nevertheless, this does not constitute a renunciation of digital technology per se, but rather a continuation and translation of their signature style to the "real" world. By making the digital realm truly tangible, they reinforce the bond between artist and creation.

Sidestepping the Industry

In line with this move towards materialisation, Tactile also documents the seductive appeal of hand-crafted objects. While basic tools for the straightforward conversion of digital images have enjoyed rising popularity since the mid-1990s – think pixelated screenshots from embroidery or knitting machines as a pointed jab at quaint traditionalism – true DIY allows designers to cultivate their own counterculture to industrial reproduction and serves as a welcome anchor in these ephemeral times where any development or trend has lived and died before we know. No longer relegated to the dunce's corner of backward homeliness, arts and craft suddenly find themselves at the vanguard of design. And where lo-tech craft meets hi-tech inspiration, the resulting stitched system errors, rough-hewn carpentry and home-glued action heroes join the ranks of Tactile's assemblage of wonderfully bizarre and inventive hybrid exhibits.

Tagging the City, Embracing the Mundane

The sheer imagination and playfulness on display is inspiring. Unafraid to leave the confines of their own discipline to explore uncharted aesthetic terrain, the featured artists embrace their new-found liberty to toy with scope and perception and translate their visions to the 3-D realm. While everyone's favourite staple – paper – makes for an obvious first port of call, it soon graduates from mere blank canvas and transfer medium to pliable plane and thus a 3-D object in its own right. Remember that each new media mimics the medium it replaces – silent movies had their dramatic moments and video indeed killed the radio star.

Products and sculptures, on the other hand, reveal a playful approach to signs and symbols, exploring both unusual applications (gun pillows or drawing pin coat hooks) and material choices (paper bling and PET pets). Moving on to intricate installations – from gallery-bound to the great outdoors – these graphic elements and icons ascend yet another dimension. Urban art, in particular, adds a spatial and social component to the flat mix, often encouraging direct audience reaction or active participation in their reappropriation of public space.

Spurred on by the merging of disciplines and rapid advancement of new techniques, design in space has come a long way from its first tentative steps into the physical world, from early wall murals and straightforward interpretations of trademark designs.

Graduating from surface, sign and symbol to increasingly complex and conceptual endeavours, the latest examples of tactile design are exploring thoughts, concepts and philosophies far removed from graphic design's commercial and utilitarian origins.

On this note, we invite you to turn over a new leaf and step into a new dimension.

- Type & Poster -

There is something afoot in the graphic design community – our keen sensors have registered an undeniable movement, almost a rush, from backlit screens towards the physical realm. Bubbling with excitement and eager to experiment, designers are starting to take their signature styles, shapes and techniques into the third dimension.

With this in mind, "Type & Poster" documents two entirely different approaches: While some transform their 2-D designs into 3-D collages, and then retranslate the captured moment into a tradition poster format, others prefer to free their digital creations from the confines of the computer and let them roam through the outside world.

Typography, in particular, seems to thrive in the great outdoors. Pared down to its basic geometry – and unfettered by the traditional constraints of grid, digital tools or well-known design rules – no material seems out of the question. Stacked up into precarious structures and often a right puzzle to manoeuvre, we get a glimpse of the childish fun and almost Sesame Street-like appeal that has gone into the creation of these these full-frontal fonts. And once disassociated from its principal habitat, it is no longer the the typeface that carries the (emotional) message, but its mix location and material that puts us in touch with its principal meaning.

Folded, welded, glued or nailed – this chapter covers a huge array of elaborate constructions, from towering masterpieces to transient, conceptual sculptures and installations captured for posterity. Here, virtually any surface or medium is up for grabs, from wool and bricks right down to tree trunks, foam, shade and ice. Due to the perishable nature of their creations, many of the featured artists invite us to join or observe the work in progress – expect some outspoken cold buffets, lavish lettered fashion invitations, a hand-shaped and packaged raw hamburger alphabet and – lest we forget – a yummy 1000pt Helvetica birthday cake.

And yet, there is nothing unskilled about these forays into another dimension. Literally bursting out of the confines of the page, this chapter sees artists and designers taking the means of communication back to the location itself, back to the people and thus back to their original intention.

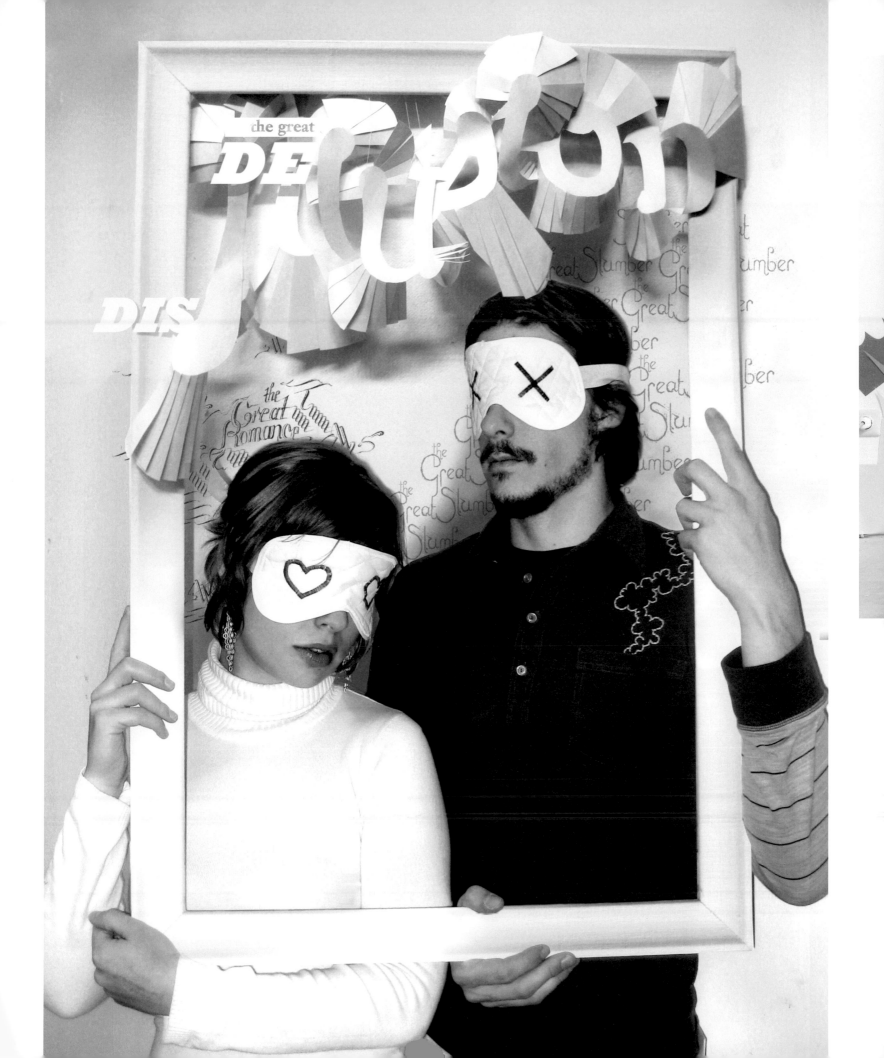

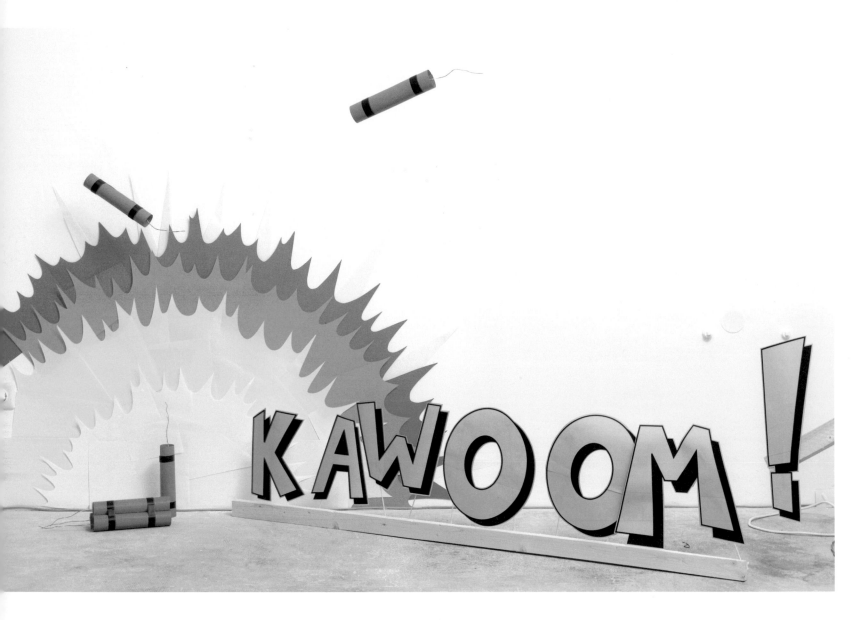

PIXELGARTEN,
CATRIN ALTENBRANDT &
ADRIAN NIESSLER
Um was es nicht geht
2007

Unafraid to make a splash, Pixelgarten's Catrin Altenbrandt and Adrian Nießler take us from 2-D to 3-D and back again: packed with humour and allusions, their bright, distinctive colour schemes and offbeat ideas inject a hint of naïve poetry into anything from editorial design to indoor installations.

Blasting out of the page, out of the confines of cartoon-inspired imagery, the resulting creations are nowhere near as obvious or superficial as their array of innocuous colours, toys or thought bubbles might suggest at first glance. Instead, Pixelgarten take everyday absurdities, moments of inspired insanity, and sneak them into their work. Whether large-scale illustrations in space, hoovers that develop a life of their own or a splash of pink paper urine against a white wall, their sporting competition pits Catrin's intuitive inspirations against Adrian's more conceptual, methodical slant.

With their systematic approach to arts and craft and a great knack with their materials, the creative twosome draw on a wealth of sources and techniques to change perception as we know it and turn reality on its head.

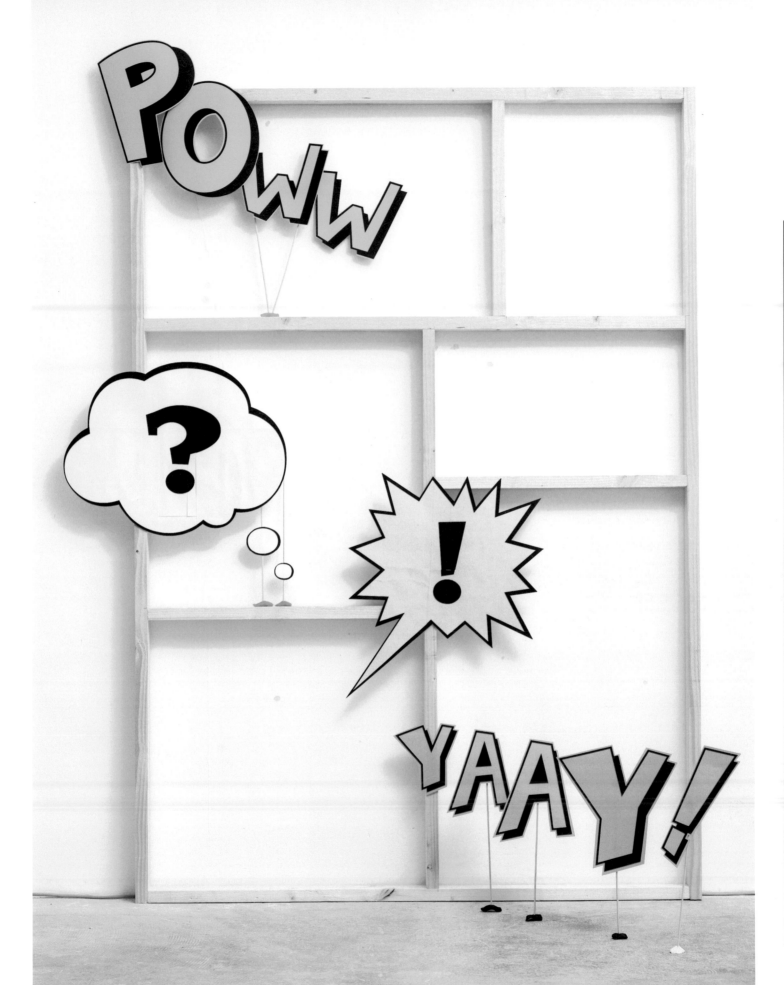

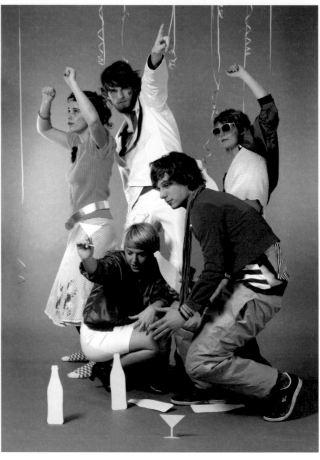

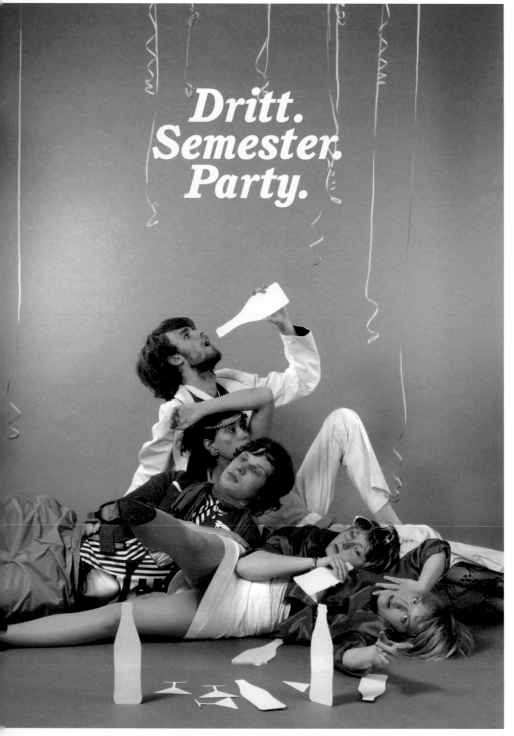

POE TRY'
MAK ESNO THING
HAPP EN

LO GE

RONNY
HARDLITZ

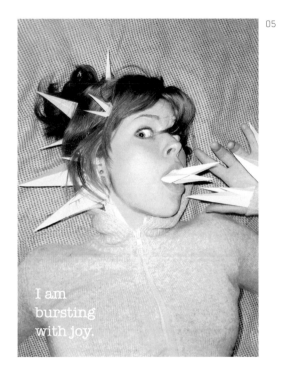

EUROPEAN
DESIGN
2007

ANIMATION
PUNKS IN
LITHUANIA

TIME LESS

BELGIUM'S
FASHION
VISIONARY

EMO TION AL

MYTH IC

TWIST ED

DO DESIGN
WEEKS
MATTER?

RADICAL

Audubon

JUNE 2006

SPECIAL ISSUE
AMERICA'S RIVE
THE MIGHTY MIS N THE LIFELINE OF OU FARMS,
AND WILDLIFE RIED TO TAME IT IN MISSION.
 HARL
LAST SUMMER'S HURRICANES WERE THE HARSHEST REMINDER YET
THAT IT'S TIME TO GIVE SOMETHING BACK.

USA $2.95 / CANADA $3.95
0 6>

7 25274 05776 6

I am
bursting
with joy.

GUILLAUME MOJON

01 Biography of Lawrence Weiner
2006

DE DESIGNPOLITIE

02 Utrecht School of Art
Educational Guide
Design students at the Utrecht School of the
Arts staged a typographic intervention for the
school's education guide. A nod to early learning
aids and latenight Scrabble marathons, their
stacked and scattered letters serve as literary
stumbling blocks for (prospective) students and
faculty alike.
for Utrecht School of Art, 2004

ALEX ROBBINS

03 Keep me Busy
Self-promotional, 2007

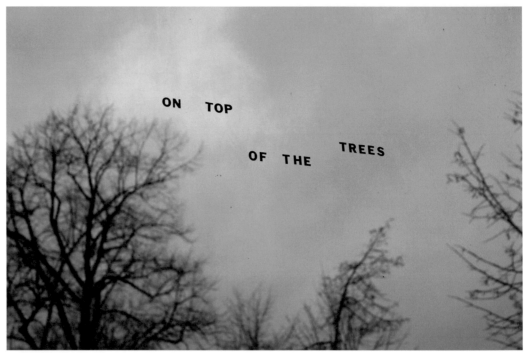

01

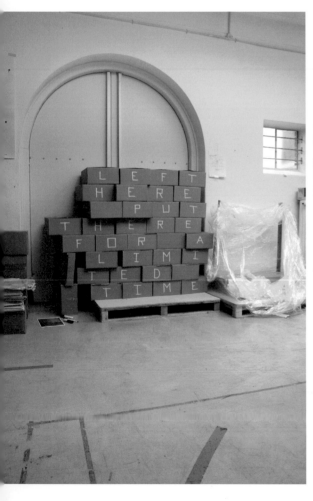

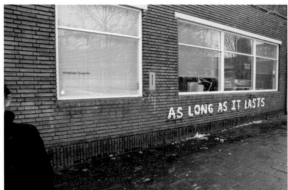

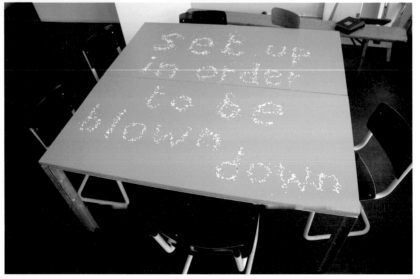

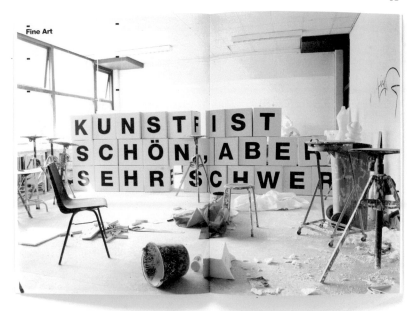

Fine Art

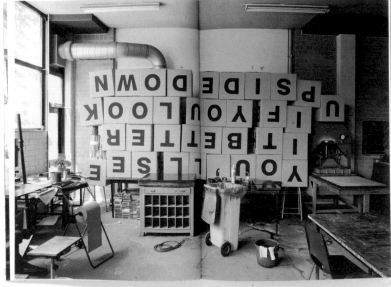

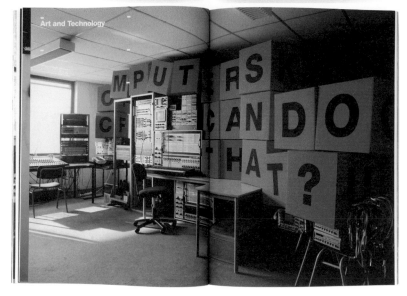

Art and Technology

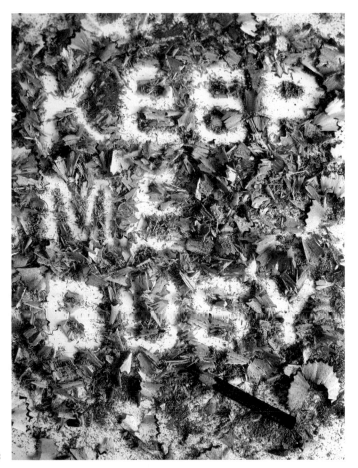

PHIL LUBLINER
01 Flagship Video
02 Fortress Tires
for Honest Magazine, 2006

MICHALUK
03 MATT MICHALUK
WITH ADAM TICKLE & ALISTAIR WEBB
Helvetica 50th Birthday
Self-initiated, 2007,
"A project designed to celebrate the 50th
birthday of the typeface Helvetica. 1000pt
type was baked to form a four-foot-long
sponge cake. The process of it being
eaten was then filmed using stop-frame
photography."

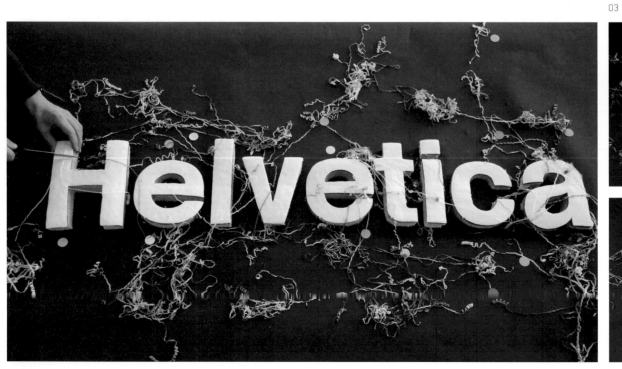

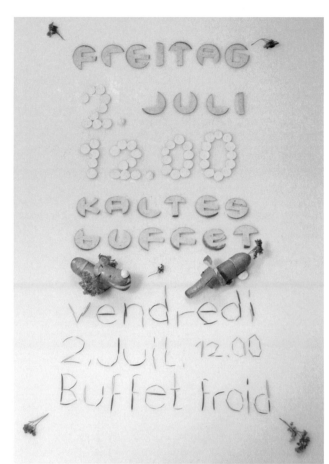

04

05

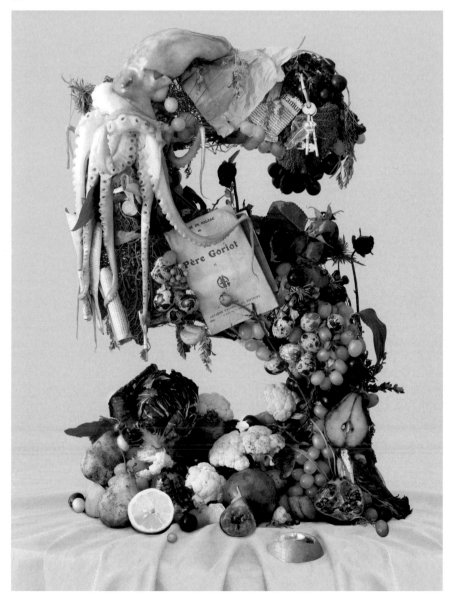

06

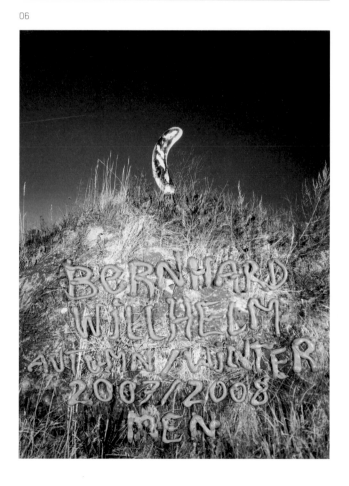

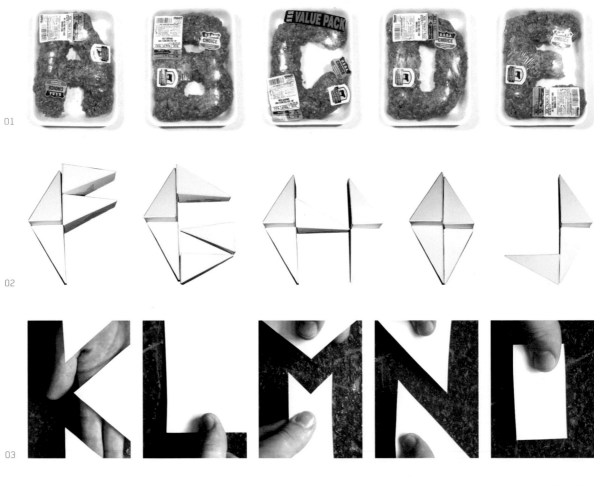

01

02

03

 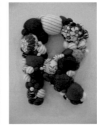 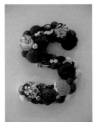 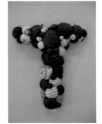

04

05

06

14 -

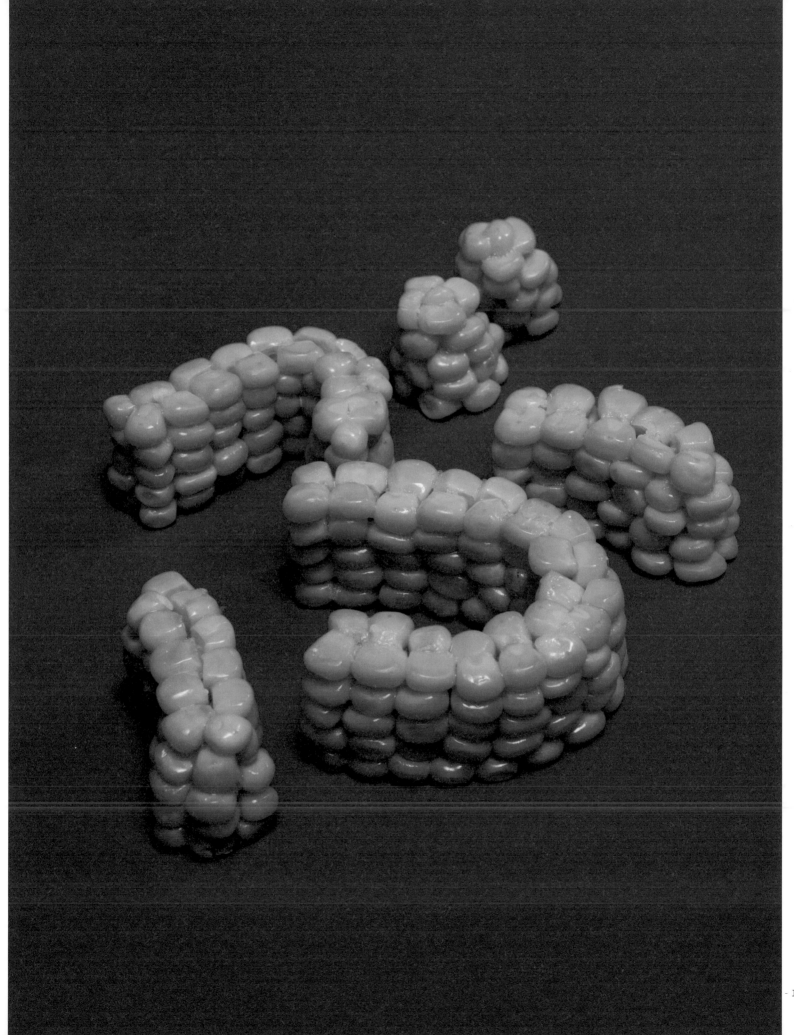

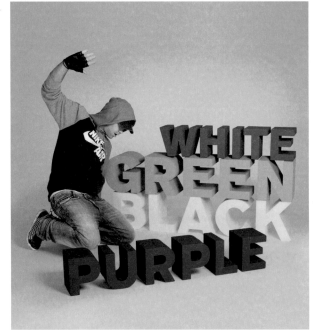

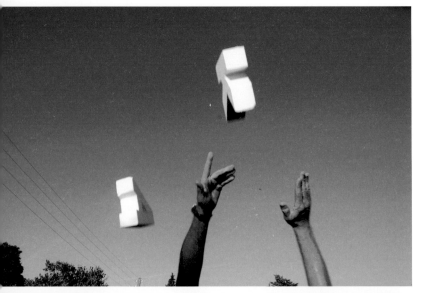

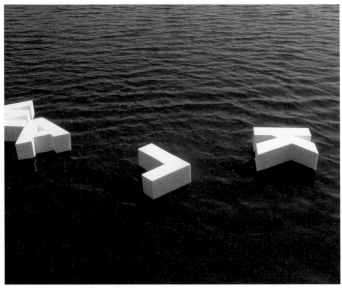

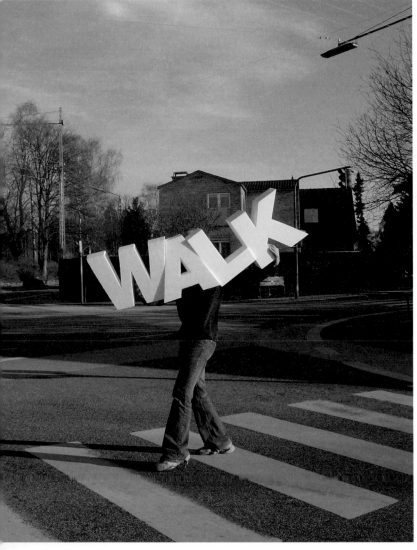

SERIAL CUT™
01 SERGIO DEL PUERTO
Serial Cut™ Fan Poster
2007

THORBJØRN ANKERSTJERNE
02 **Letter Space**
Personal project, photos by Thomas Falkenberg,
www.ptfalkenberg.dk, 2005
03 **Walk**
Personal project, 2005
04 **Slow Down**
Personal project, 2004

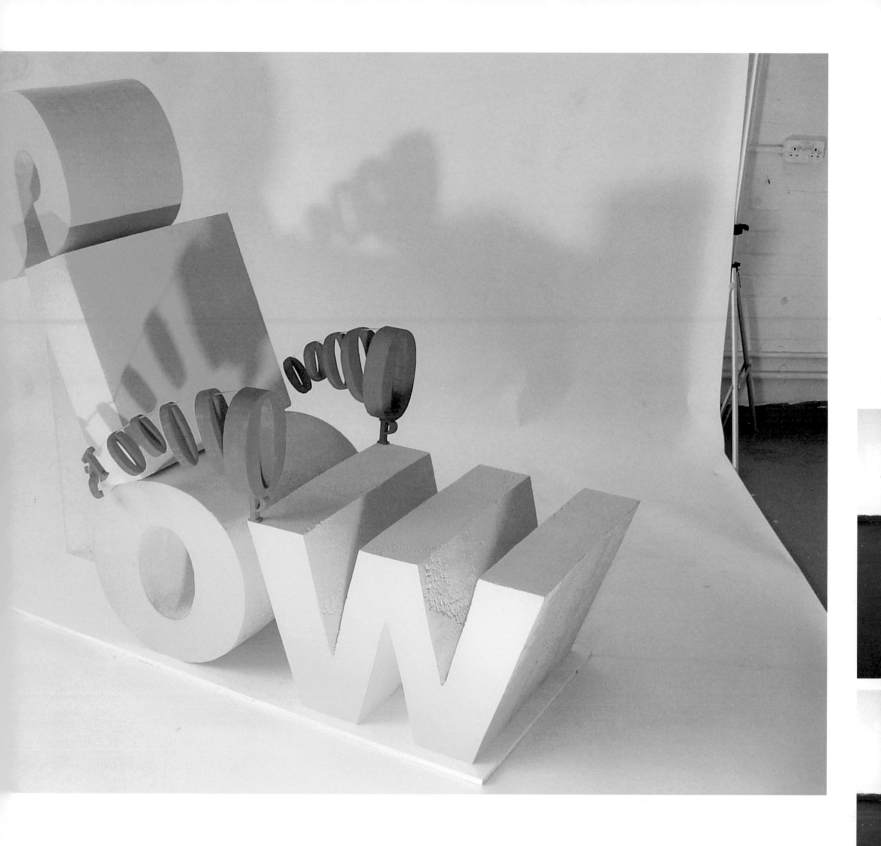

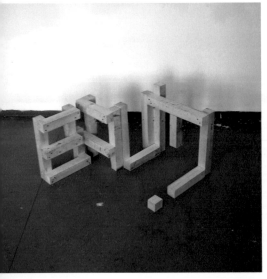

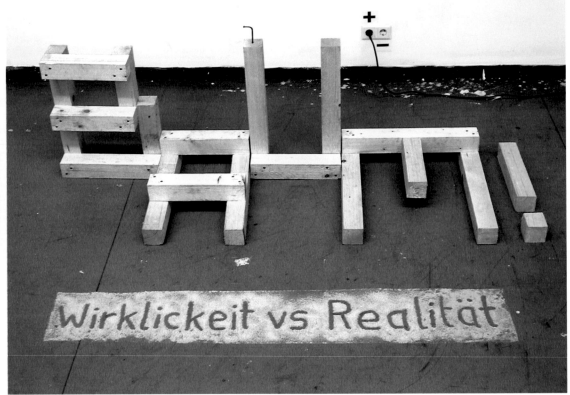

Wirklickeit vs Realität

01

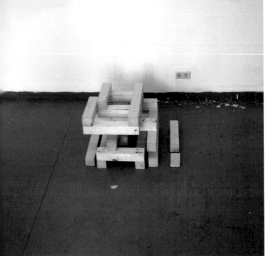

02

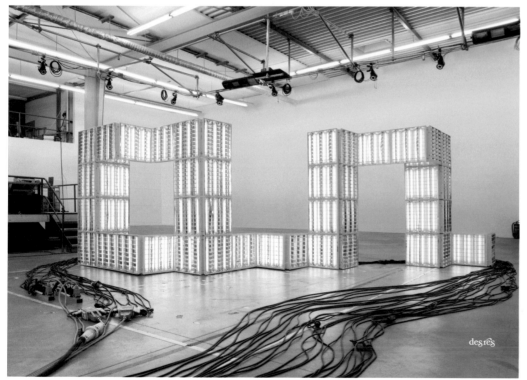

03

RUBBER TYPE
JOHANNA LEUNER
01 WITH ALEX FUCHS & XIN ZHANG
BAUM!
for BAUM! Magazin, 2007

MATHIEU MERMILLON
02 Font Blox
©Mathieu Mermillon, 2006

DESRES DESIGN GROUP
03 MICHAELA KESSLER, DIRK
SCHROD, DANI MUNO
Desres is On
©desres design group, 2006

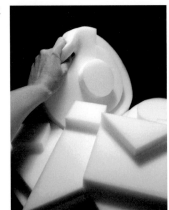

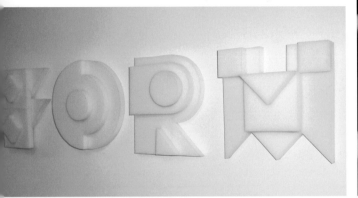

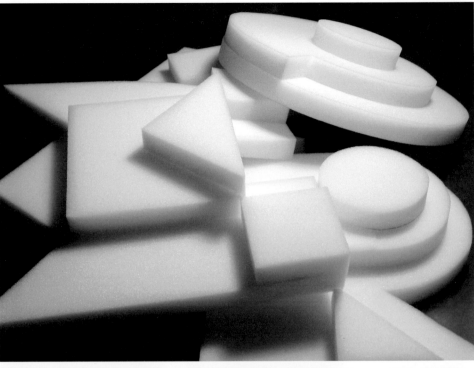

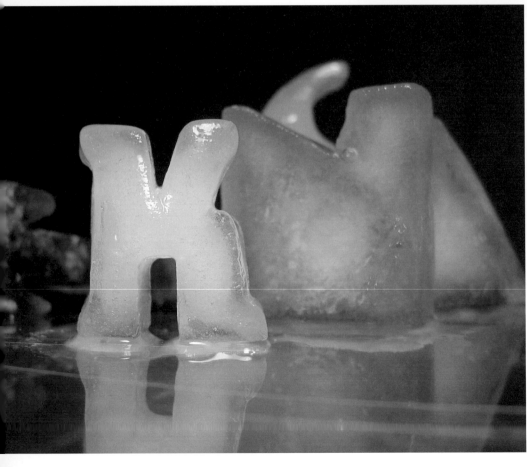

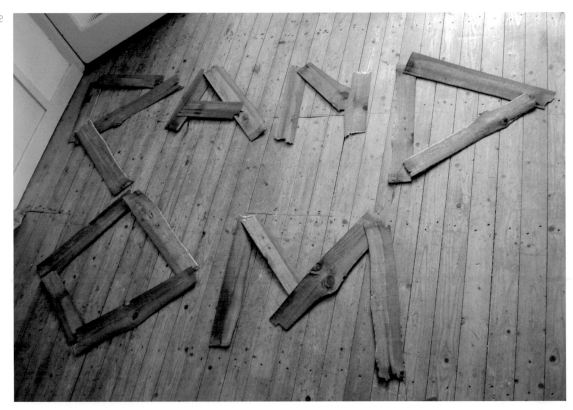

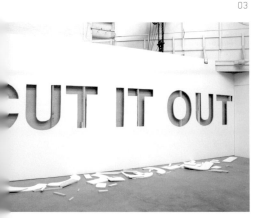

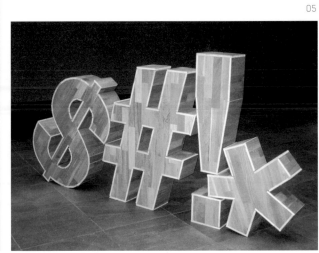

MICHAELA GREEN
01 Normal+Normal=Unormal
2005

GUSTAVO LACERDA
02 Random Logo
for Random, © Gustavo Lacerda, 2006

LINA VISTE GRØNLI
03 Cut It Out
UKS, Oslo, Norway, 2005
04 ARBEIDERPARTIET / The Labour Party
for Rogaland Kunstsenter, Stavanger, Norway, installation view, 2005
05 $#!*
(A Hommage to the Candela shell)
for Vigeland Museum, Oslo, Norway, 2006

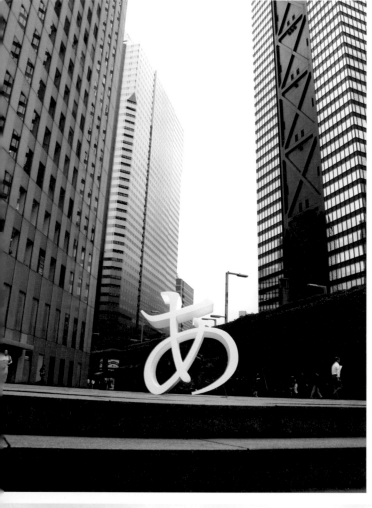

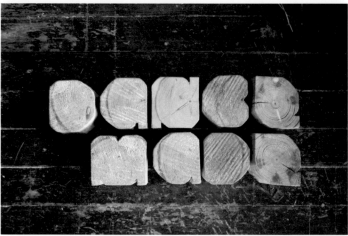

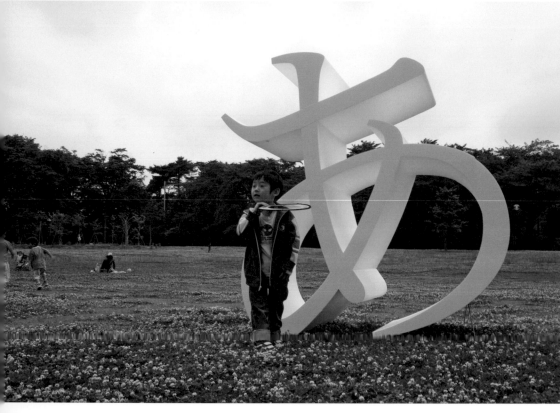

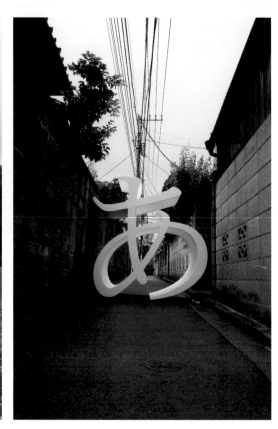

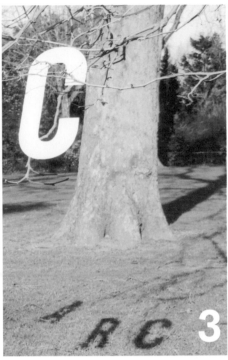

03

04

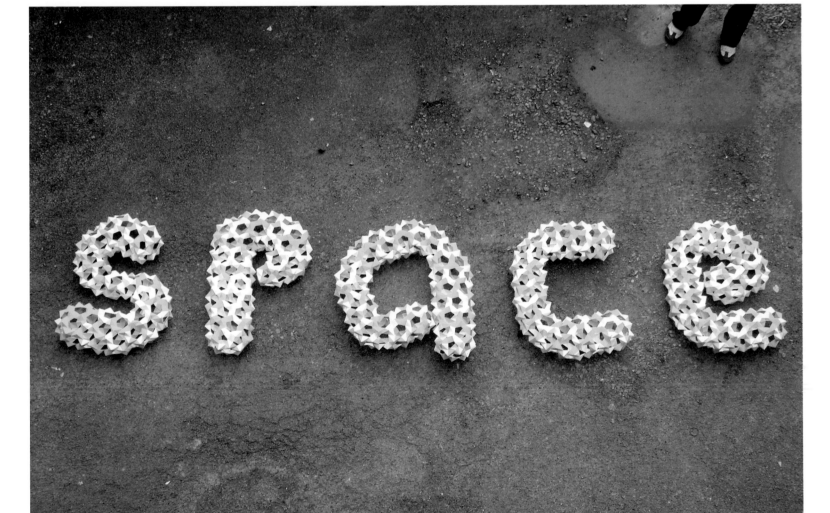

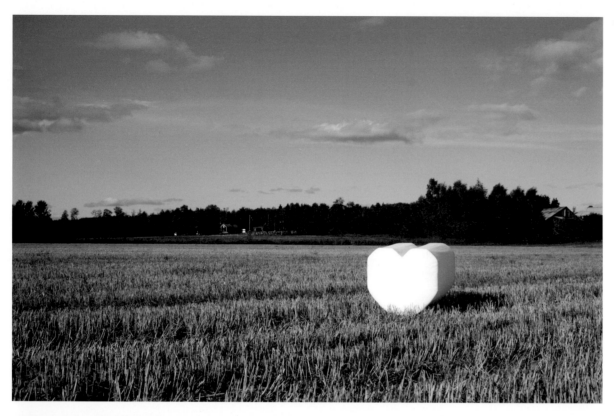

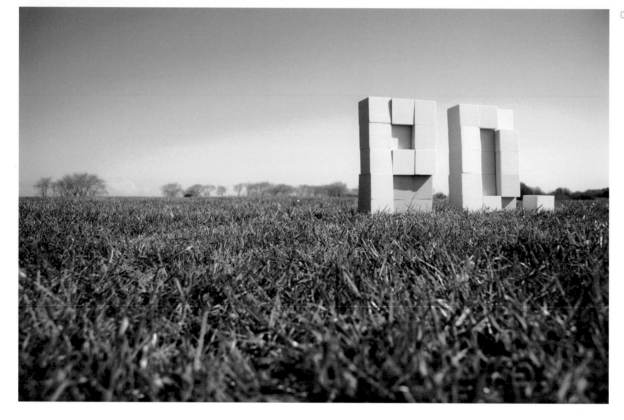

DANCEMADE
01 JENS NILSSON
dancemade Identity 2006
Personal project, 2006

MICHAELA GREEN
02 Graduation Exhibition
for University of Malmö and Form/Design Center Malmö, students of product development and design. 2006

TIMOTHY BROWN
03 TIM BROWN & FRED RIGBY
The Dead Tree
for Lark Magazine

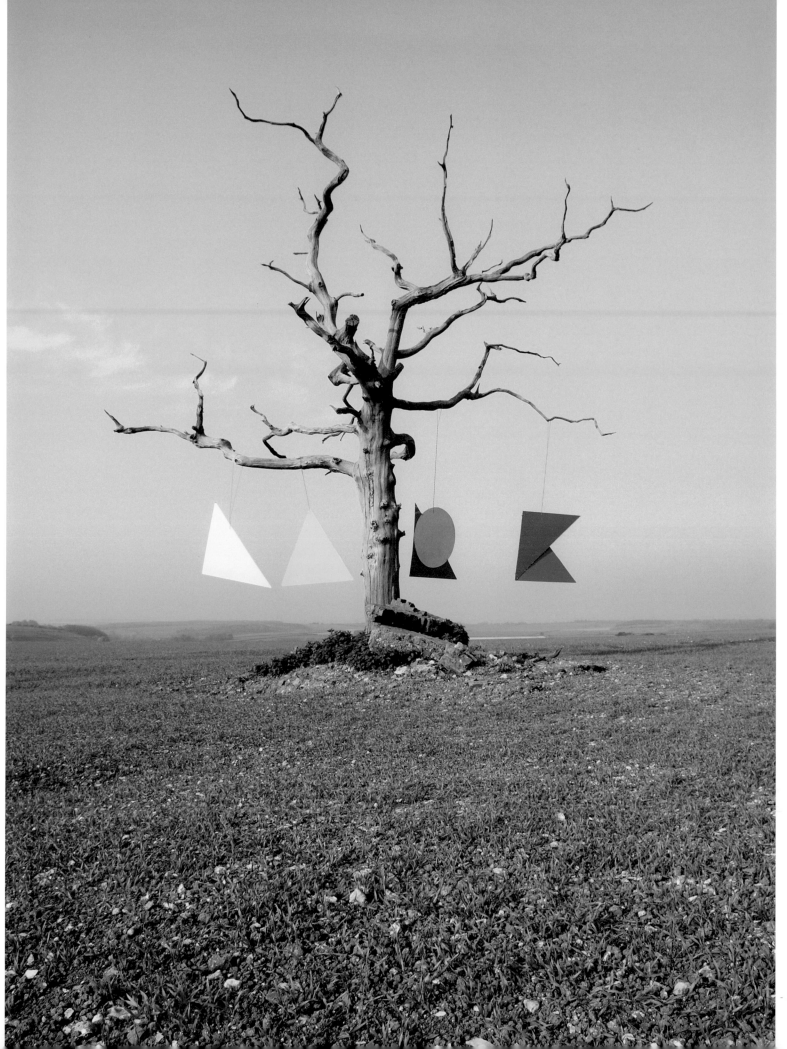

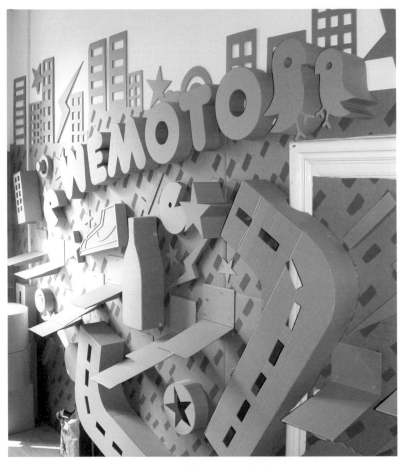

01

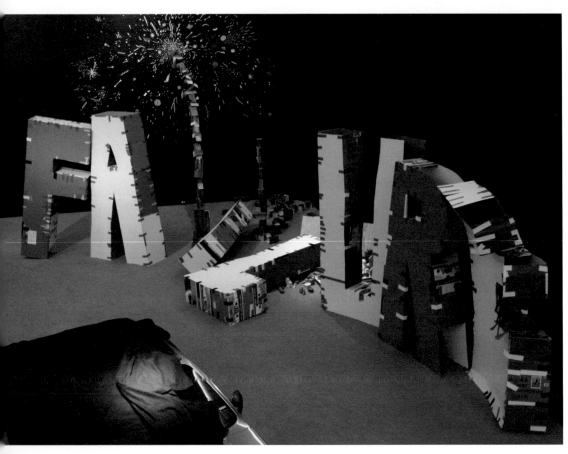

02

WEMOTO
01 STEFAN GOLZ
Bright Skateboarding Tradeshow
Summer 2006
Wemoto, production by Patrick Lotz,
2006

YOKOLAND
02 ESPEN FRIBERG &
ASLAK GURHOLT RØNSEN
The Remix Project
for Sørlandet Art Museum, art & design
by Yokoland, remix of previously made
artwork by Jonas Liveröd assistant,
Megan Zolkiewicz, 2006

STRANGE ATTRACTORS DESIGN
03 CATELIJNE VAN MIDDELKOOP &
RYAN PESCATORE FRISK
Big Type Says More
for Museum Boijmans van Beuningen,
Rotterdam, 2006

FLAG
04 FLAG AUBRY/BROUARD
Handmade
Window decoration for an exhibition
about handmade posters, Plakat-
sammlung, for Museum für Gestaltung
Zürich, 2005

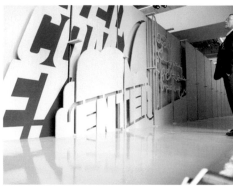
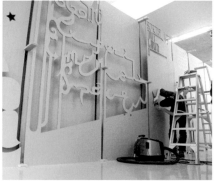
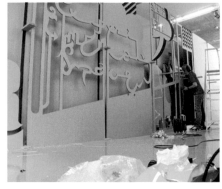

03

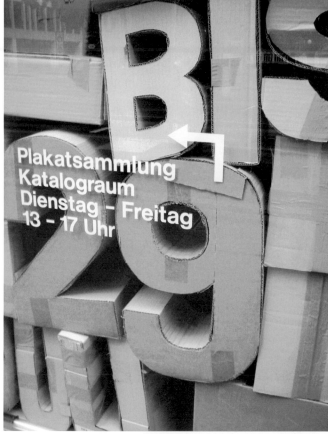

Plakatsammlung
Katalograum
Dienstag – Freitag
13 – 17 Uhr

04

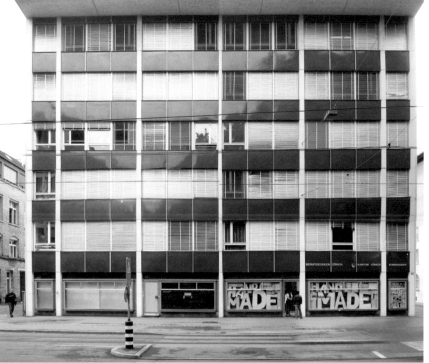

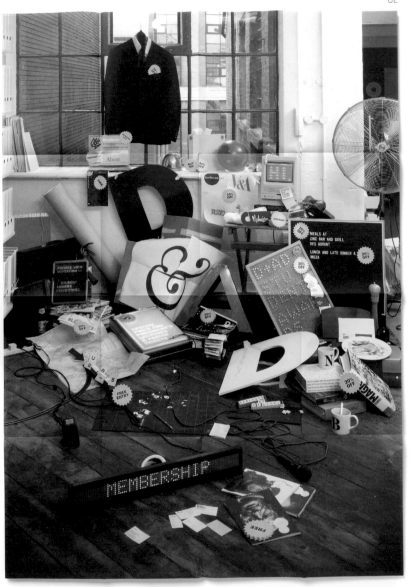

University of Brighton Open Days 2007

Wednesday 7th February 2007
Wednesday 14th February 2007

Introductory talks include a welcome by the Head of School of Arts & Communication and the Head of the School of Architecture & Design, followed by a presentation providing useful information about the university, addmissions to art and design courses, and finance.

Guided tours of course areas are on offer after each of the introductory talks. There will be an opportunity to meet staff and students as well as visit studios and workshops and view students' work.

It would be helpful if visitors could arrive at least 10 minutes before the talks are due to start.

There will be a presentation starting at 2.00pm which will provide general information about the University and staff and students will be available to discuss aspects of the course.

Mithras House (3rd Floor)
2.00pm
- Interior Architecture
- Architecture

Pavilion Parade
2.00pm
- Visual Culture
- History od Design, Culture and Society
- History of Decorative Arts and Crafts

Sallis Benney Theatre, Grand Parade
10.00 am + 1.30pm
- Fine Art Painting
- Critical Fine Art Painting
- Fine Art Sculpture
- Fine Art Printmaking
- Digital Music
- Performance and Visual Art, Music, Theatre, Dance

10.45am + 2.15pm
- Three Dimentional Design
- Wood Metal Ceramics and Plastics
- Fashion Textiles Design with Business Studies
- Fashion Design with Business Studies
- Interior Architecture
- Architecture (Morning only)

11.30am + 3.00pm
- Editorial Photography
- Graphic Design
- Illustration

For further enquires please contact:
Faculty of Arts & Architecture
Grand Parade, Brighton. BN2 0JY

Telephone the main switchboard on 01273 600900, stating the course in which you are interested, or visit our open day website www.brighton.ac.uk/opendays

Further information about the faculty can be found on our website: www.brighton.ac.uk/arts/

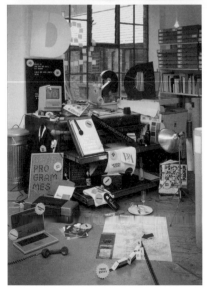

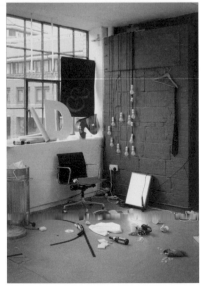

WILL HUDSON

01 WITH JON WIDDOWS
Brighton University Open Day Poster
for Brighton University, 2007

NB STUDIO

02 ENG SU
D&AD Membership Collateral
for D&AD, art direction by Ben Stott, Alan Dye, Nick Finney, photos by John Ross, copywriting by Matthew Bishop, 2006

03

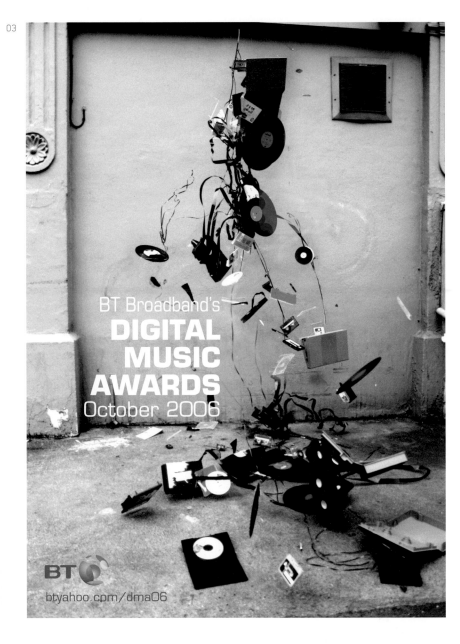

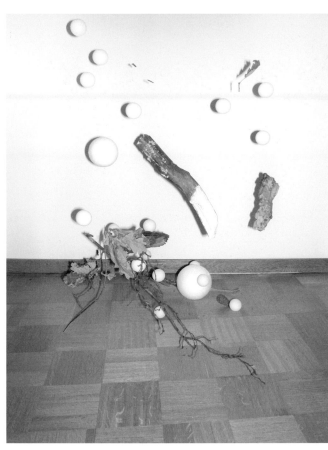

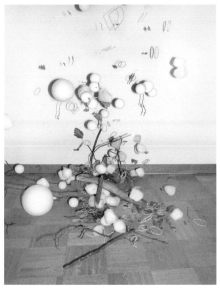

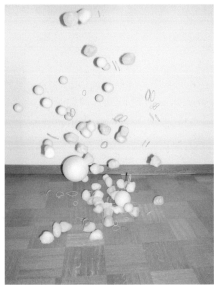

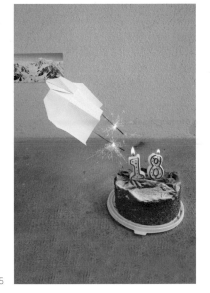

04

05

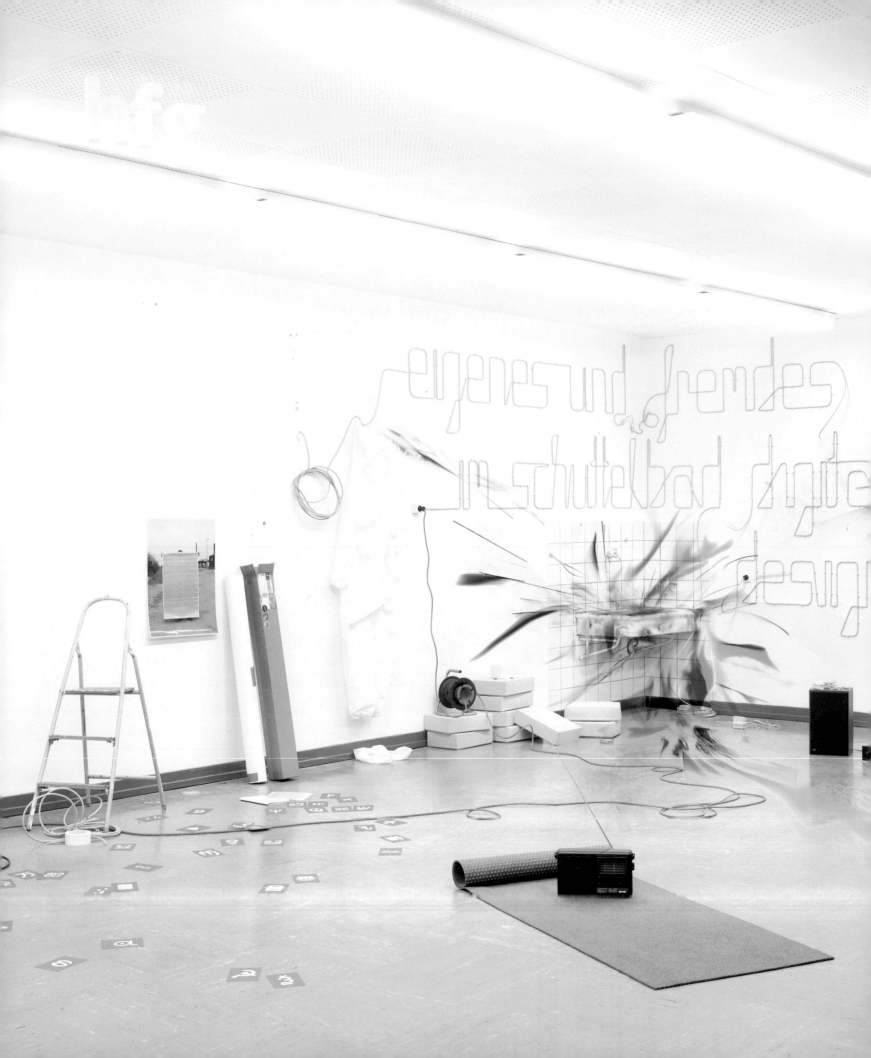

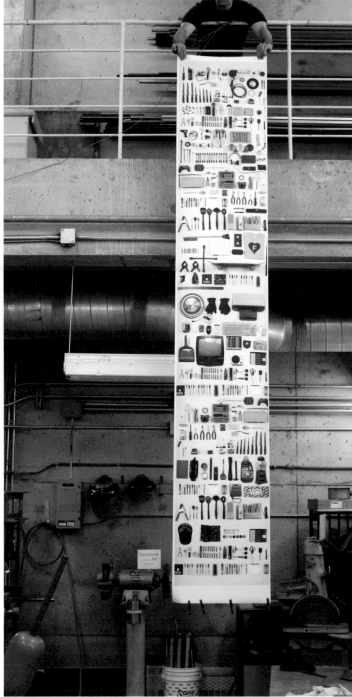

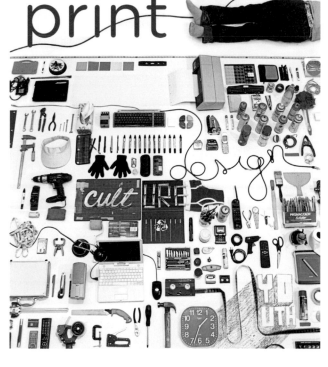

PIXELGARTEN
CATRIN ALTENBRANDT & ADRIAN NIESSLER
01 WITH DAVID HESSLER,
 Eigenes und Fremdes im Schüttelbad digitalen Designs
 for Sebastian Oschatz / Meso, 2006 / 2007

JULIEN VALLÉE
02 Print Magazine – Young Designers Youth Contest
 for Print Magazine, © Julien Vallée, 2007

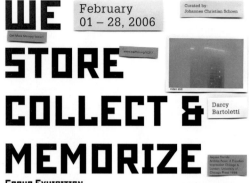

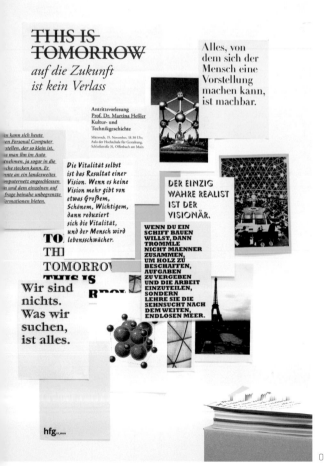

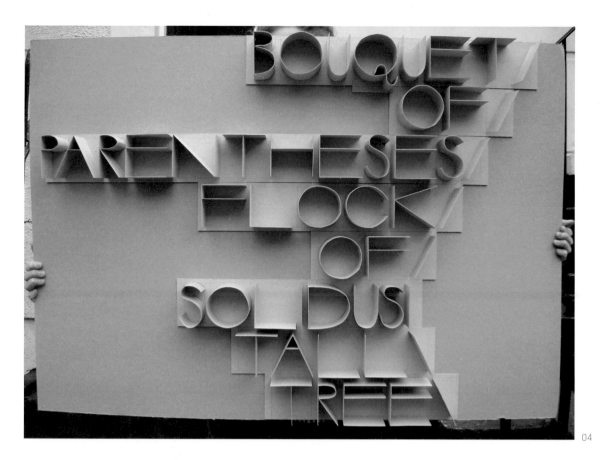

KATE LYONS
04 Public Lettering (model)
for Central Saint Martins, 2006

STEVEN HARRINGTON
05 "We Got Stoned Instead" Pyramid
for Faesthetic Magazine,
© Steven Harrington, 2006

ZUCKER UND PFEFFER
06 LENA PANZLAU & DENNY BACKHAUS
Mode aus Weißensee
for Kunsthochschule Berlin Weißensee,
2006

04

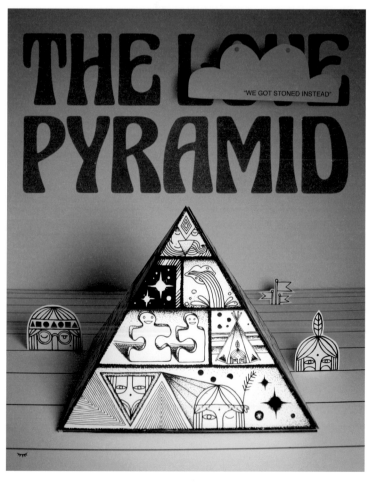

05

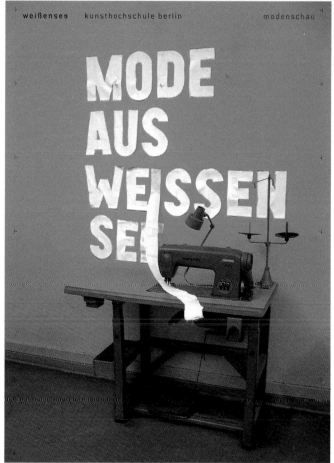

06

- *Objects, Scenes & Paper Works* -

A few pages ago, we saw graphic designers reach for their toolkits to build their own posters. Illustrators, on the other hand, prefer settings and scenes, physical collages and illustrations, where the material itself adds a further layer to the work's underlying narrative. And while many of these focus on gathering, assembling and arranging found or carefully selected objects into associative accumulations, don't be deceived by their ostensive lightness and spontaneity. Compiled with incredible precision, this is where art meets artistry.

As in the preceding chapter, origami is enjoying a strong resurgence, flanked by an undeniable predilection for cardboard landscapes, some strings attached. Although traditionally (and controversially) considered the choice of amateurs and beginners, paper is going from strength to strength as the ideal transfer medium. The obvious first point of call for many designers, a simple, plain sheet remains the perfect base for the translation of 2-D ideas to spatial reality. Caught between its original purpose as a blank canvas and the aesthetic scope of its inherent physical characteristics, the resulting works might use paper as a simple means to an end, an affordable raw material for simple, 3-D shapes to be printed, painted or customised with the designer's trademark style, or to elevate it to a work of art by turning mind-bending patterns and intricate folds into objects of delightful abstraction.

Sometimes larger than life, sometimes deceptively life-like – many of the papery objects and scenes on display explore the shadier sides of life with sparkling bling, token guns, fenced goods and CCTV – we also meet plenty of beloved characters and action figures, who have left their natural habitat to resurface as build-your-own paper models.

Most of all, now that new technologies have lowered the threshold for healthy experiments in adjoining disciplines, mix-and-match has never been this easy. While most preserve their distinct style and translate it to objects and assemblages, usually with a generous dash of humour and abstraction, increasing access to works and techniques beyond their own realm allows designers, artists and architects alike to flex their creative muscles and get right down to business.

So, whether fragile, crystalline folds, delicate pop-up scenarios or doll's houses filled with flat characters, expect many stylish, surprising and sometimes slightly schizophrenic still lifes to break the mould.

GRANDPEOPLE
Two-faced
for WIWP (wear it with pride) /
IDN 2006

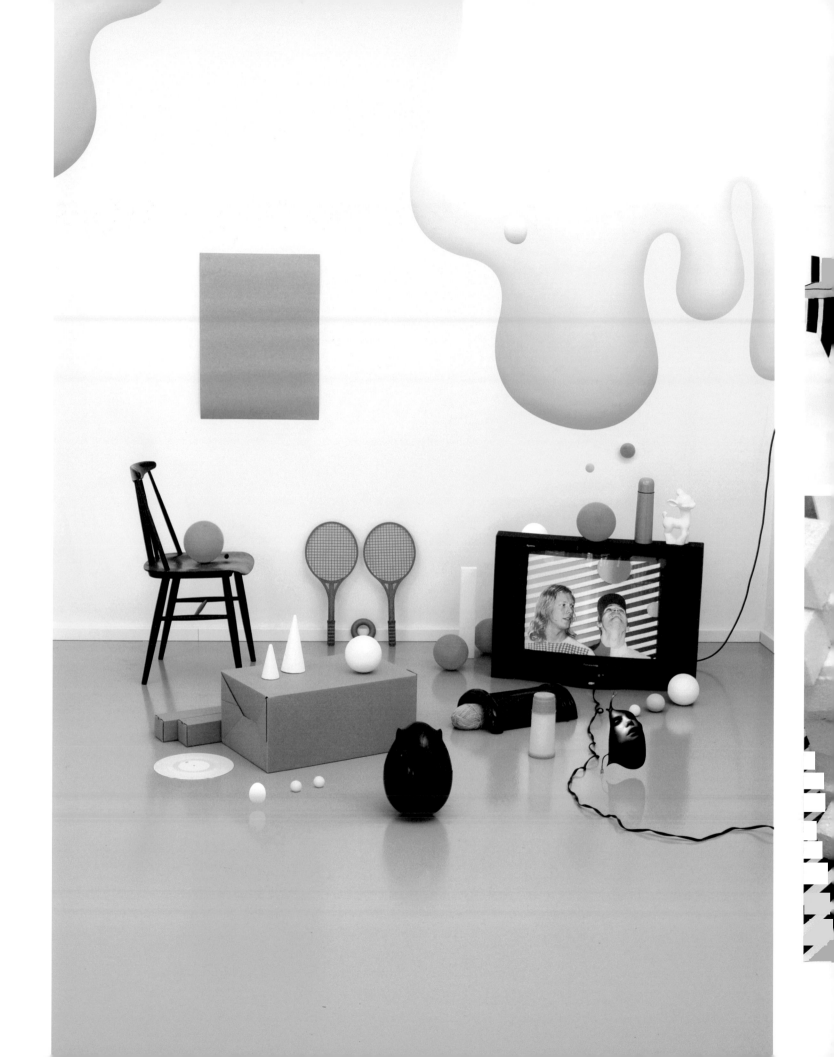

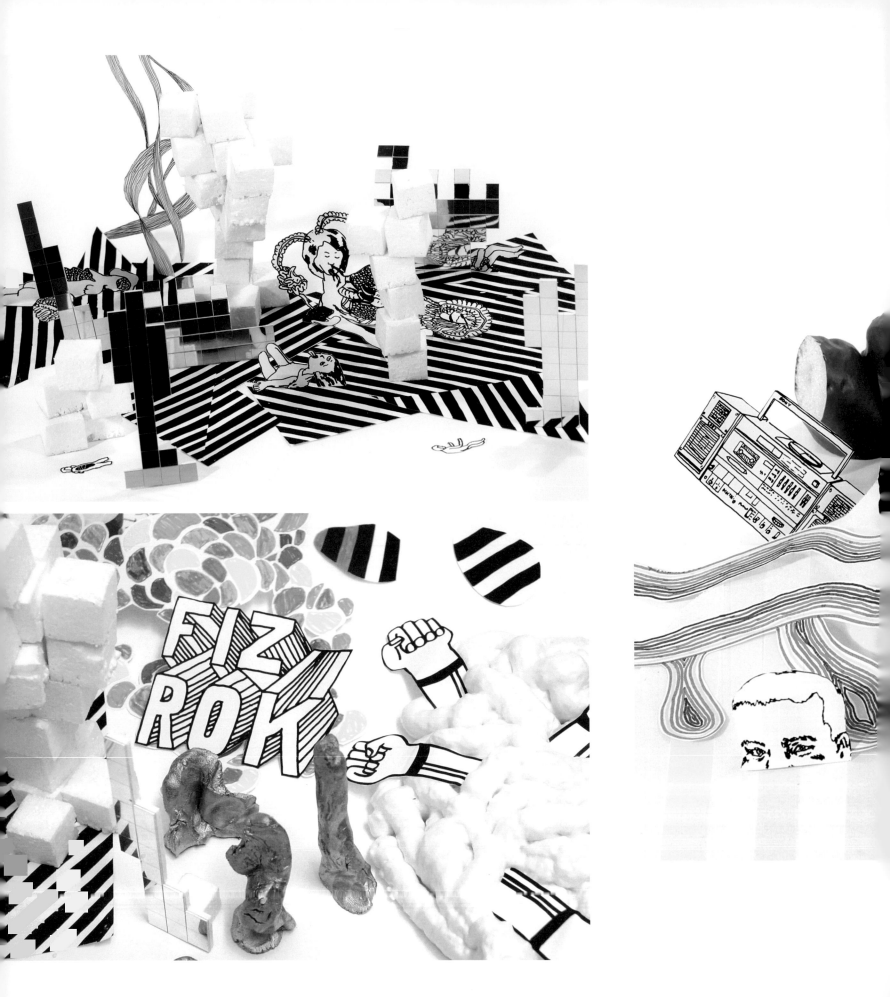

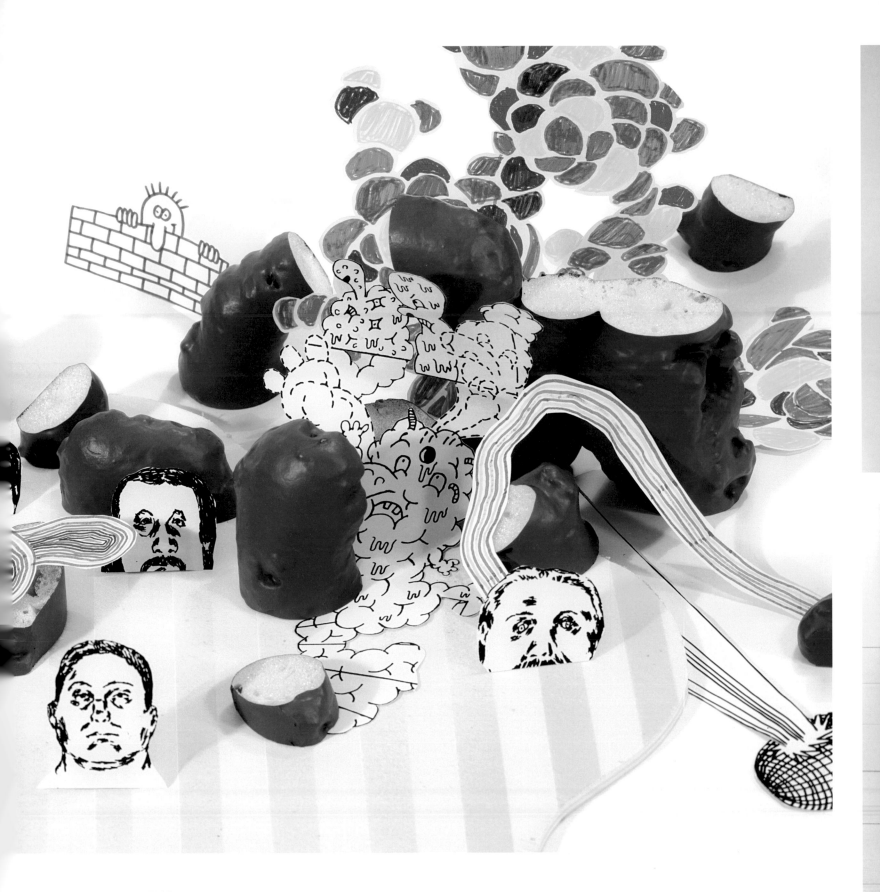

FLAG
FLAG AUBRY/BROQUARD
Armpit of the Mole
for Fundació Trenta Quilòmetres Per Segon, Barcelona, photographic still lives
for a book about contemporary drawings, Curated by Michael Quistrebert, 2005

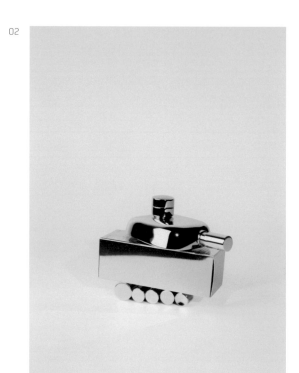

04

03

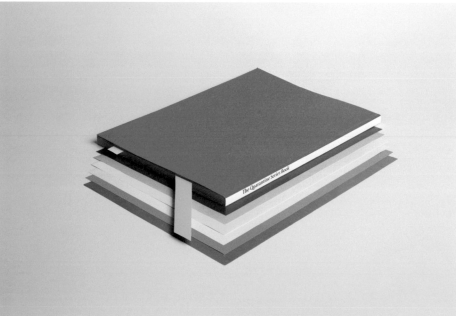

MAURICE SCHELTENS
01 Haute Hutspot
 for Volkskrant magazine, 2004
02 Eua de Mobile
 for intersection, 2004
03 Bouquet IV, Bouquet series
 Courtecy Galerie Martin van Zomeren, 2005
04 Cataloque
 Courtecy Galerie Martin van Zomeren, 2004

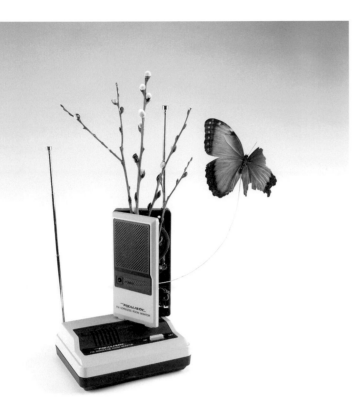

05 **THOMAS KEELEY**

IPSUM PLANET
06 WITH SERIAL CUT
lladro still life
for Lladro, concept and photographic
production with Serial Cut for the
ceramic collection created by Lladro
and Bodo Sperling.
Photo by Andrea Savini, 2006

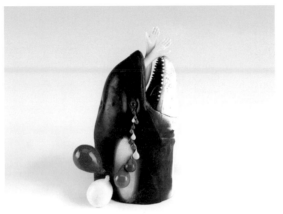

05

06

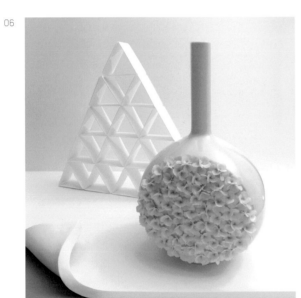

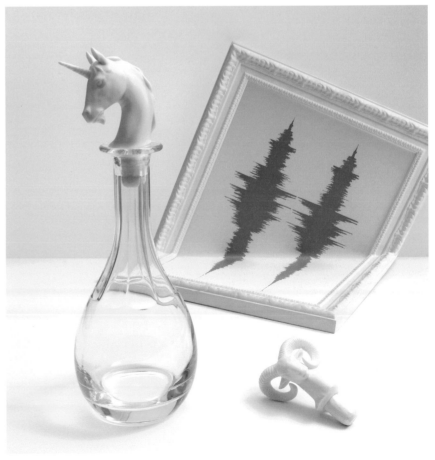

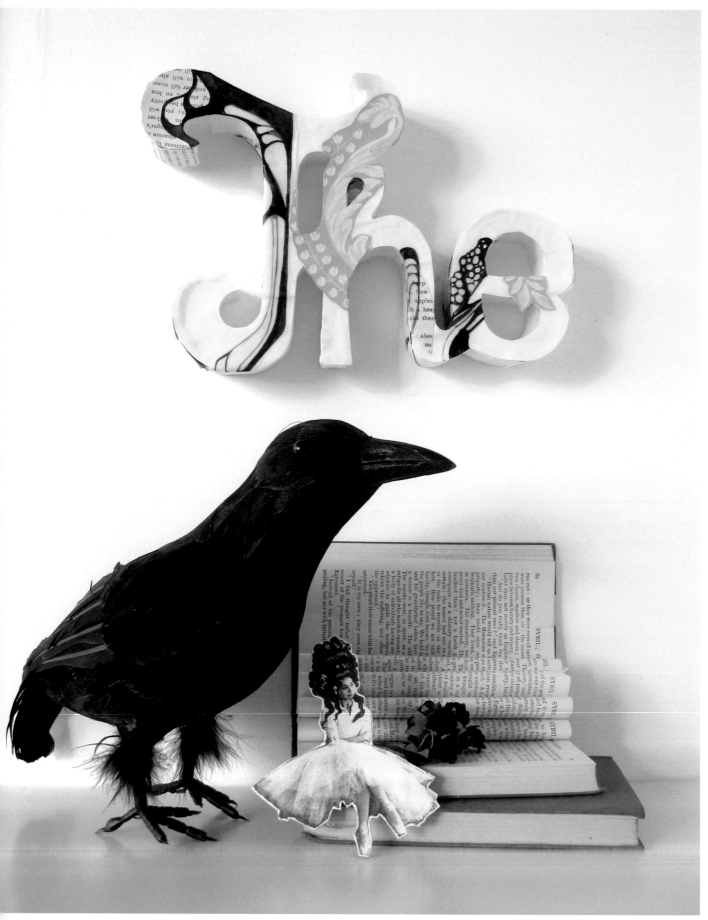

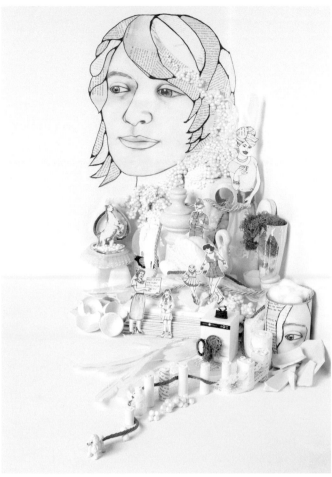

02

03

Don't expect to escape unscathed - teetering between dreamscape and ghoulish concoction, Container brew up a "tea party on the threshold of a nightmare."

Founded in 2003, this East London based multi-disciplinary art and design partnership, comprised of former graphic design students Nicola Carter and Luise Vormittag, loves to clash stark illustrations with delicate romanticism and a dash of horrified naivety in their varied forays into interior design, fashion and installations, animation and product design. With a keen sense for the morbid, lyrical and dramatic, Container invite you to drop to your knees and explore a world of optical illusions and eccentric nightmares, shining a light on everyone's favourite scare stories with more than a touch of Poe. On a less gruesome note, the self-confessed eccentrics also excel at intricate illustrations and give equal sway to their tender and romantic side. Often infused with a careful measure of kitsch, they craft still lives filled with unicorns, ballet dancers and pretty much anything a young girl reared on Barbie might desire, yet retranslated into something far more mesmerising.

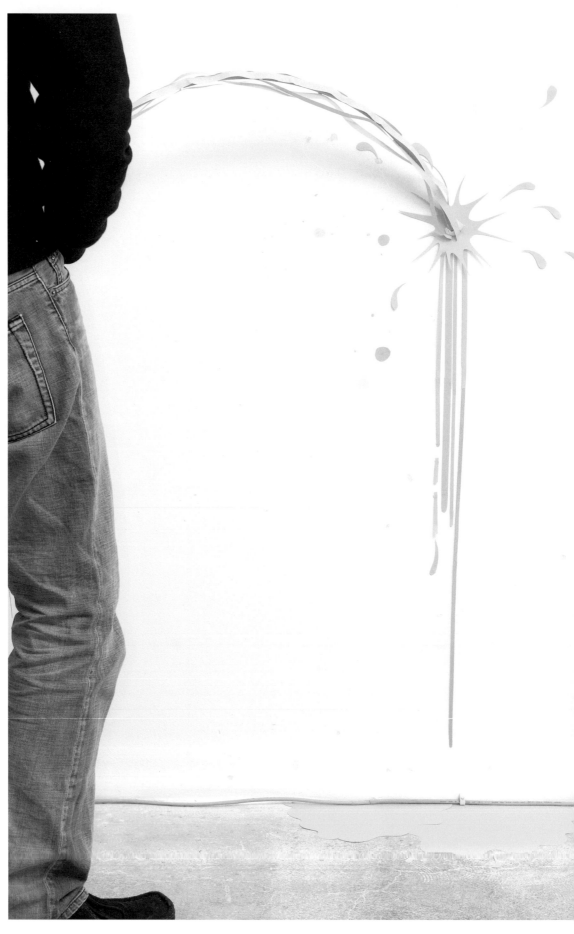

PIXELGARTEN,
CATRIN ALTENBRANDT & ADRIAN NIESSLER
01 **Um was es nicht geht**
 2006

STEVEN HARRINGTON
02 **Our Geometric Family**
 for Anorak Magazine, illustration by Steven
 Harrington, art direction by Rob Lowe
 "Supermundane", 2007

Our Geometric Family

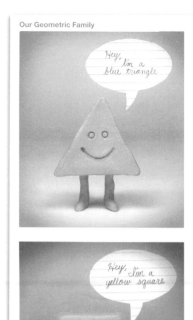
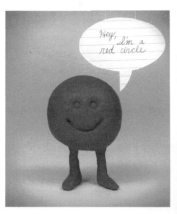
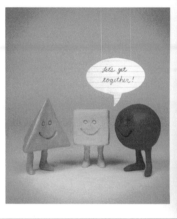
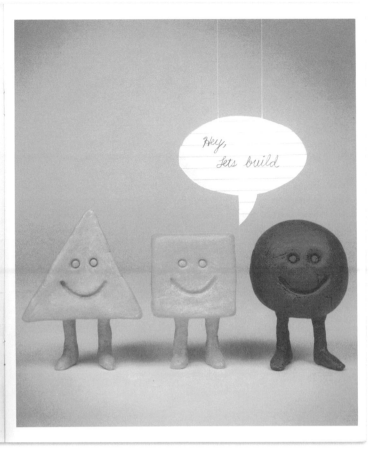
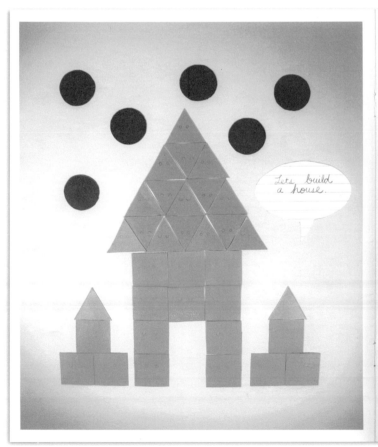

Words and Pictures **Steven Harrington**

The End

21. 3.–20. 4.

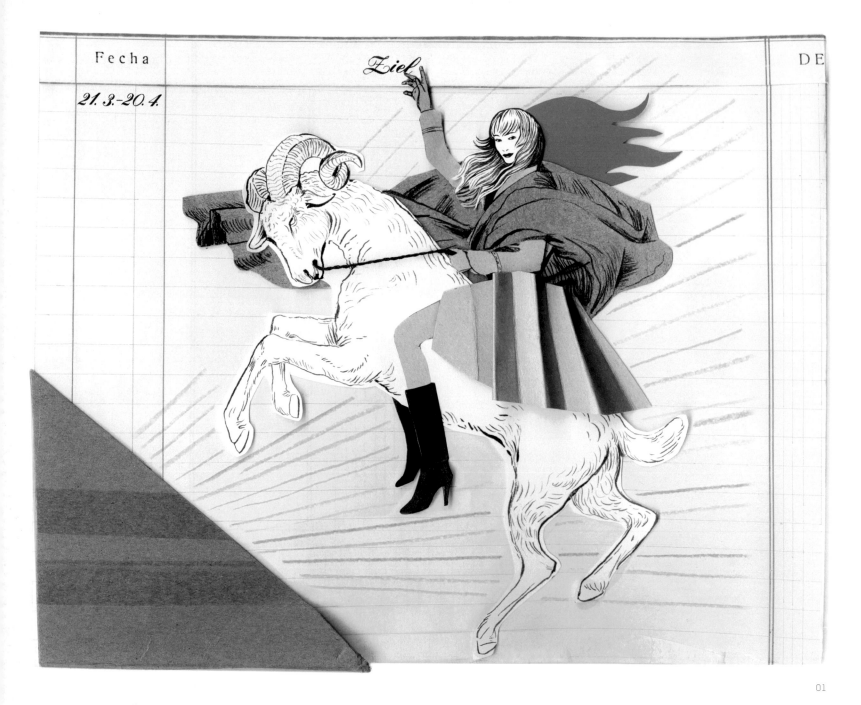

01

02

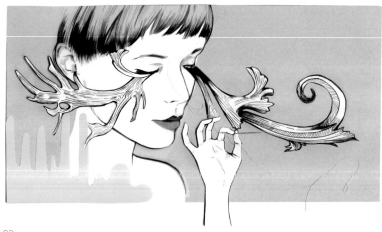

03

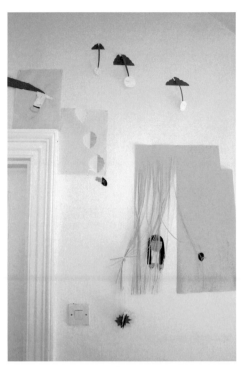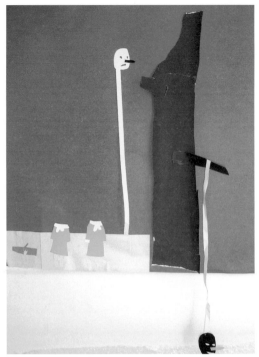

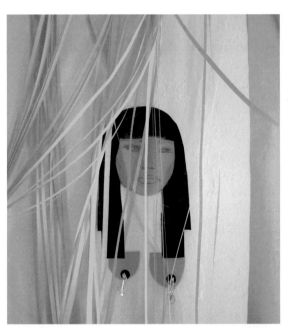

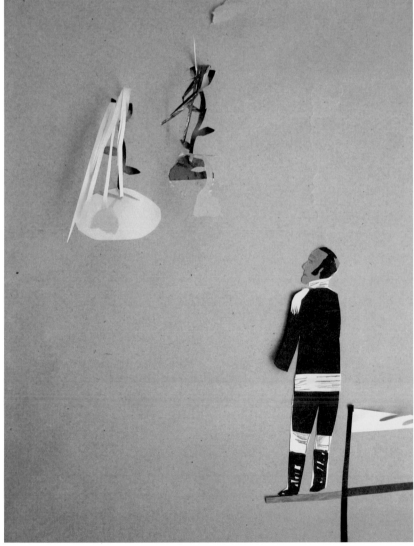

04

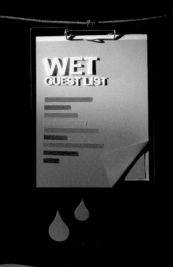

WET
GUEST LIST

WEAR IT
AT NIGHT
DOWNLOAD IT AT SERIALCUT.COM/WET

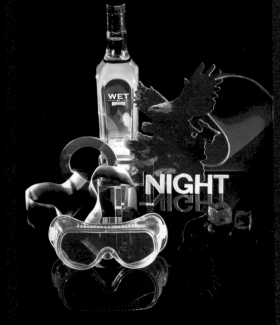

NIGHT

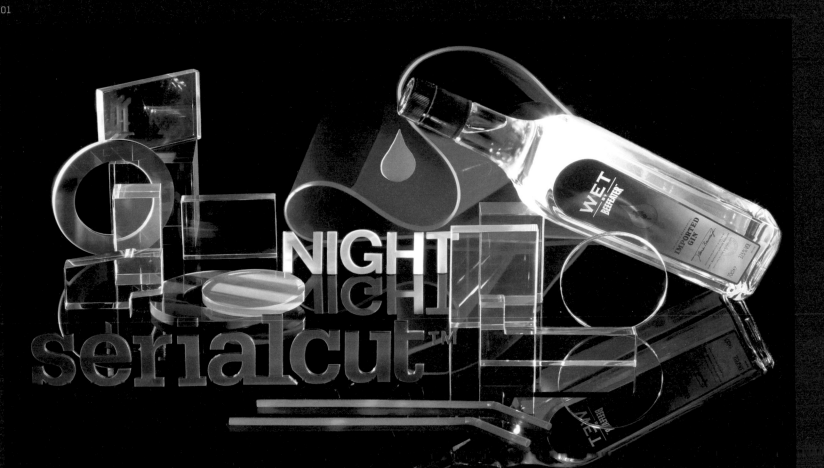

NIGHT

serialcut™

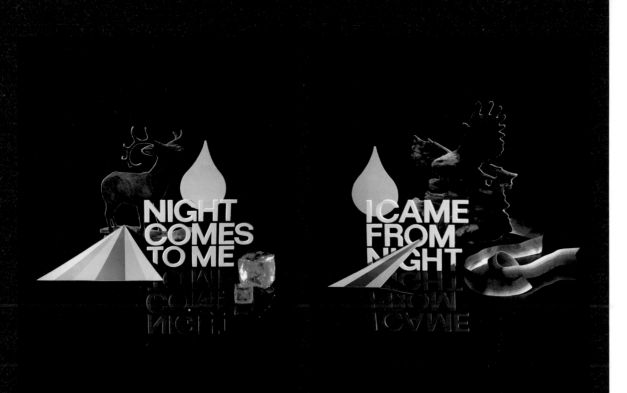

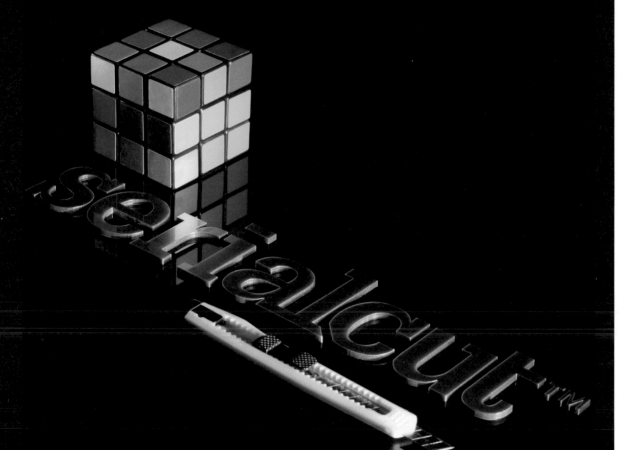

SERIAL CUT™

01 **SERGIO DEL PUERTO**
Ego Catwalk
for WAD Magazine. EGO catwalk is a new platform for emerging fashion designers from Spain: Tiago Valente, Gomez, Maria Cle, Beach Couture, Diez Campaña, Potipoti and Ute Ploier. WAD magazine featured this event in a 5-page special, and Serial Cut™ selected three looks by each designer, printed them, and made a collage, 2006

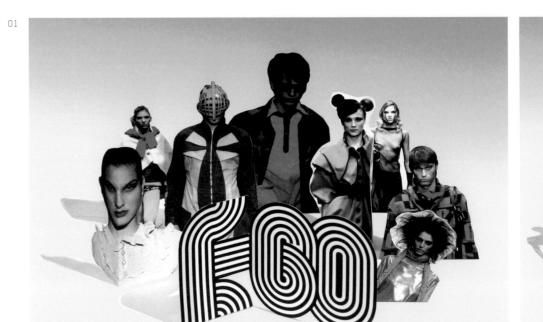

02

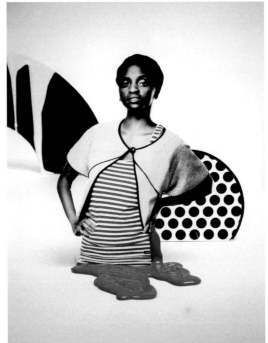

02 **WAD NORTHERN EUROPE**
for WAD Magazine, France
For this special issue, the guys from WAD sent Serial Cut™ the images of the different models, which represent all the northern countries of Europe: Sweden, Norway, Denmark, Finland, Holland and Belgium, 2006

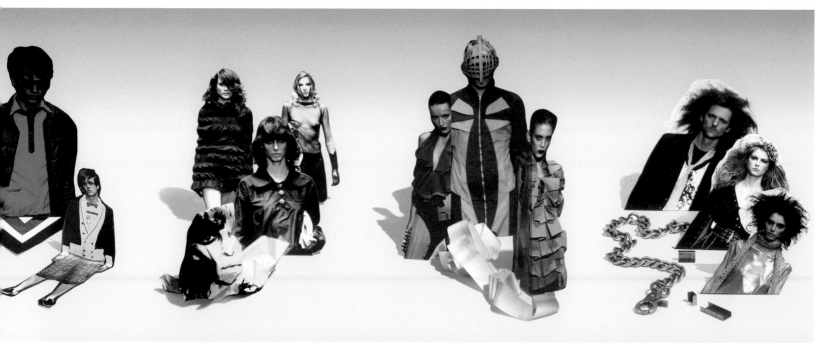

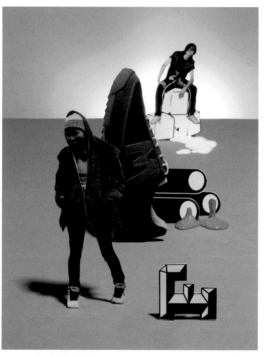

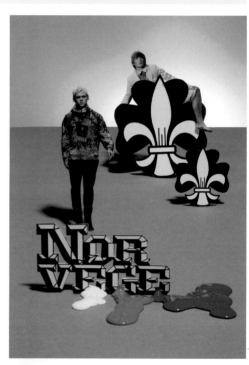

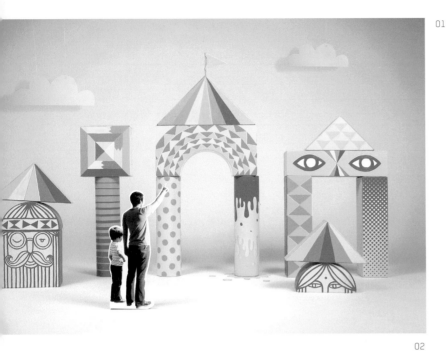

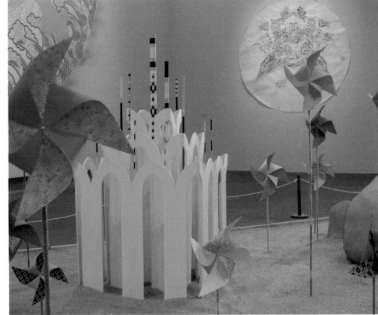

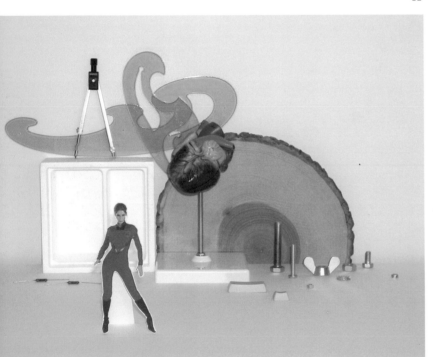

SUPERBÜRO
01 BARBARA EHRBAR
Technikschnuppertage
for Berner Fachhochschule, 2006

STEVEN HARRINGTON
02 **When John Met Nonny**
Steven Harrington, 2007

DAVID ARON
03 HANNA FUSHIHARA ARON, DAVID ARON
Purifing Structure in a Garden of Light and Sound- for Cosmic Wonder
for Yerba BuenaCenter for the Arts, made of sand, wood, gold and silver leaf,
paint, yarn and paper, 2006

04

STEPHANIE SYJUCO
04 "Everything Must Go
(Grey Market)"
© Stephanie Syjuco, digital prints, foam-
board, paper, tape, foam; dimensions vari-
able, studio production shot, 2005

THUNDERCUT
05 RMCAD box
for Rocky Mountain College of Art and
Design, "RMCAD asked us to contribute a
piece to their benefit show for the Denver
Childrens Hospital. Each piece was based
around the same object: a box.", 2006
06 Oval Art
Front Room Gallery Brooklyn NY,
"117 artists created pieces based around a
common shape: the oval.", 2006

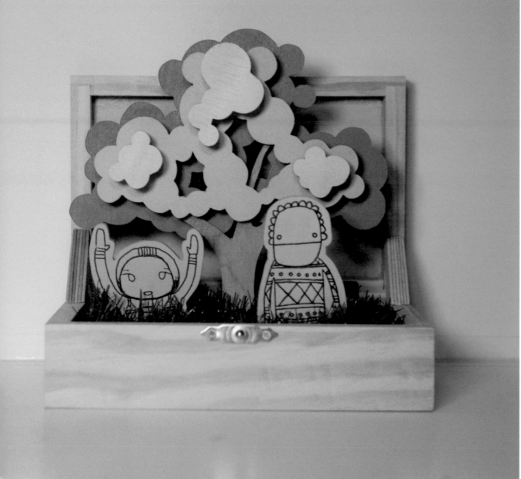

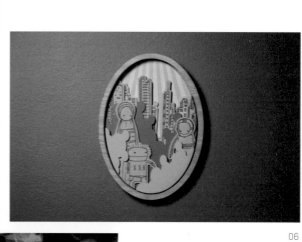

06

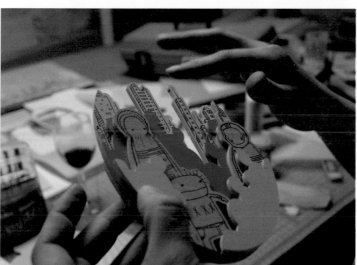

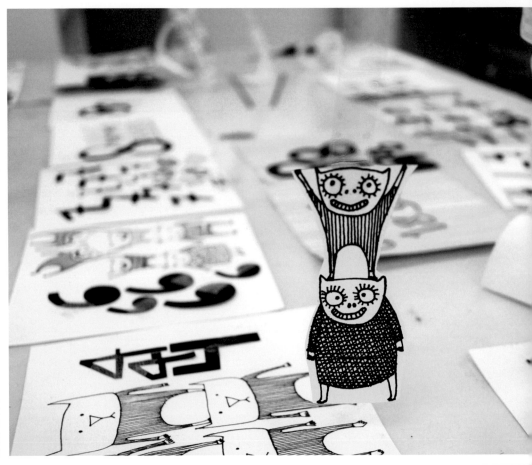

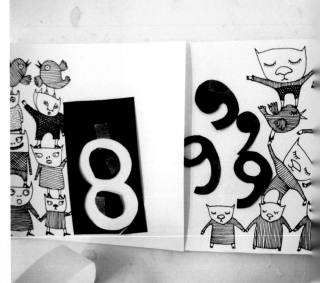

01

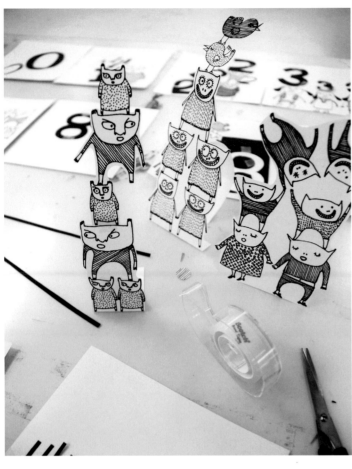

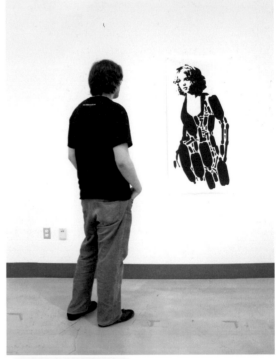

LULA
01 SARA BLOHMÉ
1, 2, 3...8 / childrens book
for HDK, photo by Elisabeth Dunker, 2007

GLUEKIT
CHRISTOPHER SLEBODA & KATHLEEN
BURNS
02 Beating a Dead Horse
for The Drama, © Gluekit, 2006

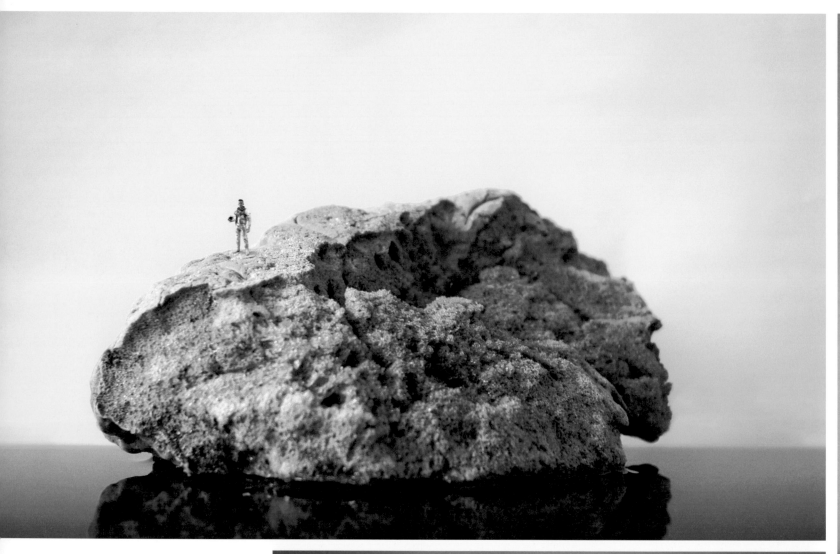

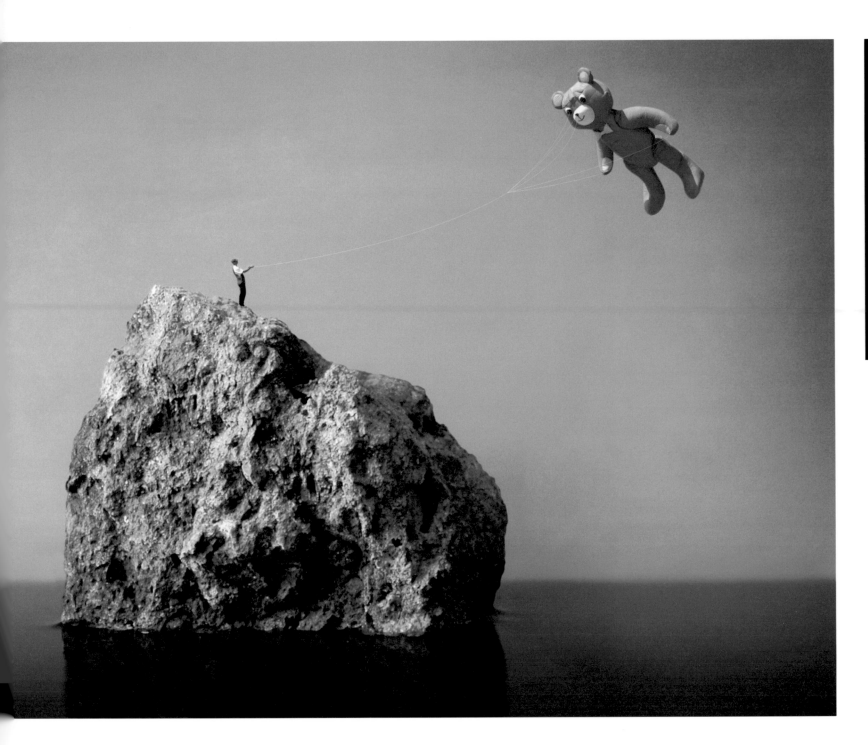

ALAIN RODRIGUEZ
Islands
© Alain Rodriguez, 2007

01

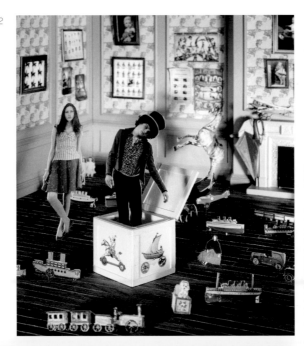

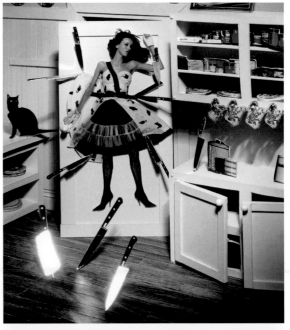

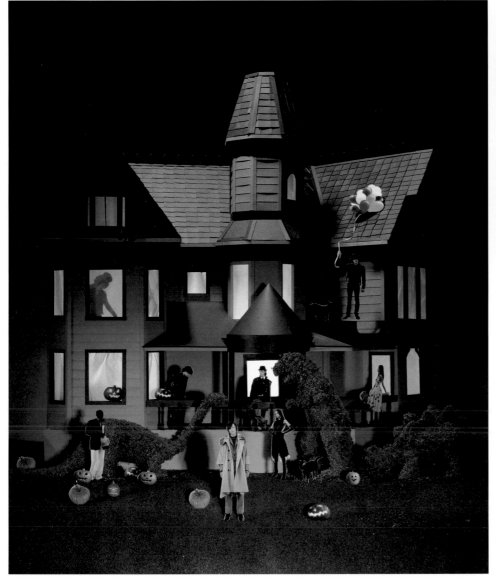

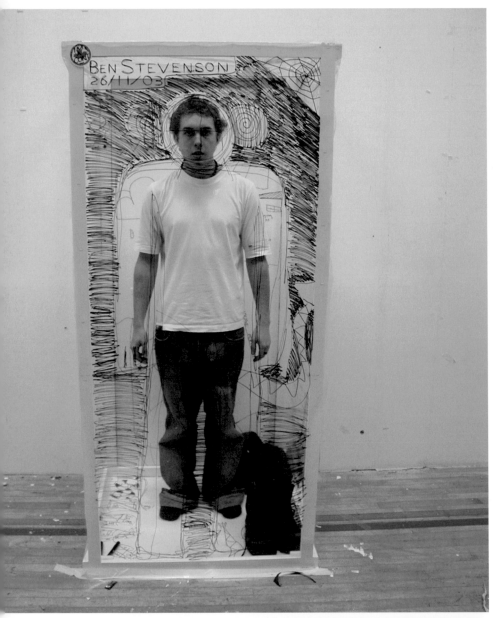

01

BEN STEVENSON

01 **Benny in a Box (24 hour Self Portrait)**
How to make a self-portrait as honest as possible? Simple: become part of the work and exhibit yourself. A firm believer in transparency, Central Saint Martins graduate Ben Stevenson spent a day on display with only a marker pen to keep himself amused. A free-standing poster and living portrait, his self-imposed confinement threw a spotlight on portrayal, exposure, endurance and communication – a welcome tour de force for artist and audience alike.
self-initiated, © Ben Stevenson, 2003

VIVELETUNING

02 HELM PFOHL, CHRAGI FREI
wheel CD Packaging
for wheel, photos by Beat Schweizer, 2005

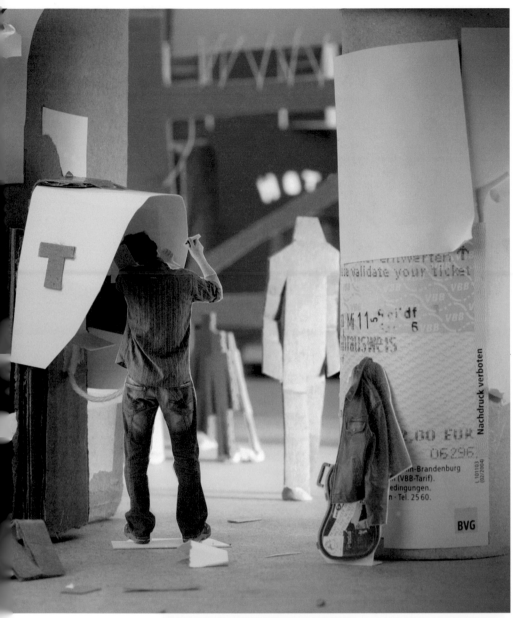

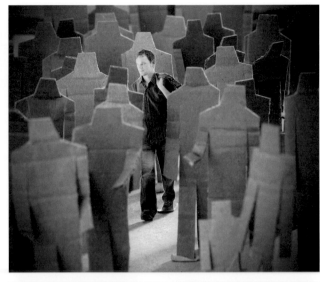

02

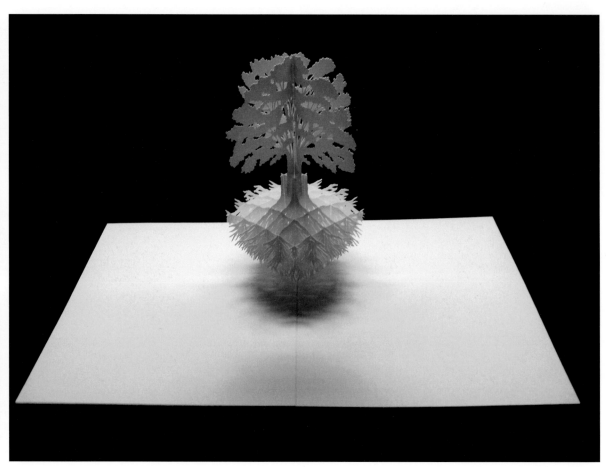

HIROKO OHMORI
01 jyu-kon
© HIROKO, sponsored by Shimada
KAMIWAZA expedition, 2005

EVAQ STUDIO
02 ASIF MIAN
Fast Cars
for Aesop Rock, Definitive Jux Records,
music video, directed by Asif Mian Art
Direction, Design by Asif Mian, 2005

THOMAS ALLEN
03 Fury
04 Topple
05 Uncovered
06 Teeter
07 Chemistry
08 Knockout
Courtesy of Foley Gallery, 2006

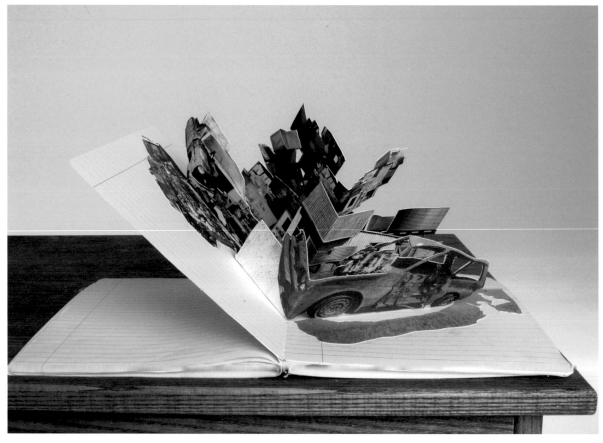

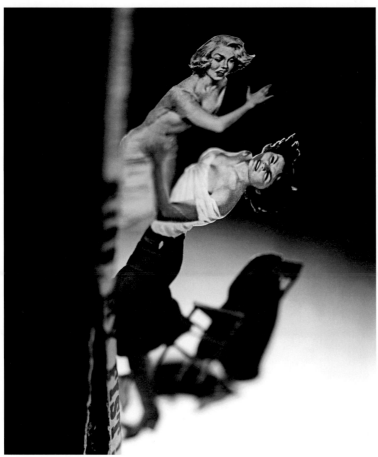

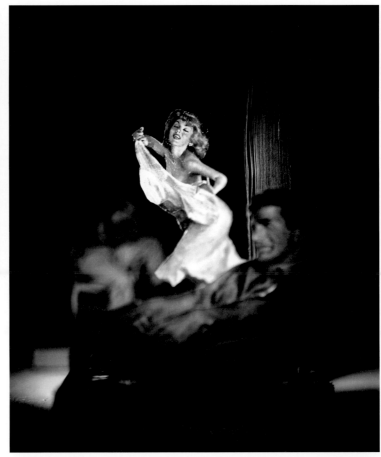

05

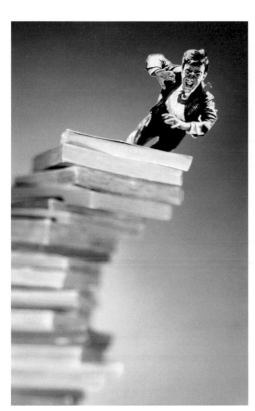

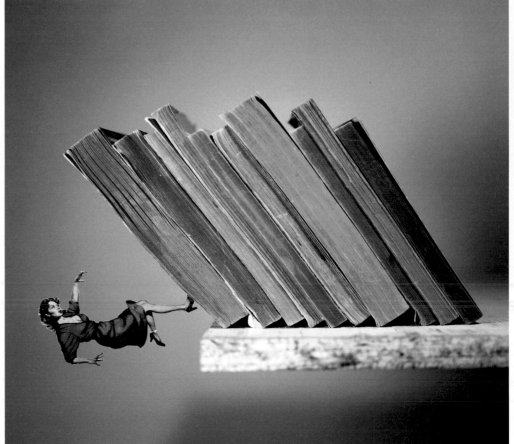

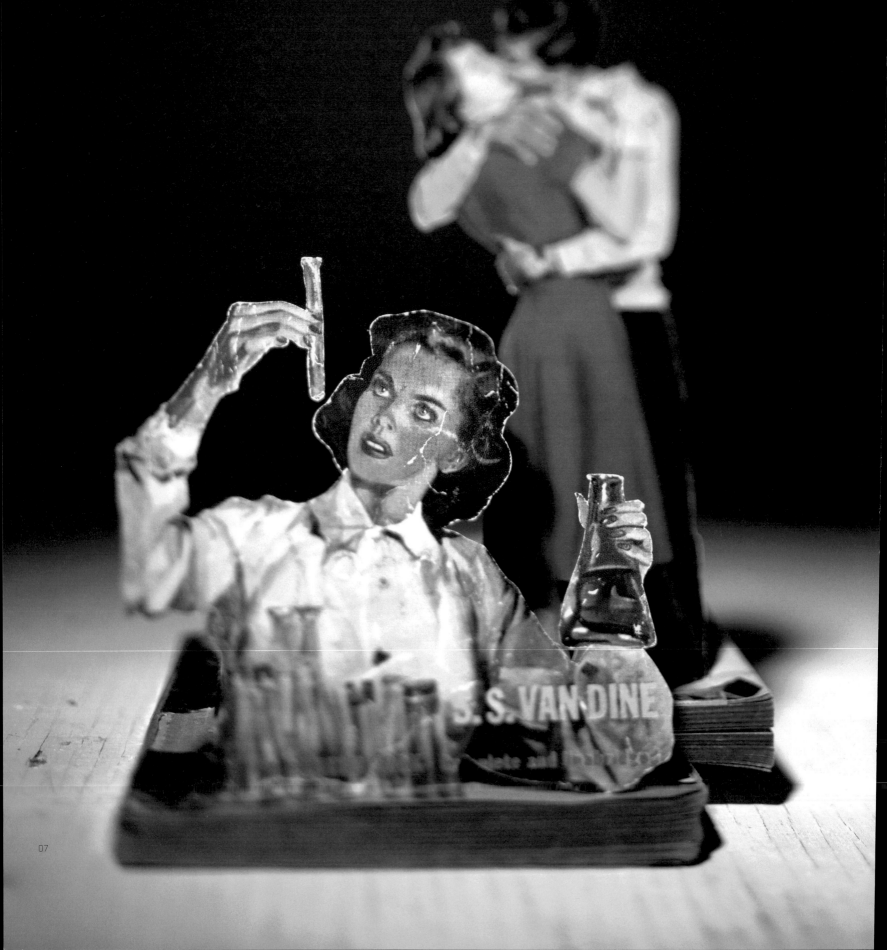

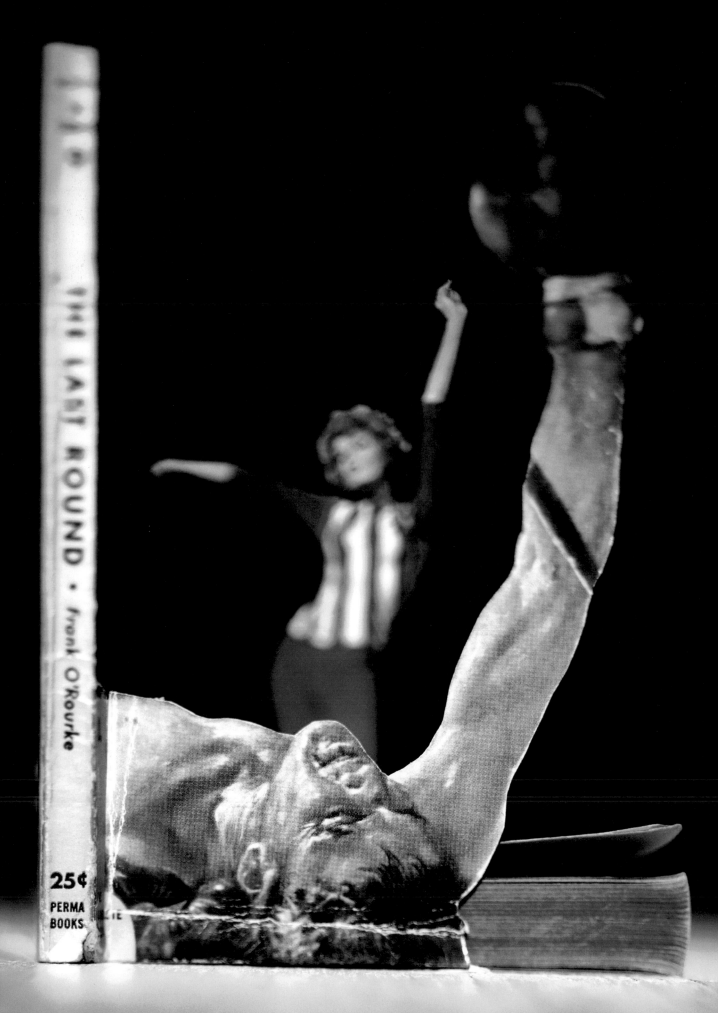

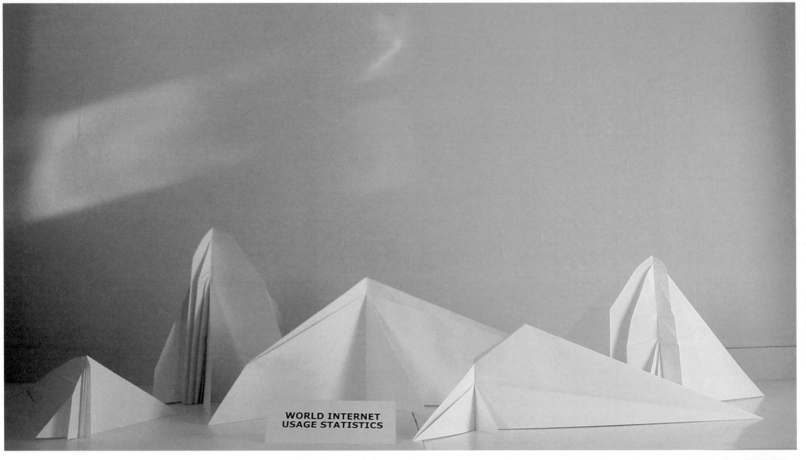

WORLD INTERNET
USAGE STATISTICS

01

ETIENNE CLIQUET
01 Internet Statistics
02 Top Ten Languages Used in the
 Web (Number of Internet Users by
 Language)
03 Browser Statistics On January 2006
04 Internet level of penetration in 13
 countries in 2003
05 Top Ten Languages Used in the
 Web (Number of Internet Users by
 Language)

Conceptual artist Etienne Cliquet
returns some order to the fold with
his origami statistics, adding a level of
aesthetic abstraction to dry facts. The
resulting unlabelled paper sculptures,
reminiscent of pristine mountain
ranges, make statistics more tangible,
yet force the viewer to draw his own
conclusions about the underlying cat-
egories and interpretation.
© Etienne Cliquet, 2006

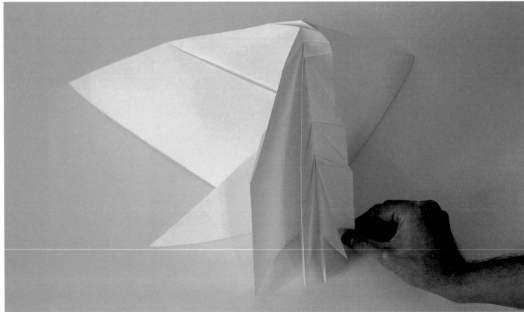

02

03-05

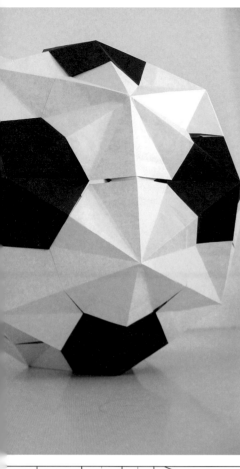

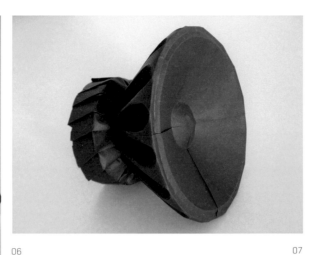

06

07

ETIENNE CLIQUET
06 Origami Soccer ball
07 Origami Speaker
08 Origami Statistics Crease-Pattern
© Etienne Cliquet, 2006

SIMON ELVINS
09 **Paper Record Player**
A 100% paper device, Simon Elvins's fully working manual record player is a prime example of purist design and engineering. When the handle is cranked at a steady 33 1/3 rpm, the cone serves as both pickup and speaker for Elvins's choice of vinyl, "The Sound of Music".
2005

09

08

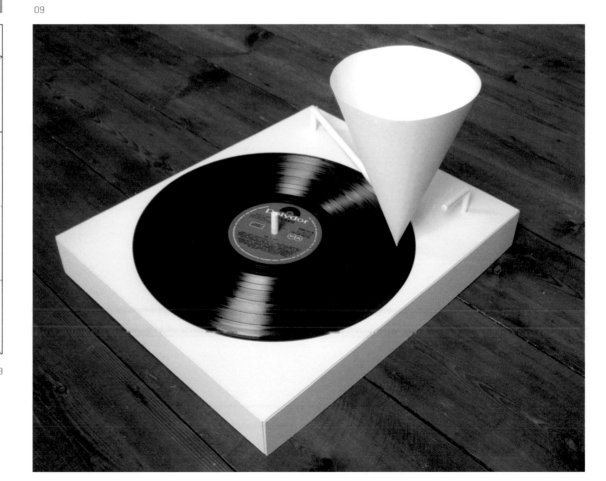

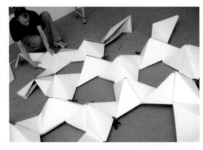

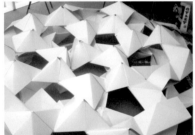

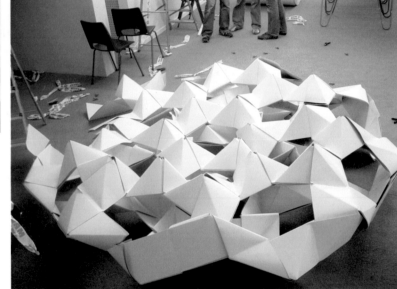

01

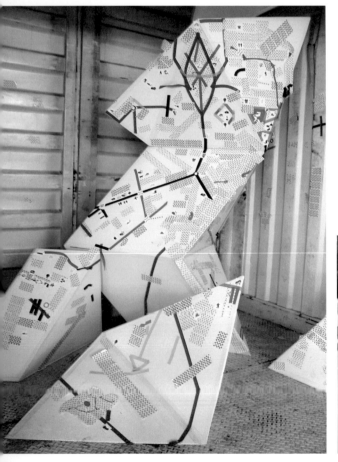

02

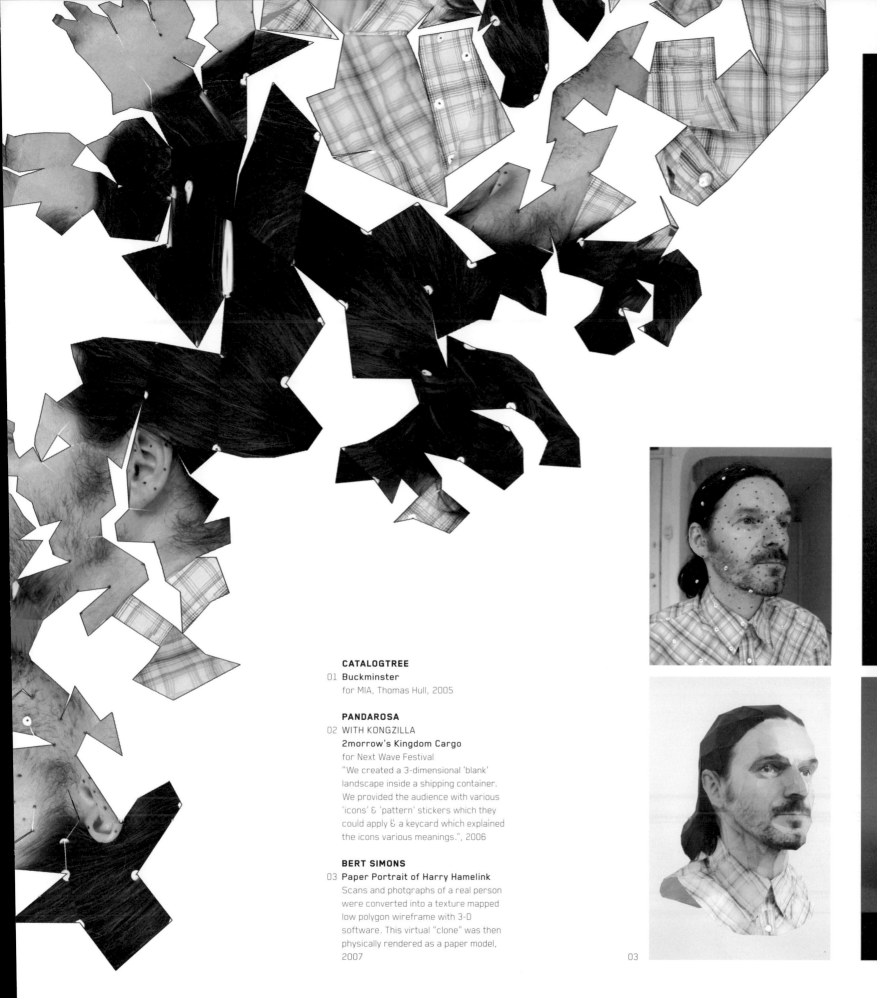

CATALOGTREE

01 **Buckminster**
for MIA, Thomas Hull, 2005

PANDAROSA

02 **WITH KONGZILLA**
2morrow's Kingdom Cargo
for Next Wave Festival
"We created a 3-dimensional 'blank'
landscape inside a shipping container.
We provided the audience with various
'icons' & 'pattern' stickers which they
could apply & a keycard which explained
the icons various meanings.", 2006

BERT SIMONS

03 **Paper Portrait of Harry Hamelink**
Scans and photgraphs of a real person
were converted into a texture mapped
low polygon wireframe with 3-D
software. This virtual "clone" was then
physically rendered as a paper model,
2007

03

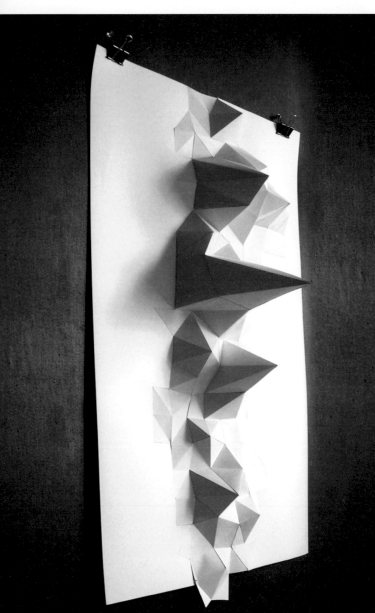

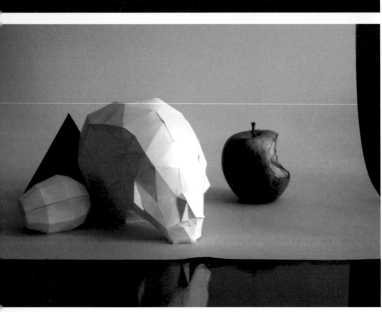

PIERRE VANNI
01 Exhibition 1 – A Small Panorama of
Graphic Design
Indoor poster for Manystuff,
© Pierre Vanni, 2006
02 **Vanités**
© Pierre Vanni, 2006

RICHARD SWEENEY
03 **Strategic Hotel Annual Report**
for Strategic Hotel
04 **Tetrahedron**
*Self-initiated project, paper, adhesive,
diameter 50cm*
05 **Icosahedron II**
06 **Icosahedron II**
*paper, adhesive, diameter 67cm,
Produced as part of an exploration into
paper-folding techniques during a degree
in three dimensional design at Manchester
Metropolitan University, England.*
07 **Icosahedron**
*Self-initiated project, paper and adhesive,
diameter 33cm*
08 **Tetrahedron**
*Self-initiated project, paper and adhesive,
diameter 50cm*
© Richard Sweeney, 2005-2007

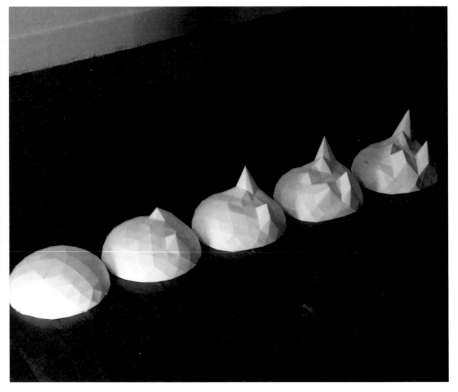

03

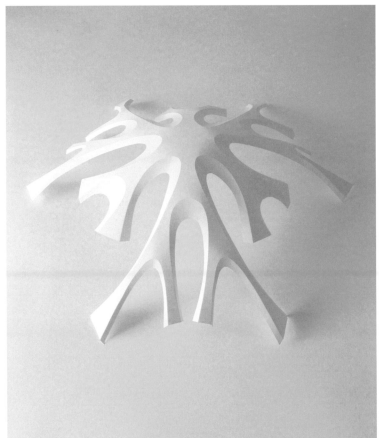

04

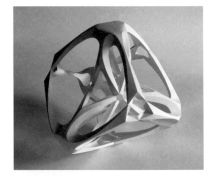

05

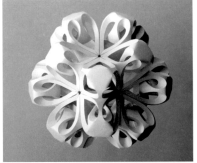

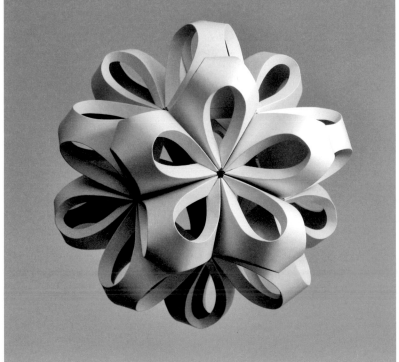

06

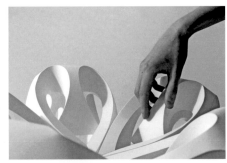

07

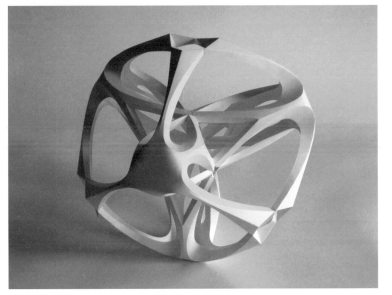

08

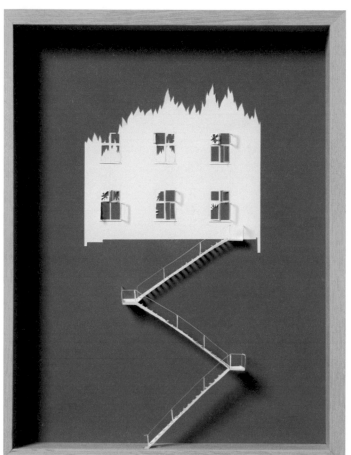

PETER CALLESEN

01 **Fire Escape Unable to Escape Fire**
 Acid-free A4 80 g. paper and glue in
 artist-made frame 47,5 x 37 x 7 cm

02 **Water Always Finds its Way**
 Acid-free A4 80 g. paper and glue in
 artist-made frame 47,5 x 37 x 7 cm

03 **Holding on to Myself**
 Acid-free A4 80 g. paper and glue in
 artist-made frame 47,5 x 37 x 7 cm

04 **Stepladder**
 120 X 100 Cm 80 Gms
 Acid-free Copy paper & glue
 Courtesy of Helene Nyborg Contemporary,
 Copenhagen, 2003

02 03

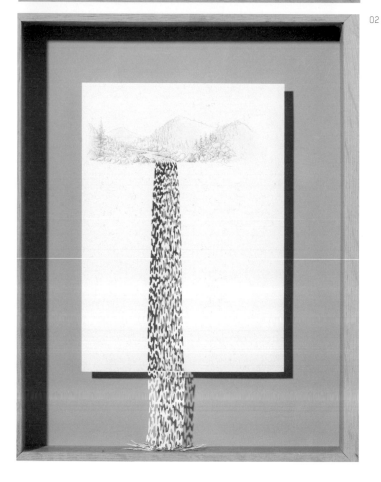

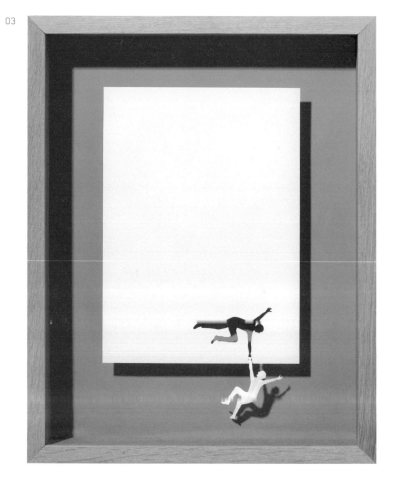

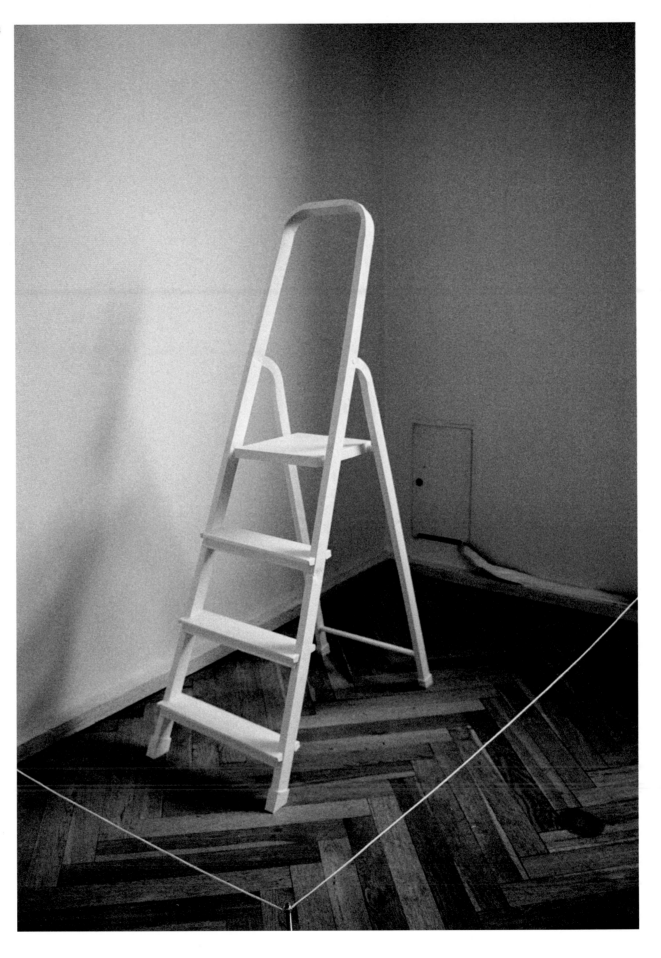

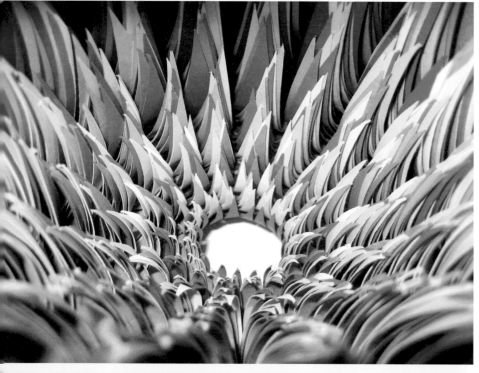

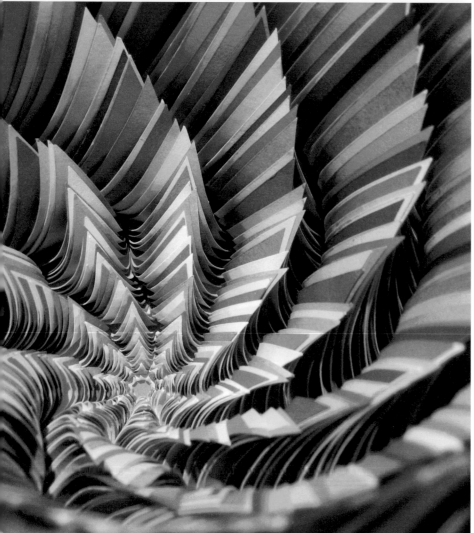

JEN STARK

........................

With just a few cuts, Florida native and Art Basel regular Jen Stark transforms reams of multi-coloured construction paper into stunning 3-D sculptures with staggering spatial properties – or simply "insanely cool pieces," according critics.

A true labour of love, Stark has been stacking, cutting and trimming her paper creations since she spent a year in Aix-en-Provence, "Because when I arrived, I had very few art supplies to work with. Paper was cheap so I started to experiment. Now I really love doing these sculptures – and I love the repetition involved. It is very meditative."

Not a tip out of place, Stark's whorls, whirls and edges not only add a new dimension, they also imply a keen grasp of the underlying engineering principles. Ruthlessly geometric and often reminiscent of geological formations, her striated masterpieces require only few expert cuts to release complex shapes from the flat surface and reveal what lies beneath in a glorious explosion of colour.

Incidentally, her love of order, perspective and filigree patterns also translates into books filled with drawings and even a beautifully trippy and mesmerising kaleidoscopic paper animation.

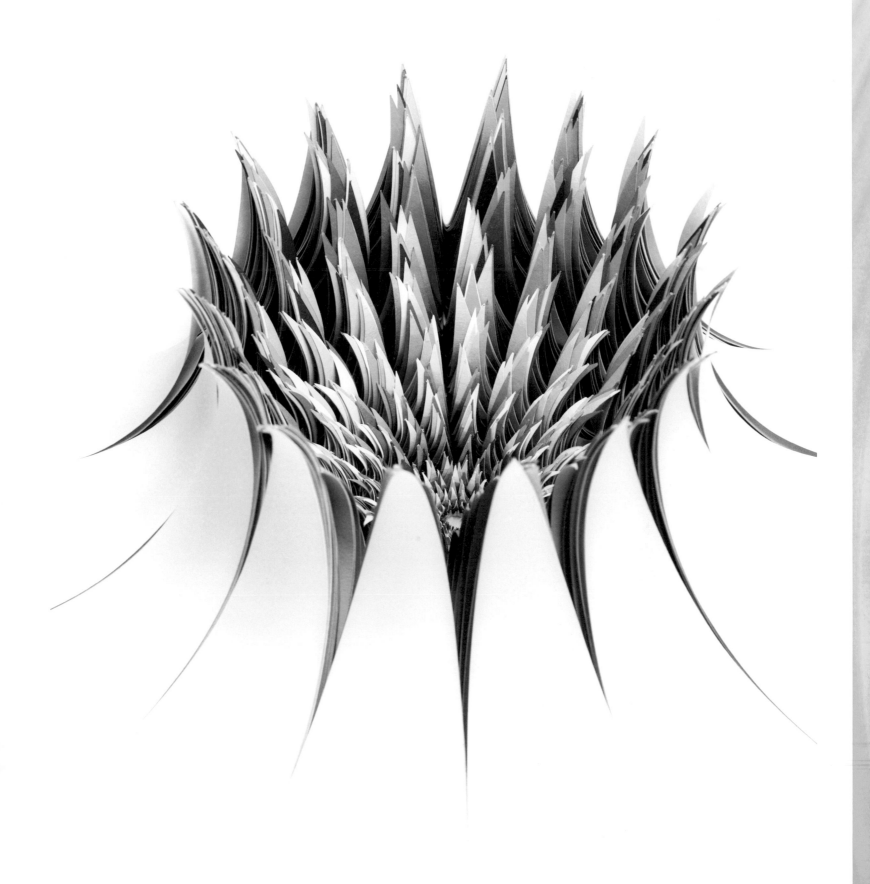

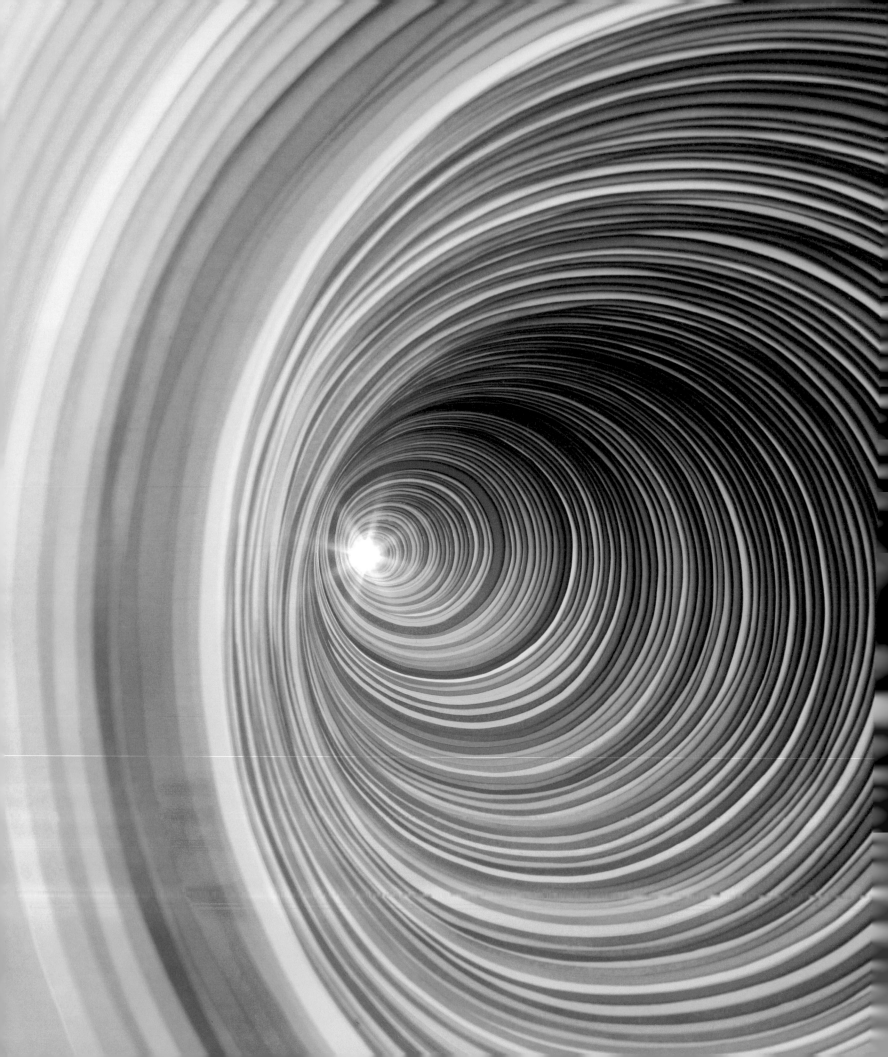

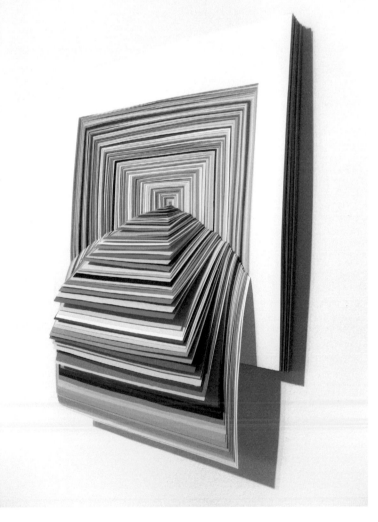

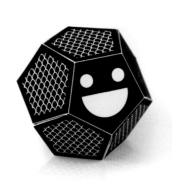

01

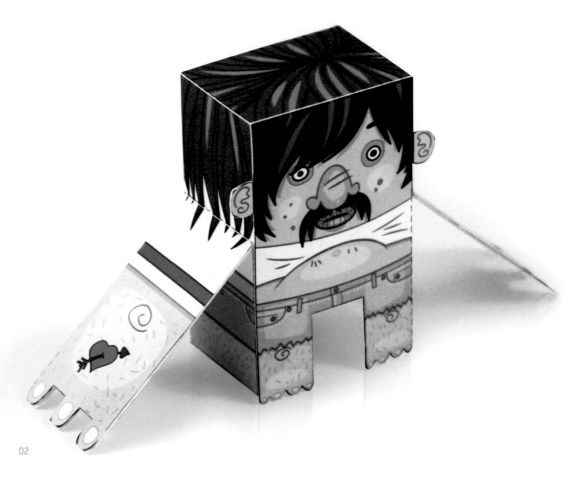

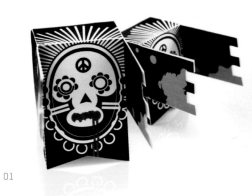

01

01

02

02

03

FWIS / READYMECH
01 Readymech Series 002
© Fwis, 2007
JULES
02 Readymech
for FWIS, 2006
FIREGIRL
03 RENATO SEIXAS
2D - 3D
for Search Megazine,
Touch Me - Cut Me - Bend Me - Shape Me - Glue Me -
And Play Me, 2006

03

03

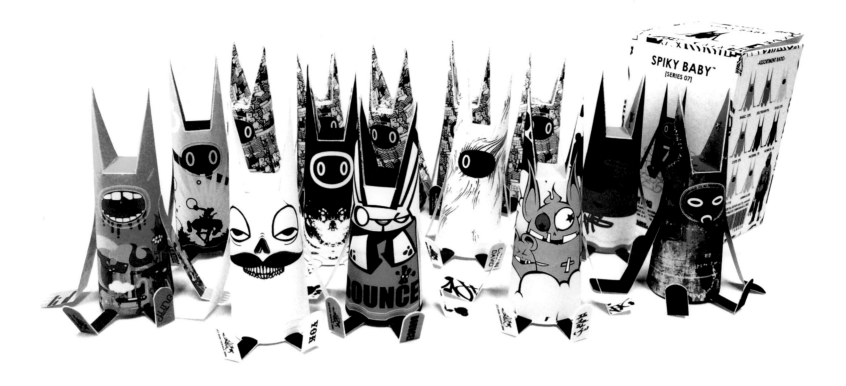

04

SHIN TANAKA

Print, cut, fold, enjoy. — Twenty-something graffiti writer, paper toy maestro, T-shirt designer and web specialist Shin Tanaka invites lovers of action figures and designer toys to ignore their overpriced objects of desire and discover the joys of his truly democratic must-haves instead. Unlike the flurry of limited editions and "don't open the box" creations running rampant on designer desks around the world, Tanaka's equally covetable critters are available free of charge as exclusive blueprints for DIY home enjoyment.

Based on a changing roster of blueprints, he invites other designers to fill his cute creations with colour and life, resulting in a small army of bright and beautiful individuals, available for downloading to anyone willing to wield a pair of scissors.

Nevertheless, be sure to expect the unexpected. Like the Kinder egg moment of childish surprise – and to add an exclusive twist to this otherwise egalitarian principle – Tanaka's system will not let you pick your own favourite, but allocates a random character from the website's eclectic line-up, with only a limited number available of each design.

Enterprising souls, by the way, are encouraged to customise their own characters: simply download one of the latest templates and give it your best at the drawing board.

05 06 07 08

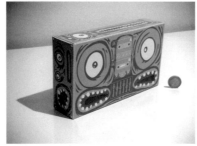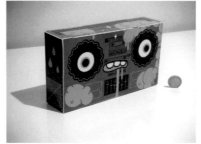

01

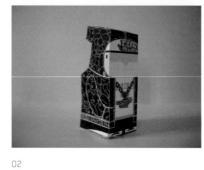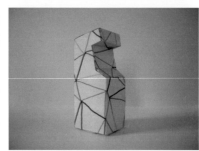

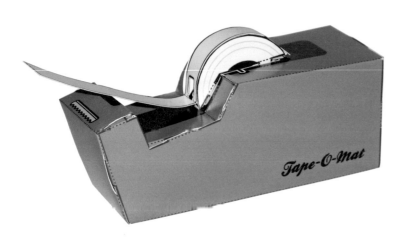

02

03

04

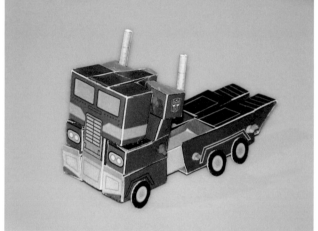

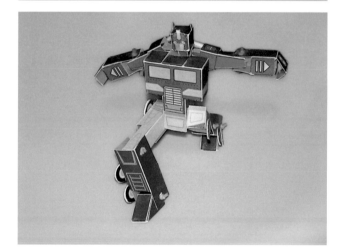

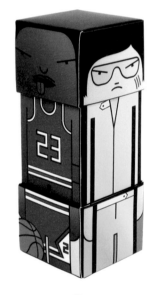

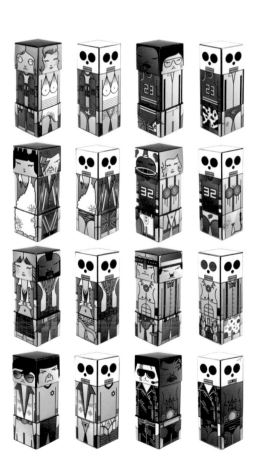

05

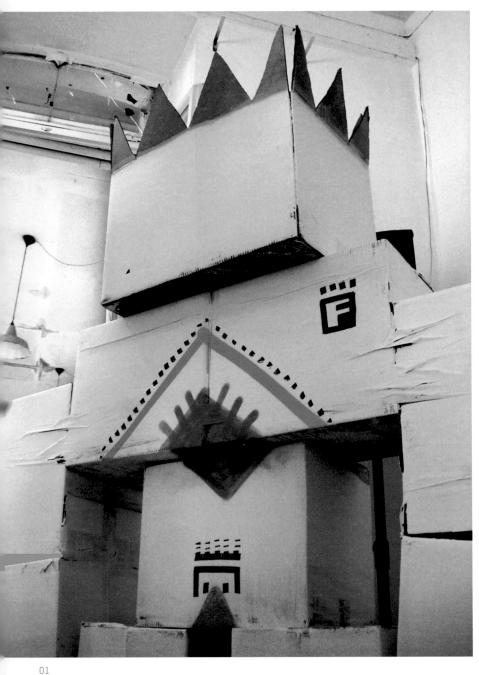

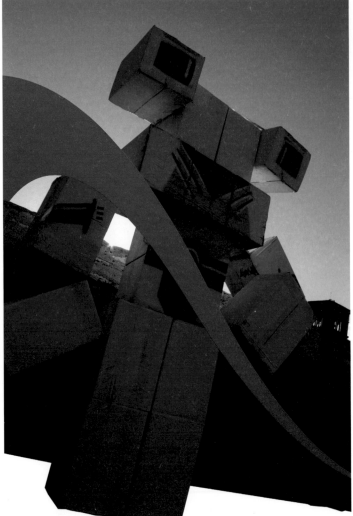

01

02

FUPETE STUDIO
01 **IROBO @ RIALTO**
02 **IROBO @ RIALTO**
for RialtoSantAmbrogio, curation by Fabio
Campagna, photos by Marco Caruso, assist-
ance Erika 'Gerjka' Gabbani, 2007
03 **IROBO @ ROMA**
Personal project, curation by Marvin Mila-
nese, spaces by 47thFloor and Sc02, photos
by Eolo Perfido and Ernesto De Angelis, 2007

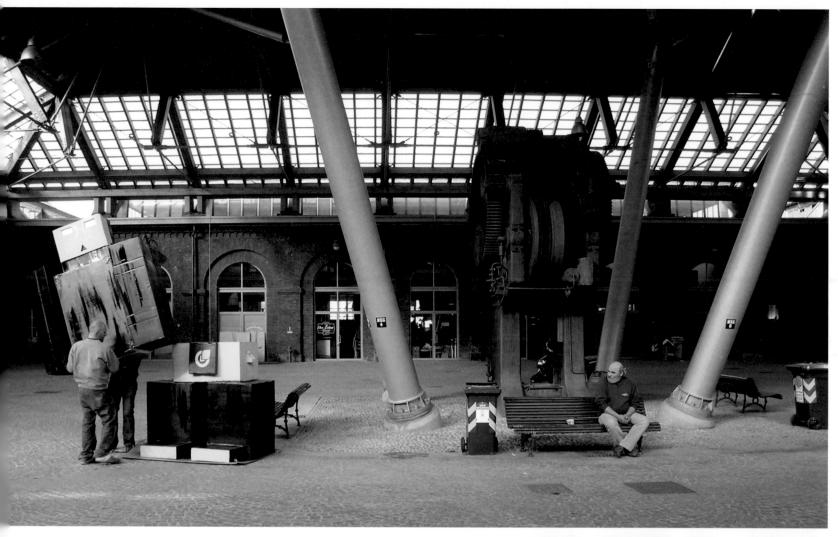

04

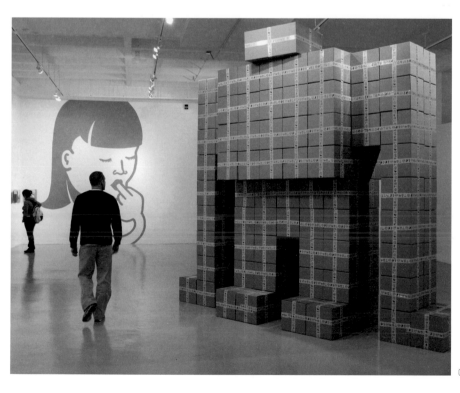

05

DIMOMEDIA LAB
04 MASSIMO SIRELLI
D-Droid
Paper Robot, an installation cre-
ated for the first anniversary of
Dimoemdia Lab Studio, 2007

MICHAEL SALTER
05 **Visual Logistics**
University Of Texas, Arlington,
Michael A. Salter, 2006

- 81

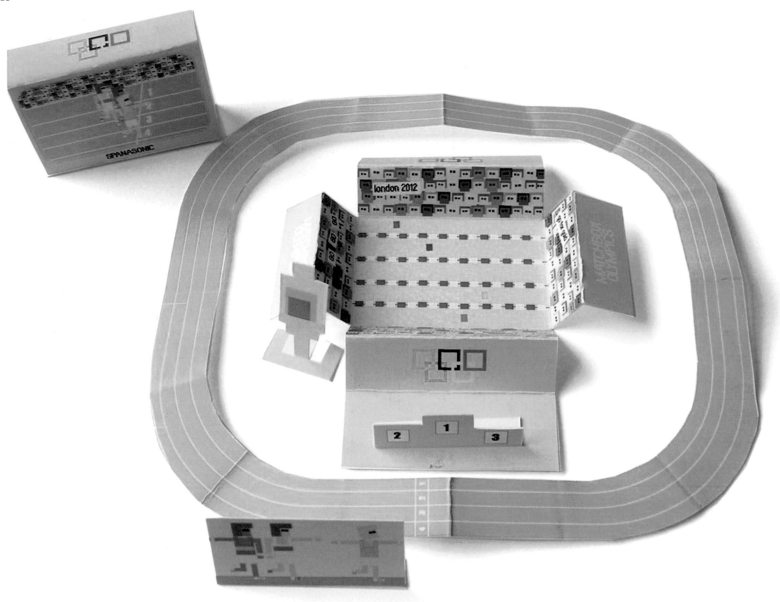

CRAIG KIRK
01 Matchbox Olympics
02 The Matchbox Player
03 Matchbox Drive-In
04 The Matchbox Festival
2005 - 2006

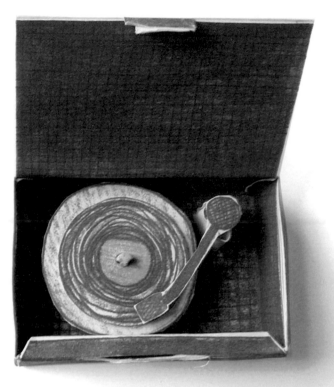

02

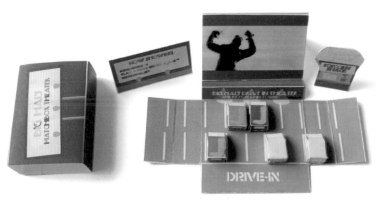

03

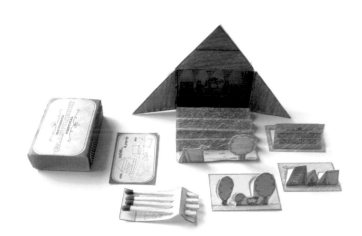

04

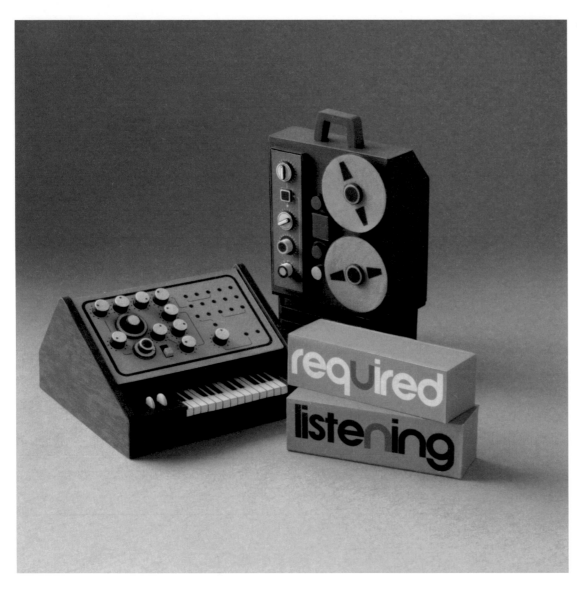

DAN MCPHARLIN

01 Required Listening CD/LP
Do Right Music, © Dan McPharlin, 2007

STEPHANIE SYJUCO

02 Future Shock Nesting Boxes
Archival Inks on laminated board, in edition
of 20. Printed and assembled by Electric
Works, San Francisco
Southern Exposure Gallery, San Fran-
cisco, CA, © Stephanie Syjuco, 2005

03 Bling Bling
© Stephanie Syjuco, 2005

01

04

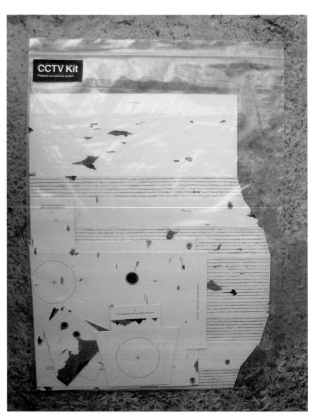

02

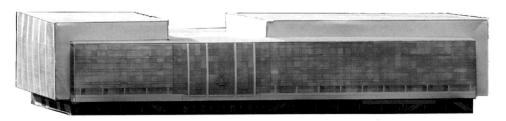

03

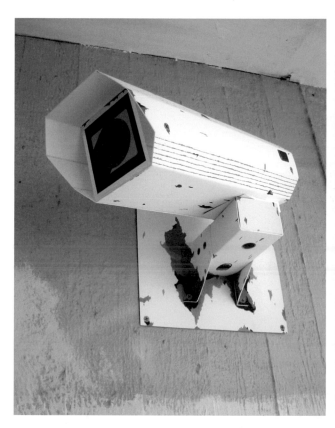

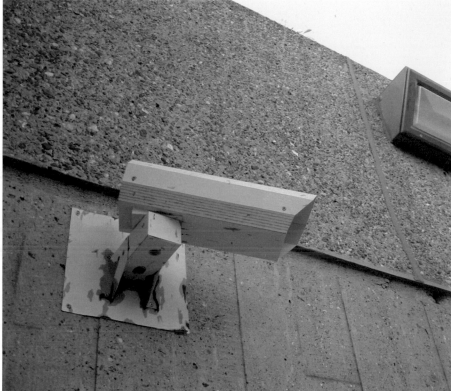

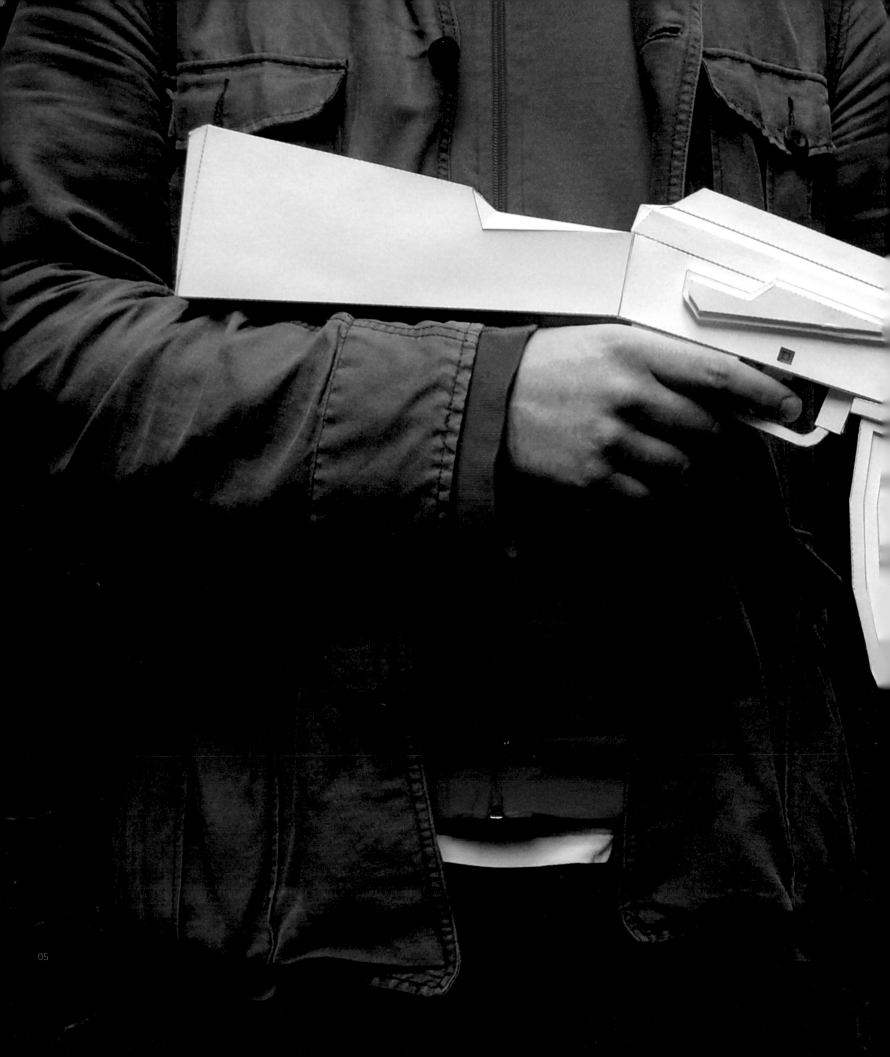

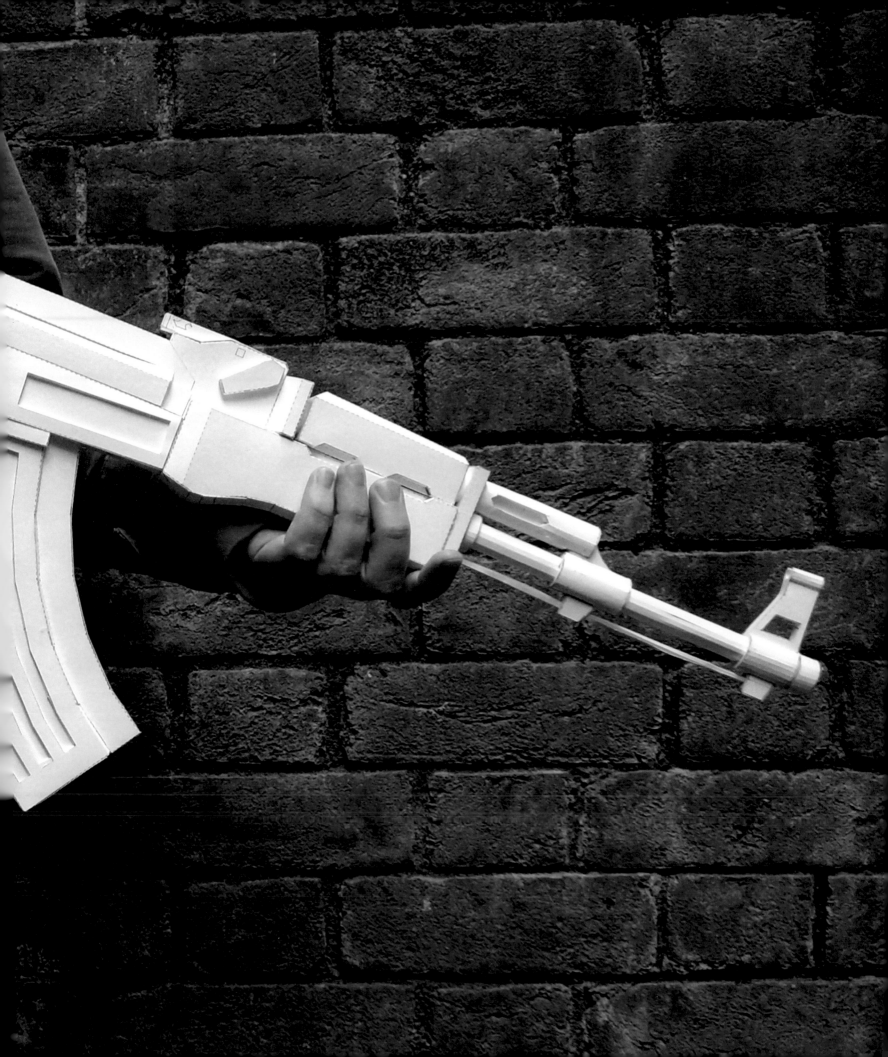

CARLO GIOVANI

for MTV Magazine, photos & illustrations by
Carlo Giovani, © Editora April, 2005

04 **In Nature, Everithing Turns into More Nature**
for Instituto Souza Cruz, agency: SLM Ogilvy,
art director: Rodrigo Allgayer, Editor: Renato
Angel,i creation director: Luciano Leonardo,
illustrator: Carlo Giovani, illustrators assistants:
Heitor Yida and Ligia Jeon, photo by Carlo Giovani,
poducer: Magda Menezes, assistance: Karine
Moraes & Sonia de Souza, 2007

01

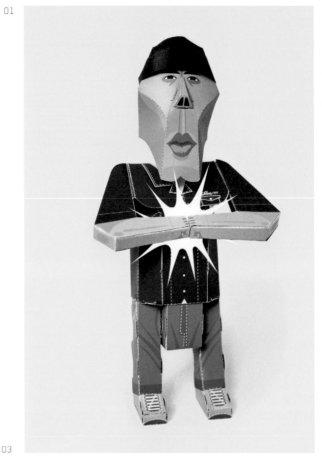

02

03

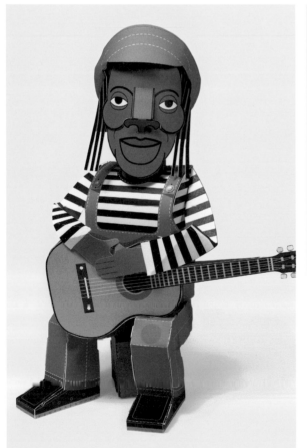

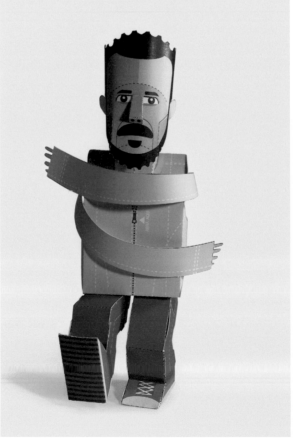

- *Dressed Up* -

Don't get us wrong – this chapter might be the fabric of invention, but it is by no means about fashion as such. Instead, the assembled artists, stylists, createurs and designers dissect and explore the scope of fabric, skin and hair far beyond its obvious purpose to cover and warm our frail existence.

Here, on the transitional brink between carefully arranged scene and full-blown installation, people take centre stage to lend a human touch, a sense of reality to conceptual and stylised depictions. The logical next step from posters and scenes, it is the – sometimes only perceived – human presence that makes the objects on display truly tactile and tangible.

While some of the works take the medium's inherent properties to the extreme – with facial adornment, fetishised objects and outlandish proportions – others turn to the carnivalesque, to bizarre dreamscapes, to huggable creatures and magical wonderlands. Yet whether proudly worn statement or overgrown mascot - all add a novel perspective on fashion and the body.

Uchu Country, for example, whose sculptural hair creations display a masterful manipulation of the medium, use untreated tresses for their elaborate creations, contrasting uninspired editorial beauty spreads – more often than not no more than a favourable backdrop for lucrative cosmetics advertising – with images that startle the viewer into attention.

By staging this topic in a new light, in a range of surreal settings and environments, the works in this chapter inject fashion and fabric with a new lease of life.

IJM
Chinese Spring
production / concept by Frank Visser & Ijm, photo by Jossy Albertus, cloud made out of felt by Heleen Klopper, model: Cindy@ Ullamodels

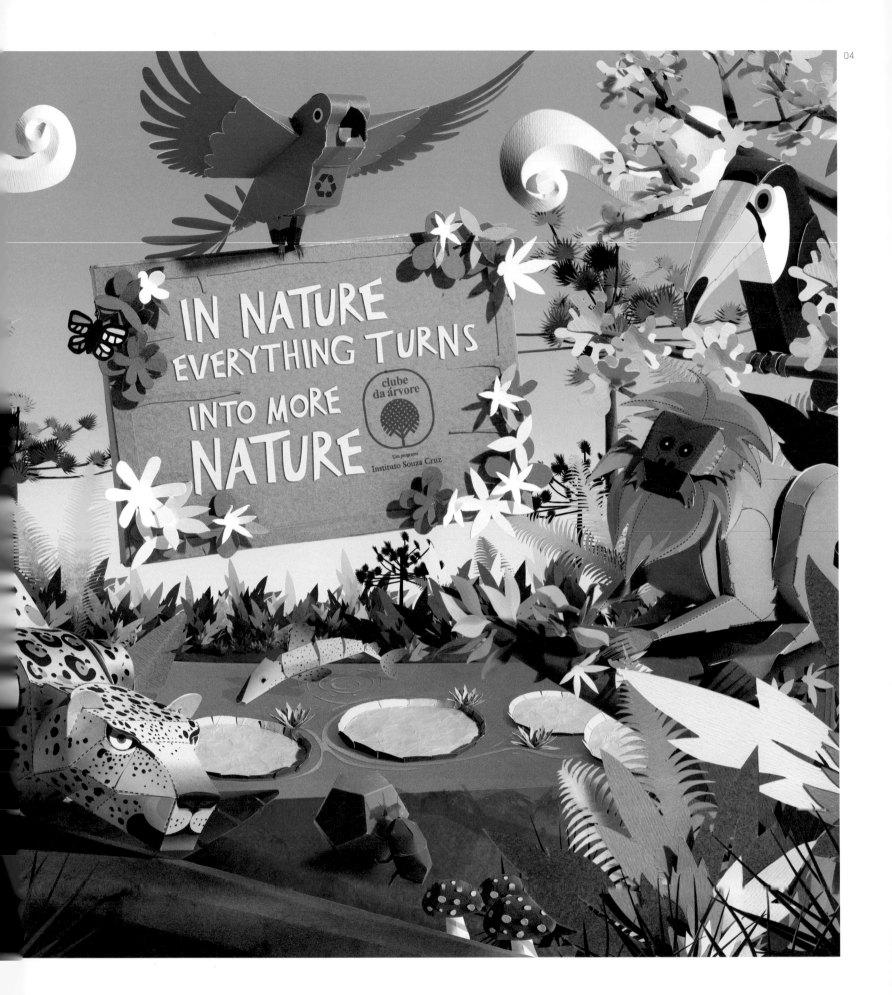

 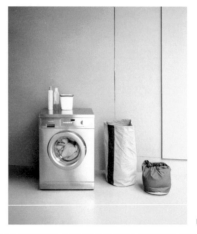 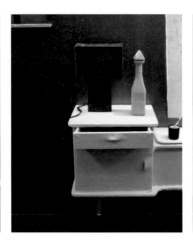

 02

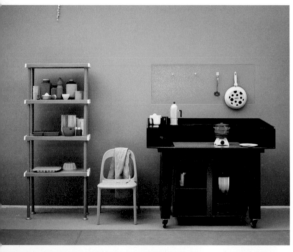

 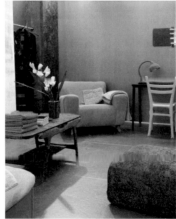 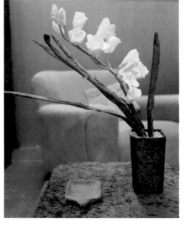

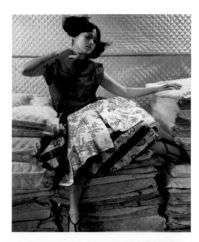

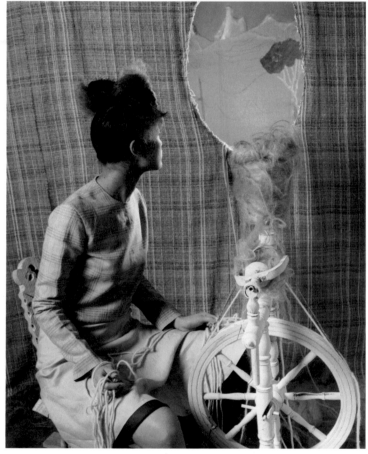

IJM

01 **Room 17**
production/concept by Frank Visser &
IJm, photos by Ingmar Swalue

02 **At His Place**
production/concept by Frank Visser & IJm
photos by Yamandu Roos

03 **Chinese Spring**
production/concept by Frank Visser & IJm
photos by Jossy Albertus

04 **Paper Garden**
production/concept by IJm, Liza Witte,
Anouk van Griensven
photos by Karin Nussbaumer
model: Mireille@ Paparazzi

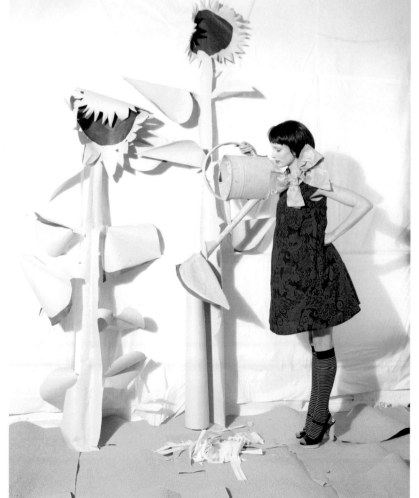

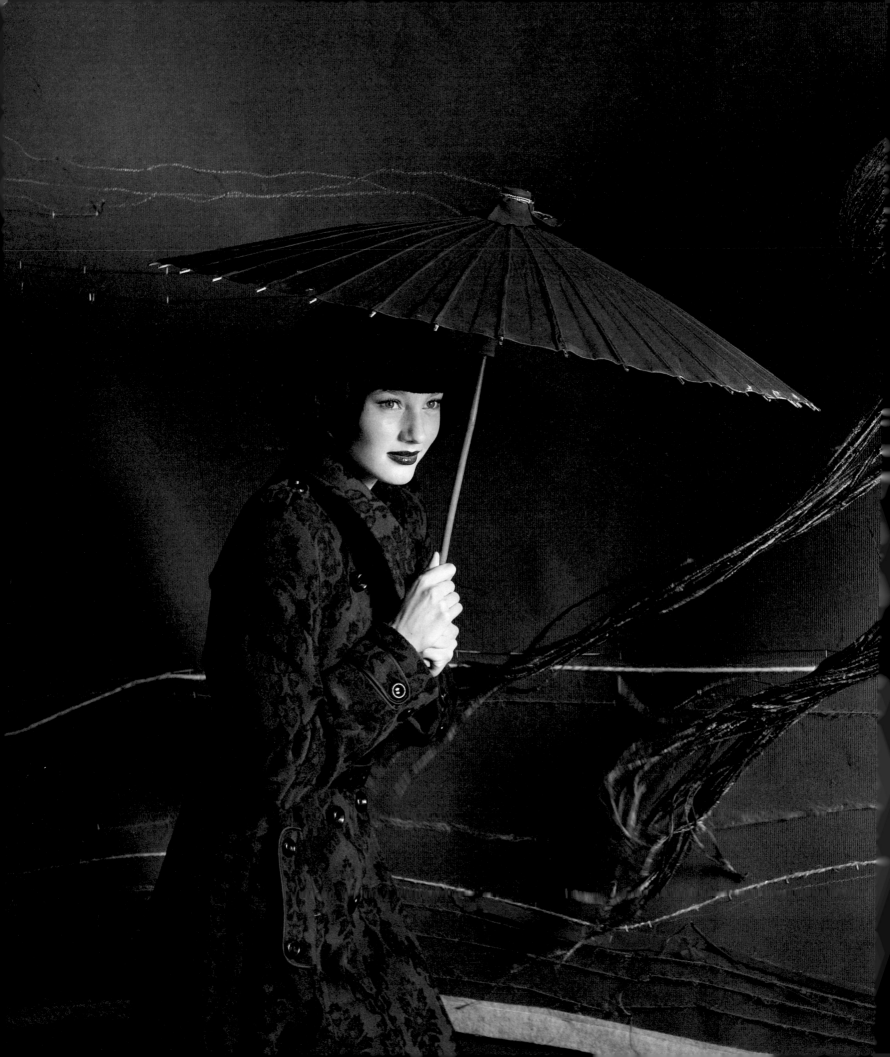

IJM
Cinema Oriental
production/concept by Frank Visser & IJm
fashion styling by Annelie Bruijn
cloud made by Violla van Melle
photo by Karin Nussbaumer
model: Tess@ Paparazzi

........................

Welcome to the doll's house.
The brainchild of IJM founder, avant-garde stylist, set builder and fashion aficionado Frank Visser, "Cinema Oriental" not only pays homage to Michel Gondry's visual poetry, but twists and knits influences from furniture, fashion, flea-market finds and classic movie scenes into a stylish and stylised parallel world between dusty 50s nostalgia and brightly coloured pop references.

Swathed in fabric, his surreal settings take mundane objects from their familiar surroundings and engulf them in a soft, dreamlike wonderland of felt, wool, silk and cloth where even the darkest of clouds comes with a silver lining.

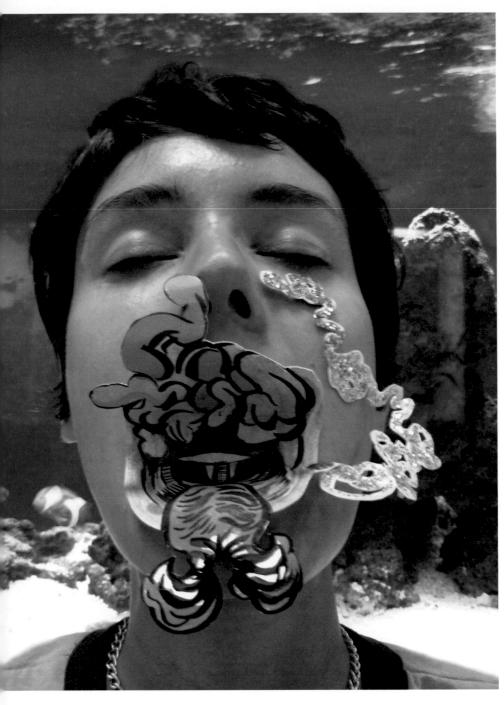

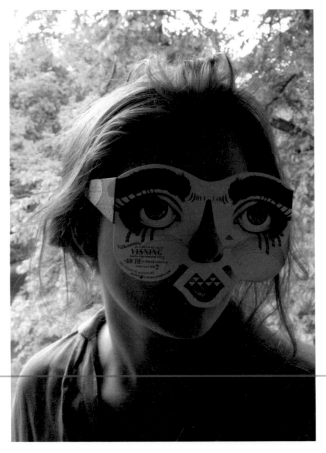

CHRISTA DONNER
01 Mouthful
Concept by Christa Donner,
Photo by Kristine Seeley, 2006

JOHAN HJERPE
02 Spring / Summer 2005 Invitation
for Diana Orving, 2004

PIXELGARTEN
03 CATRIN ALTENBRANDT / ADRIAN NIESSLER
Um was es nicht geht
2006

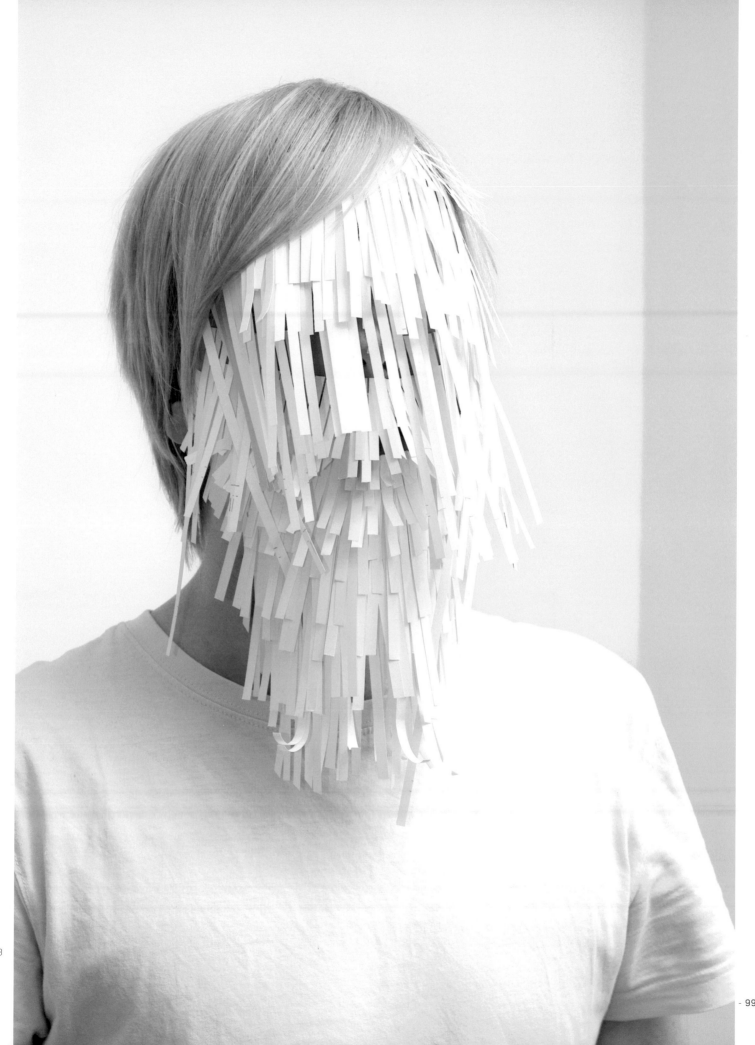

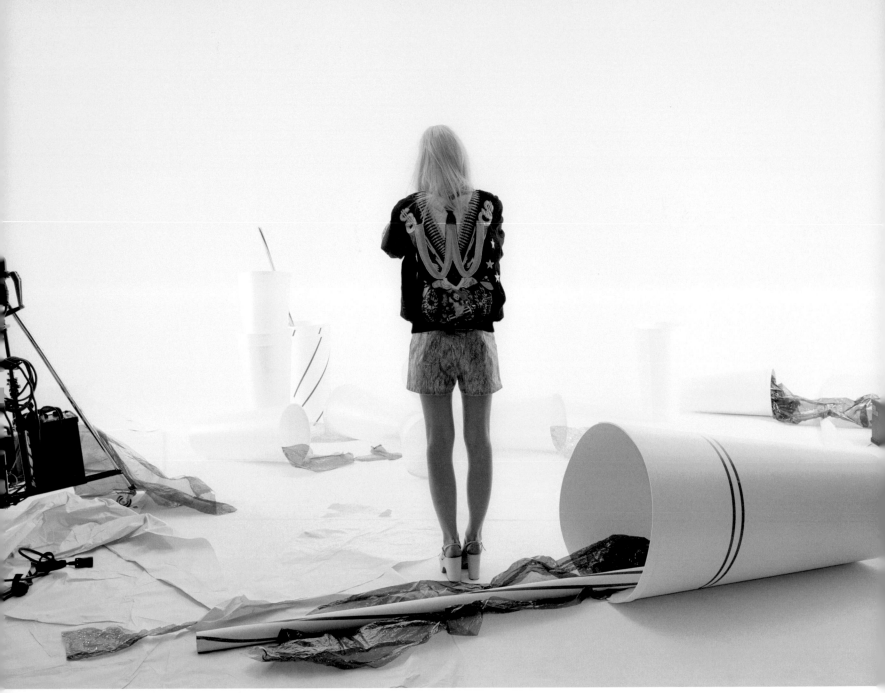

03

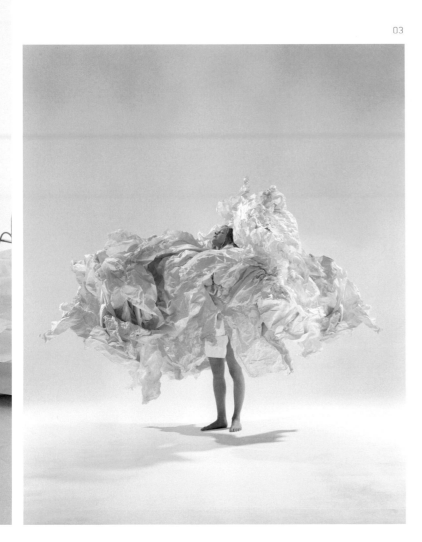

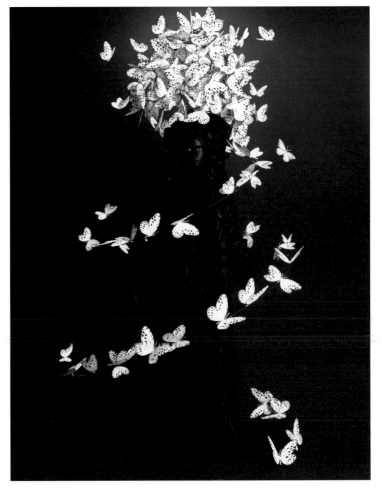

04

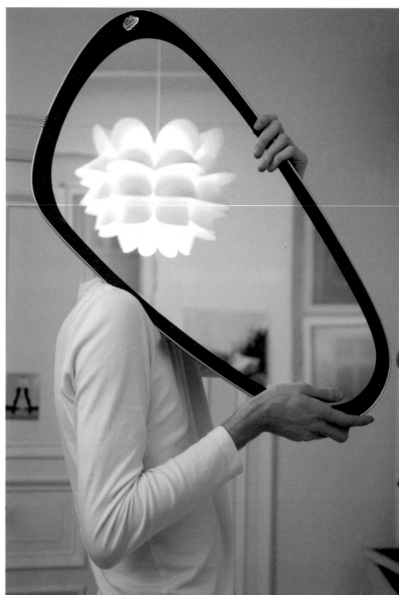

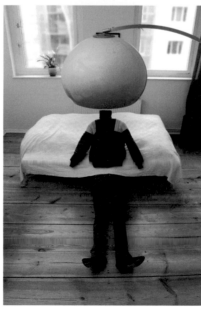

01

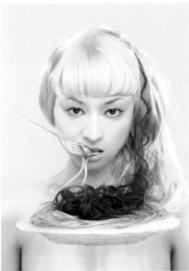

ZUCKER UND PFEFFER

01 DENNY BACKHAUS
Wohnen
Personal work
Attended by Loredana Nemes, 2006

UCHU COUNTRY

02 **Relax Magical Hair Tour**
for Relax/ Magazine House,
hair design by Nagi Noda, photos by Mote
Sinabel, design by Mitsuyo Sakuma &
Toshiyuki Nagai, hair by Shinji Konishi,
Asami & Michiwo Kutsukake, make-up by
Kimiyuki Misawa, 2006

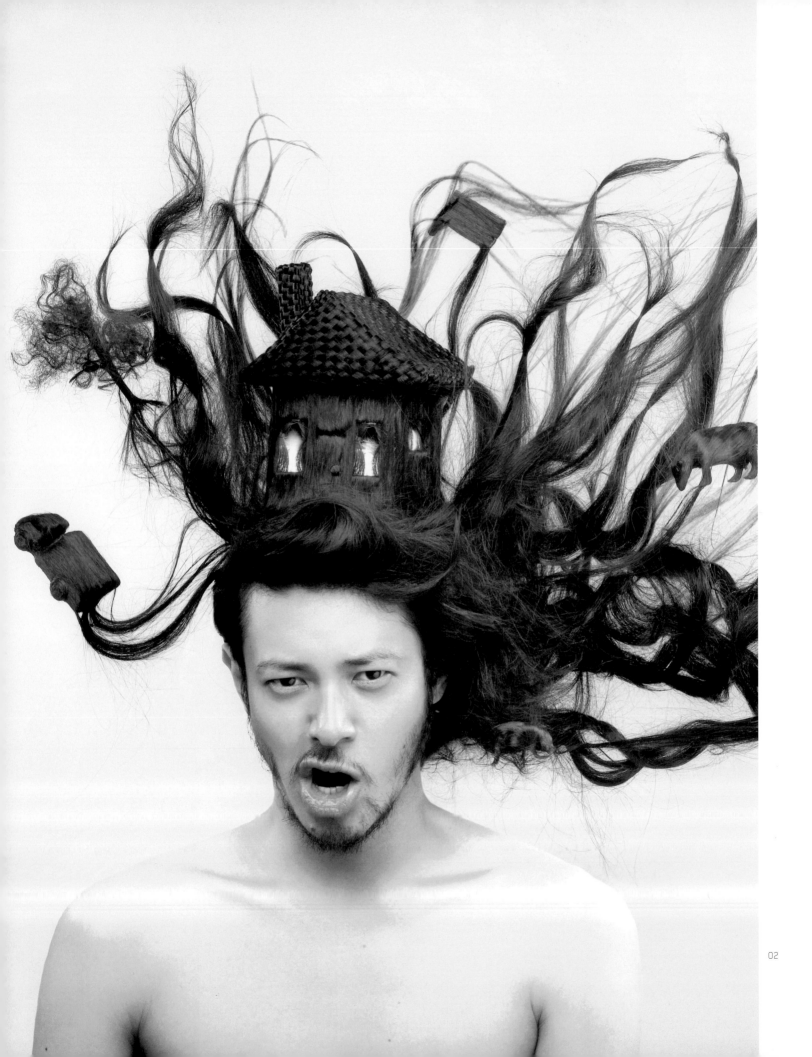

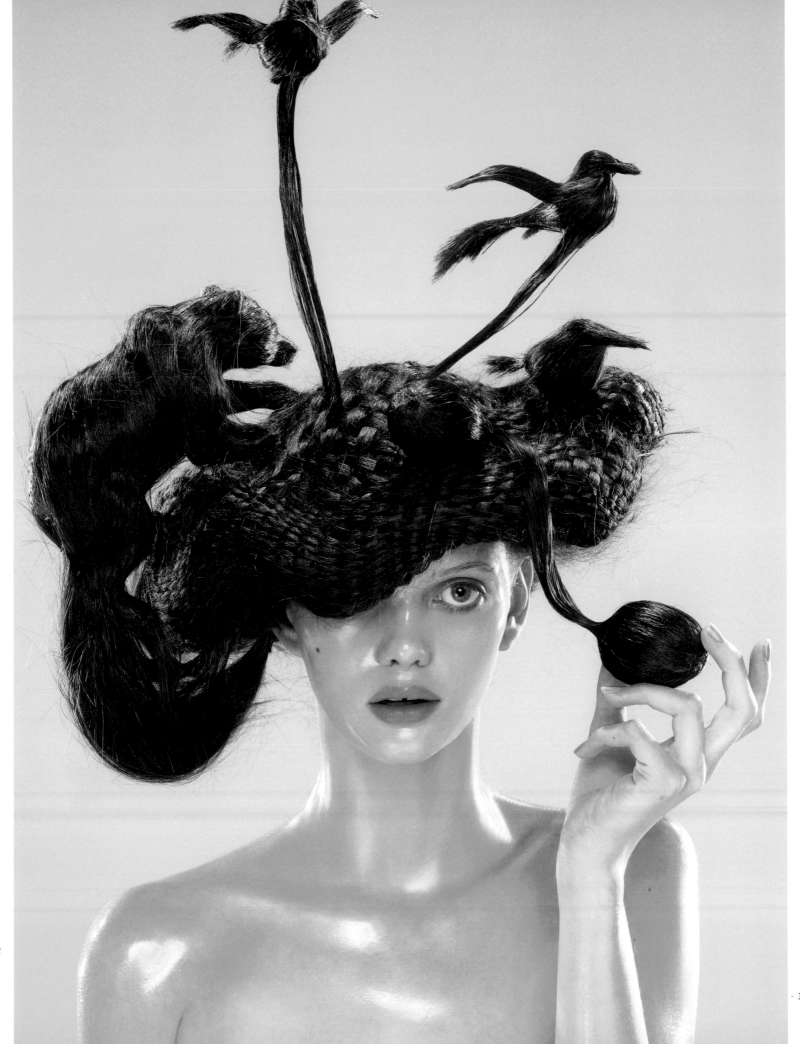

01

BRYONY BIRKBECK

01 **Music Video For Indie Band Friendly Fires**
 for Friendly Fires, 2007
02 **Giant Cheerio, Giant Spoon**
 Personal project, 2005
03 **Vikings & Cake**
 for Brighton University, degree show promotion, 2006

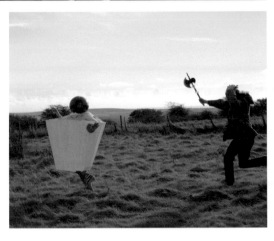

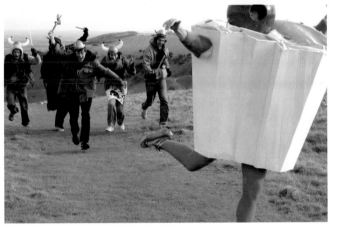

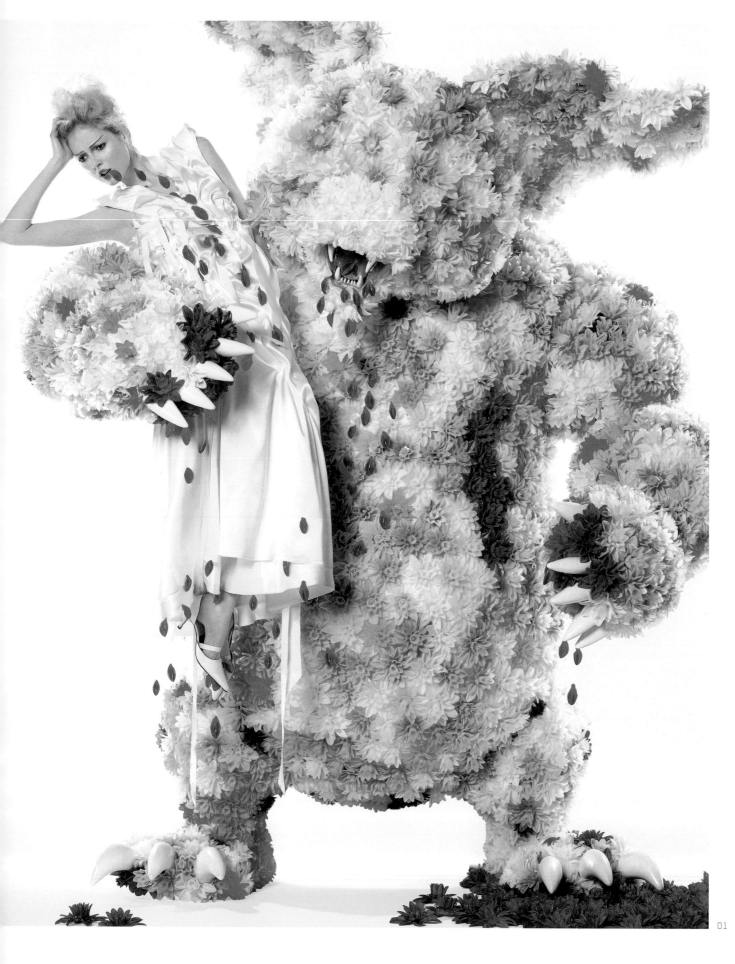

UCHU COUNTRY

01 Laforet Spring 2005
for LAFORET HARAJUKU Co.,Ltd, art direction by Nagi
Noda, photo by Shoji Uchida, design by Mitsuyo Sakuma,
Hair by SHINYA, Makeup by COCO,
flower artist: Musubi Aoki, stylist: Kyoko Fushimi, 2005

COTTON MONSTER

02 JENNIFER STRUNGE
**Inflatable Red Giant Monster
& Inflatable Green Giant Monster**
photo & copyright by Jennifer Strunge , 2005 & 2006

WAYNE HORSE

03 The Pascha and His Millions of Little Helpers
for nike,
Realised this costume together
with maomaland, 2006

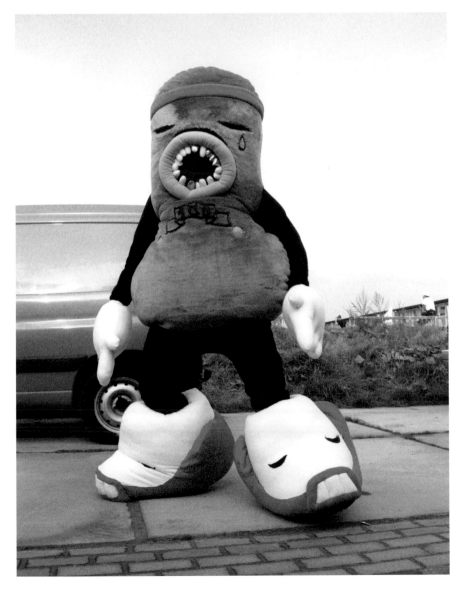

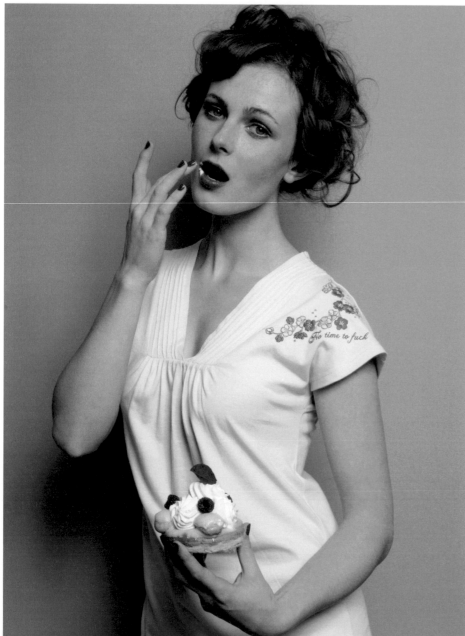

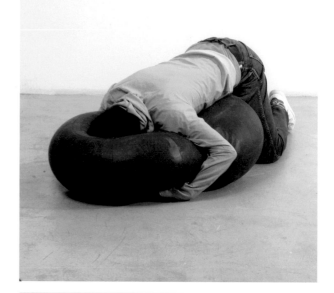

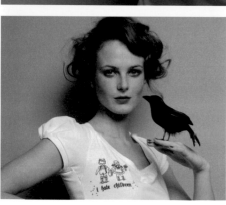

03

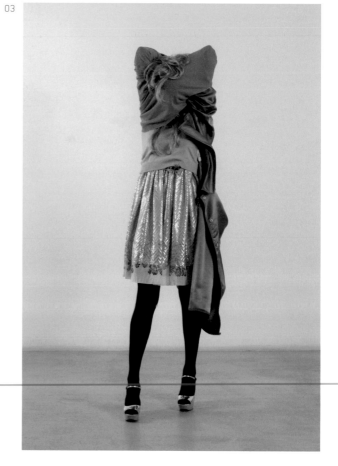

LOCHER'S
01 NICOLE LOCHER
 No Time To Fuck
 I Hate Children
 © Locher's, 2007

DANIEL FIRMAN
02 **Bubble Style**
03 **Ester**
 Sculpture, human dimensions plaster,
 clothes photo by Marc Domage, private
 collection, 2006

01

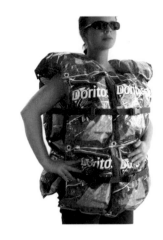

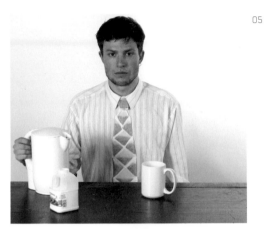

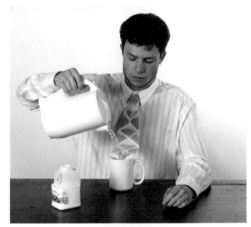

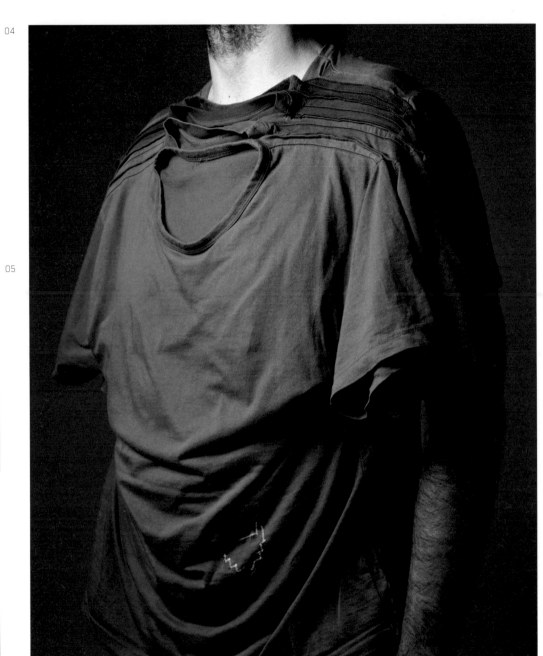

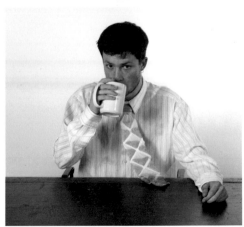

04

05

06

- *Products & Sculptures* -

In an age where "anything goes", designers and artists are starting to enjoy the ensuing liberation of mind and media. While some might explore the stunning scope of new techniques and production tools, others (re)discover the joys of hands-on production, of one-offs invested with sweat and emotion.

Charting these disparate schools of thought, "Products & Sculptures" presents separate philosophies with equally delightful outcomes. On the one hand, we have those who take full advantage of an increasing number of sophisticated digital helpers to create mind-boggling templates for their avant-garde visions, on the other, a growing band of enthusiasts who prefer to steer clear of modern technology and resort to their own wits and skills instead.

No quaint, Luddite rejection of industrial processes, and at a time where the arts and crafts have finally shaken off their fusty image, these DIY enthusiasts yearn to get back in touch with their own creations, to imbue them with personality and, indeed, faults, in order to make them truly authentic. Combining independent distribution with sweatshop-free labour and – often enough – a childlike enthusiasm for model-building, these hand-made products, from Airfix models to ingenious early learning typography, evince strong ties to those long-lost cherished days of colouring books and superglue bliss.

The second faction actively embraces the latest technological advances, such as rapid prototyping or novel foam, ceramics and casting techniques, for their unequalled ease, swiftness and affordability. With access to the right tools, these skilled visionaries translate abstract thoughts and digital templates into previously unimaginable one-offs and small editions.

But whether flawless finish or loveable flaws, both groups have traded "form follows function" for "form follows fun". In this spirit, the depicted delights not only toy with our material expectations, but also hold plenty of surprises when it comes to shape, scope and style.

From blood-puddle pillows and Gameboy purses to vegetarian staples turned farmyard animals, expect to be seduced by objects and sculptures as you have never seen them before.

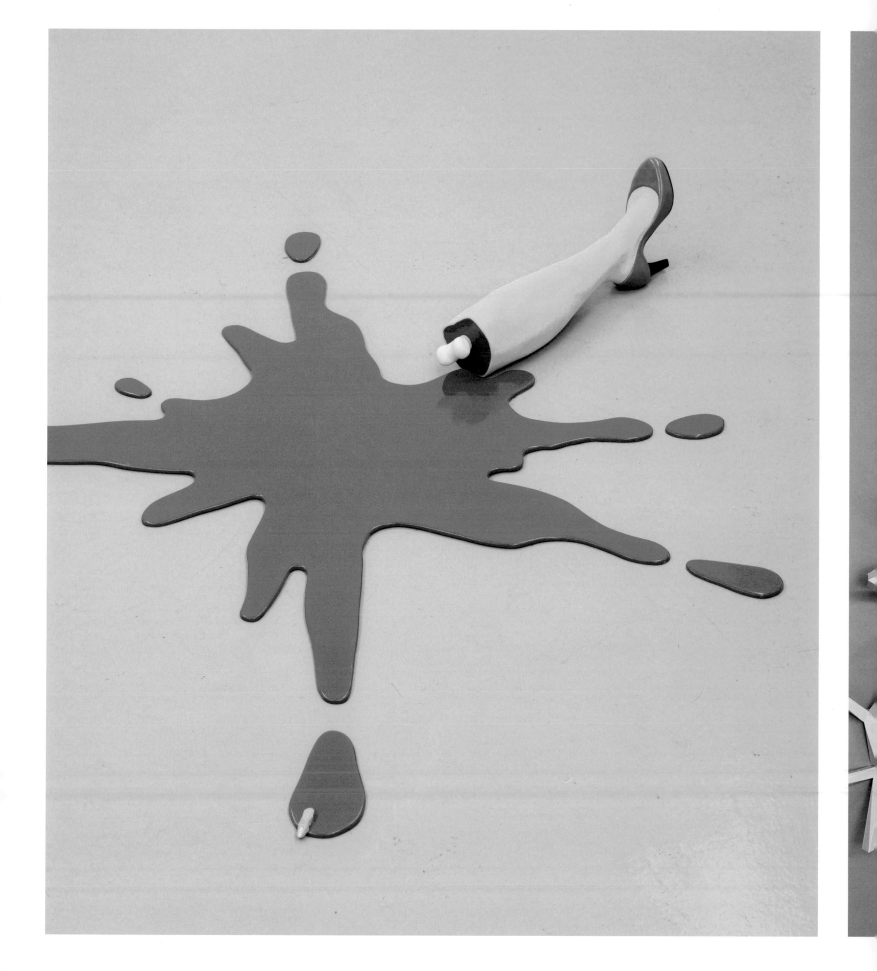

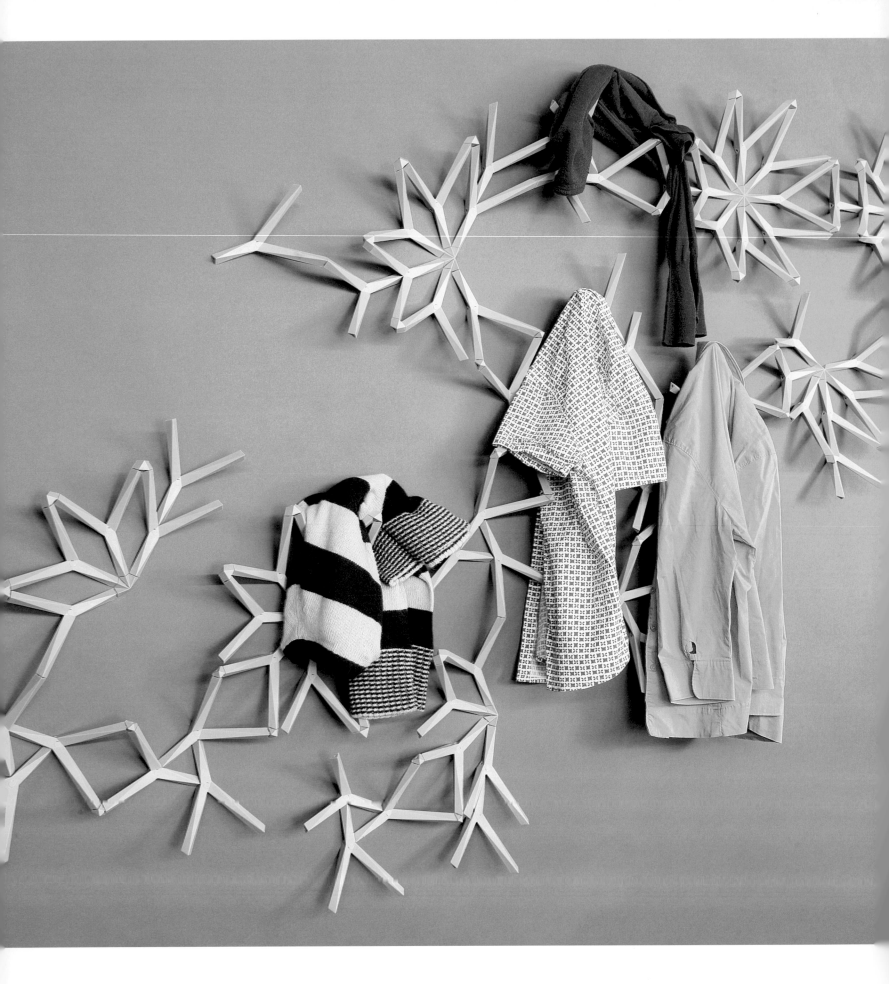

03

04 05

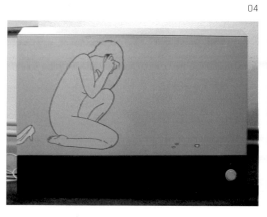

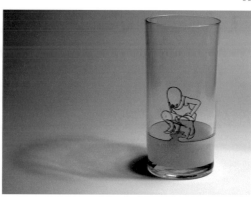

MOS
01 WITH MICHAEL MEREDITH
IVY
for CrowleyJones,
© Michael Vahrenwald, 2006

HANNA WERNING
02 Giant Pin
2004

JAMIE WIECK
03 "Carrier" Bags
Personal project, 2006

AGATA BOGACKA
04 Heater
05 Glass
Courtesy of Raster Gallery and
Agata Bogacka, 2004

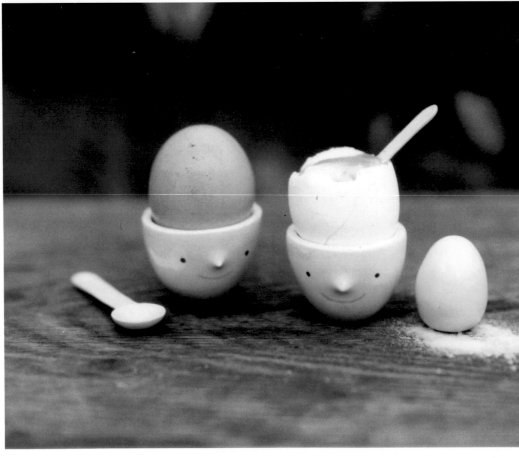

01

05

02

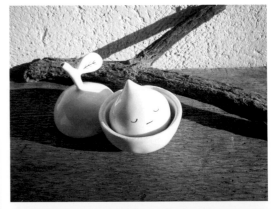

LOLA GOLDSTEIN
01 Egg Friend, with Tiny Spoon and
 Salt Shaker
03 Pottery for Winter
04 3 Pots for Spices, and Tiny
 Spoons.
 © Lola Goldstein, 2006

DECOYLAB
05 MAIKO KUZUNISHI
 Melamine Plate - Blue
 for Decoylab Product, 2006

HANNA WERNING
06 IB Rörstrand
 for Rörstrand, 2007

JAMIE WIECK
07 (Don't) Play with Your Food
 Personal Project, 2006

03

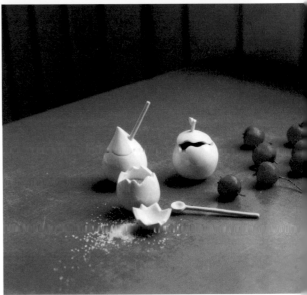

04

116 -

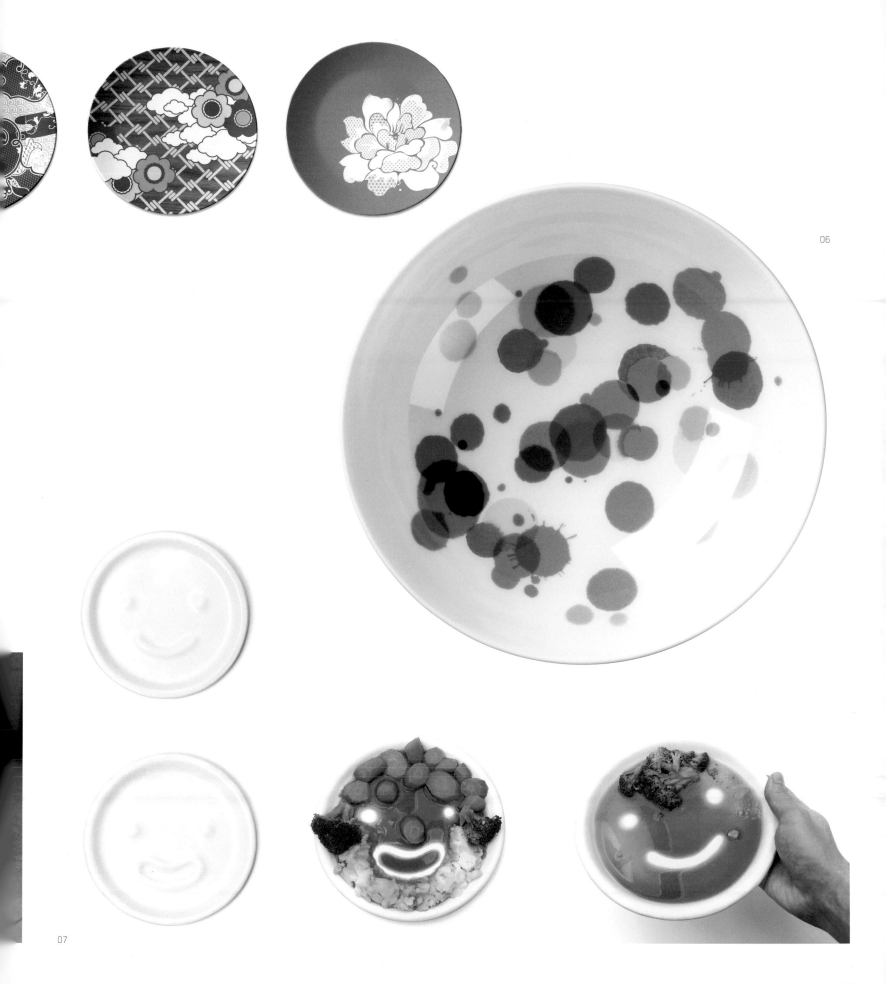

01

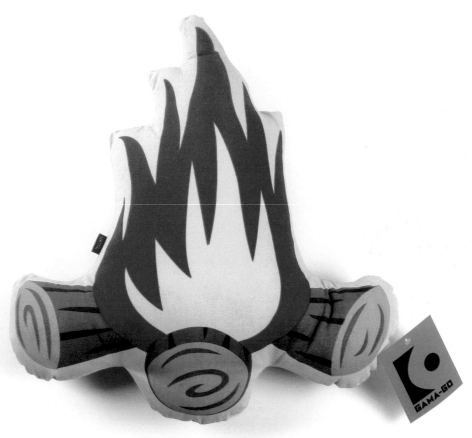

02

04

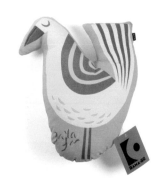

03

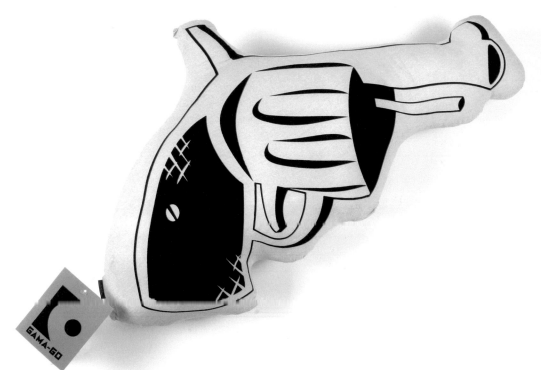

05

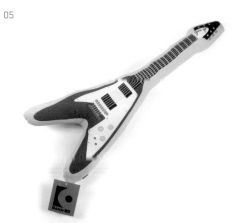

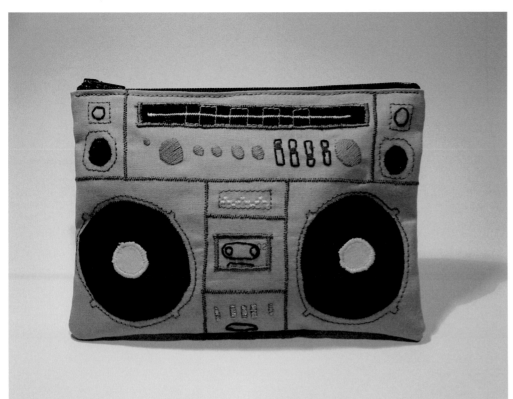

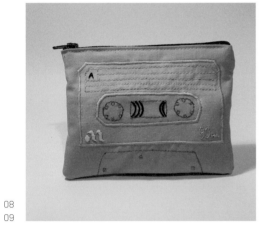

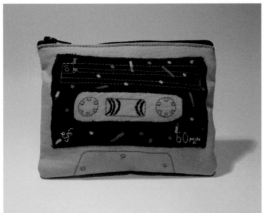

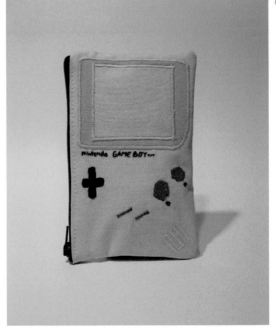

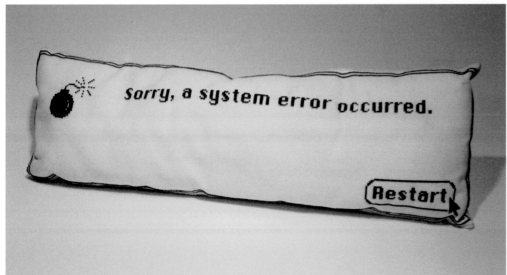

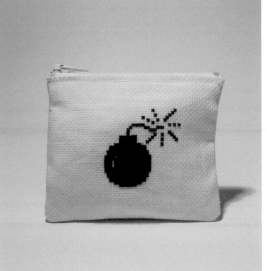

01

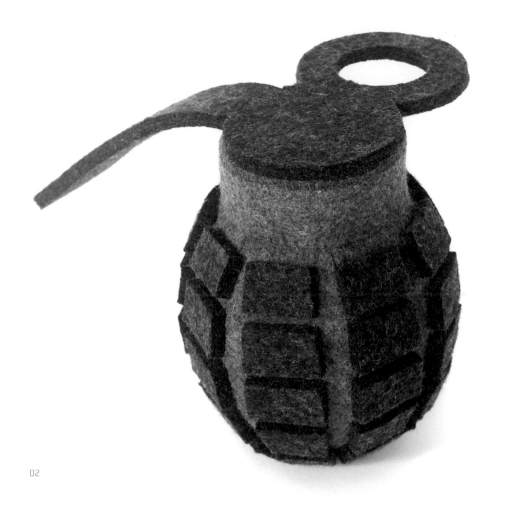

02

03

04

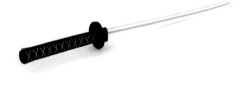

05

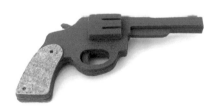

06

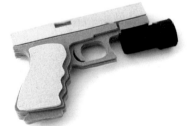

07

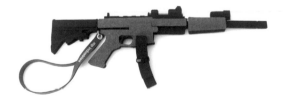

08

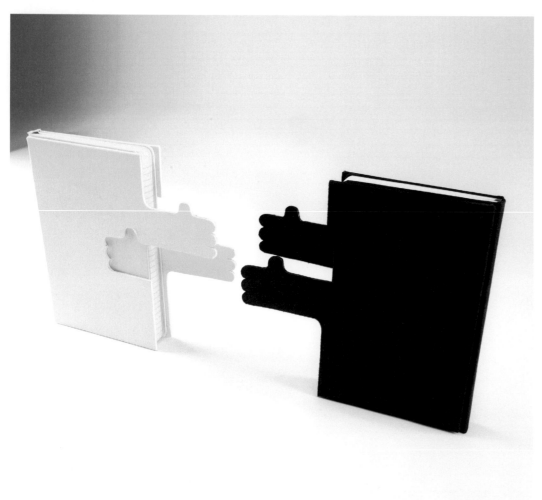

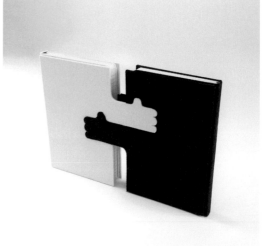

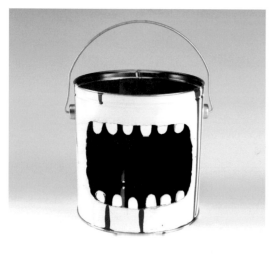

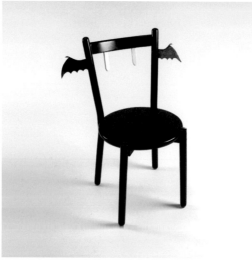

01

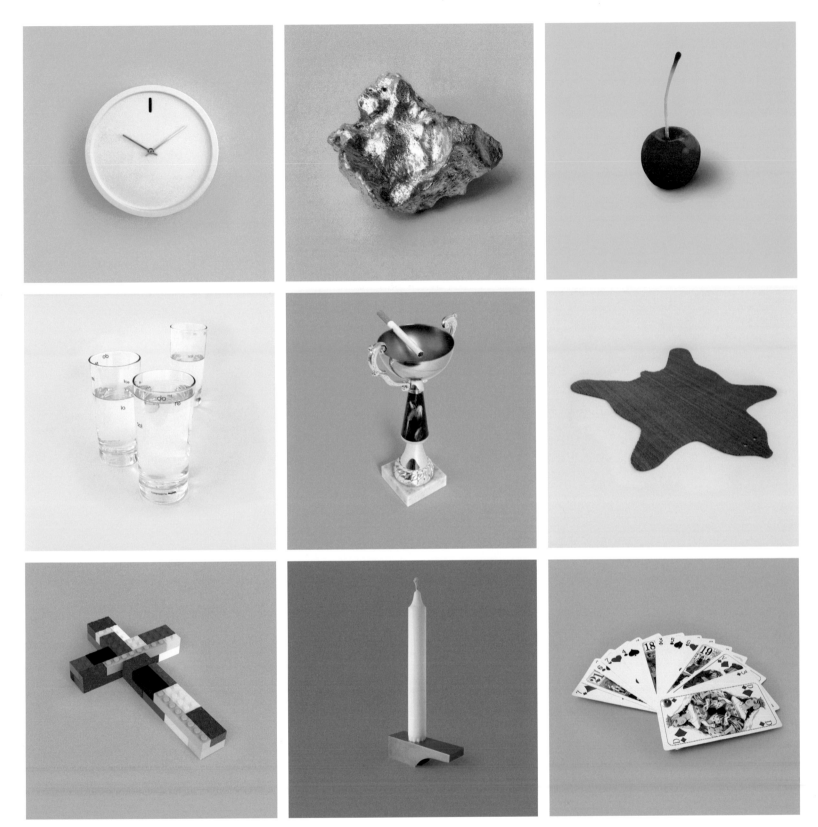

FORMAFANTASMA
SIMONE FARRESIN & ANDREA TRIMARCHI
01 **Cio Che Basta**
02 **Formafantasma 02**
03 **Forma Fantasma 03**
formafantasma, 2006 - 2007

01

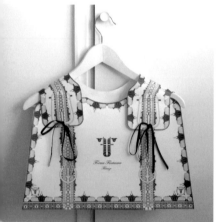

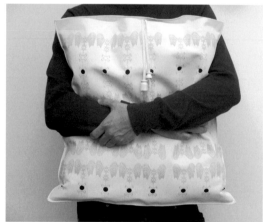

02

03

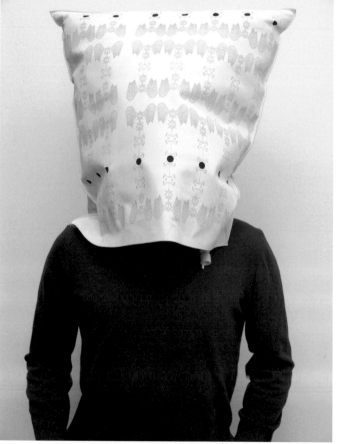

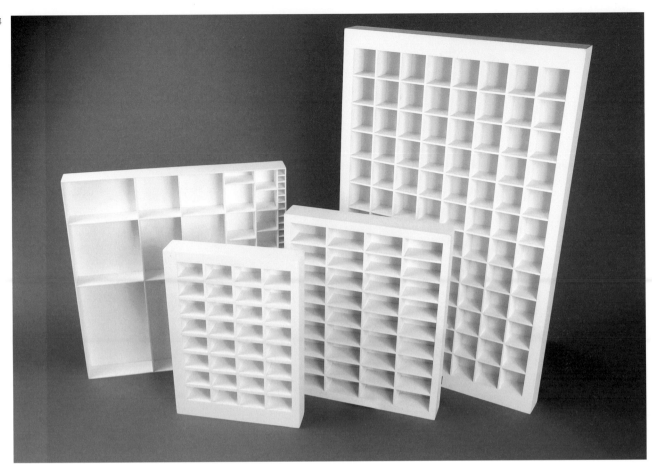

ASTRID STAVRO
WITH BIRGIT PFISTERER
04 **ART OF THE GRID Shelving Units_Family**
05 **ART OF THE GRID_Family of Notepads**
The Royal College of Art, art direction by
Astrid Stavro, published by Miquelrius, 2006

05

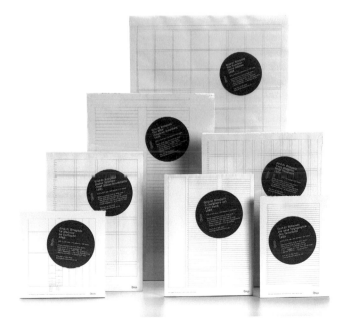

"Order is the actual key of life." *(Le Corbusier)*
Whether we like it or not, grids have become an essential part of our life. The design equivalent of a building's foundations, we may not always notice them, but their influence on what we see, hear and do is everywhere. Without grids, our lives would be messier, uglier and more confusing places to live in. To help us keep our lives in order, Astrid Stavro has come up with Grid-it!, an award-winning range of products based on grids that has changed the history of design.

By moving these ruled sub-dividers to the fore and divorcing them from their original content, Stavro calls design to order with a series of grids that played a historic role in the development of design systems. Covering a wide spectrum of classic and contemporary variations, her tangible products not only recall a "Greatest Hits of Grids", but also underline the medium's inherent dichotomy. "By definition, a grid does not hold interest in isolation, but should be guided by function, content and the design concept. Making the grid overtly visible can be a 'trick' to imply false technical rigour. Any grid should be judged by the quality of the resulting design and not by the intricate tracery of its own form."

A heartfelt homage to her products' invisible precursors, Stavro strongly encourages any Grid-it! client to explore the product's original template to appreciate the grid in relation to its content.

Or, in the words of Anthony Froshaug, "Admit constraints: then, having admitted, fill with discovery."

Foldschool - Rocker, Chair, Stool

Lightweight, recyclable and not averse to the odd splash of paint, cardboard proved the perfect material for Swiss architect Nicola Enrico Stäubli's collection of surprisingly resilient DIY seats for kids. A clear statement against the high price tag of contemporary design furniture, Foldschool cuts out all steps of the sales and production process and invites enthusiasts to get busy themselves. With all patterns and instructions available on the Internet free of charge, assembly requires no more than a cutter, ruler, paper, cardboard, glue, masking tape and a modicum of aptitude. The result: a unique and ergonomically shaped piece of children's furniture that demonstrates that simplicity and elegance are by no means exclusive. Choose from stool, chair or rocker.
Pictures by Rolf Kueng
(www.kuengfu.ch), 2007

01

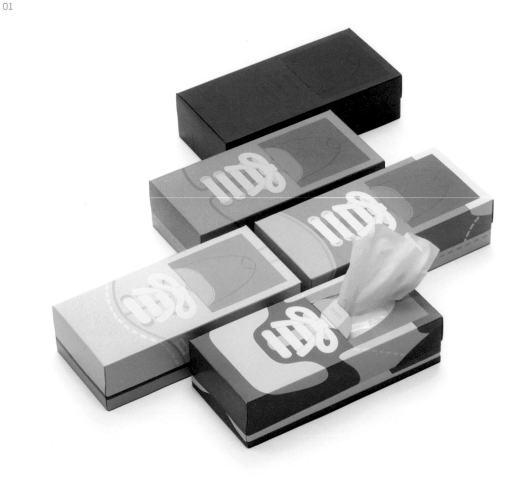

03

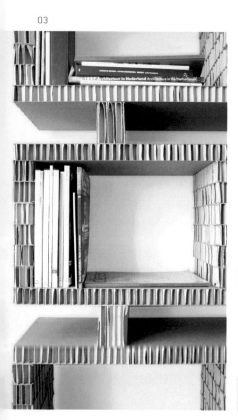

04

05

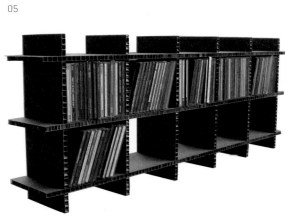

06

07

08

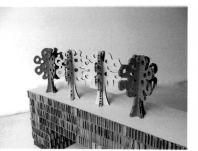

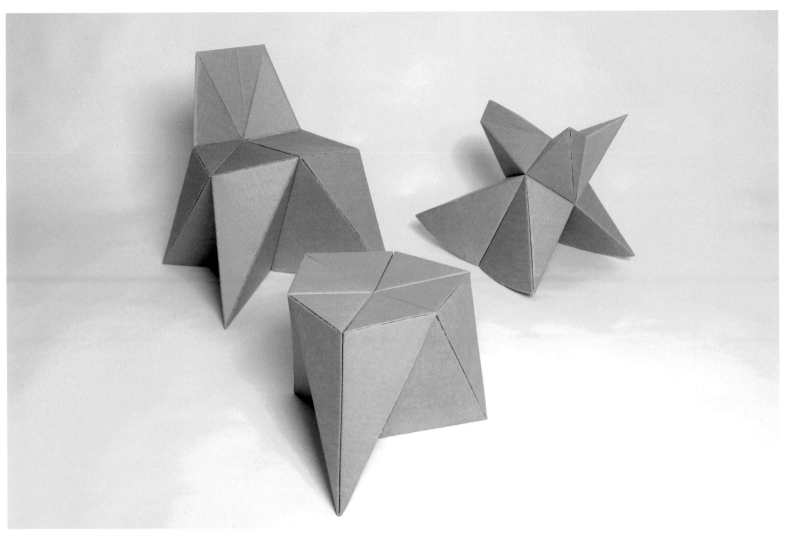

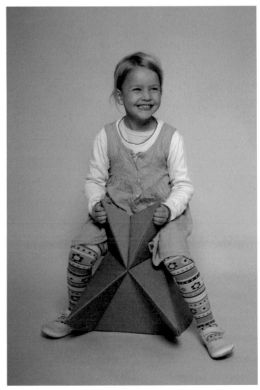
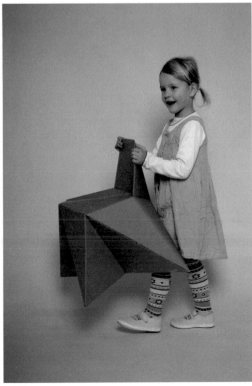
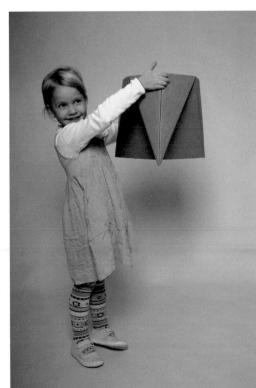

DAINIPPON TYPE ORGANIZATION
BIRD / TOYPOGRAPHY
RABBIT / TOYPOGRAPHY
FISH / TOYPOGRAPHY
for KOKUYO, © Dainippon Type Organization
/ KOKUYO, 2006

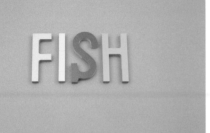

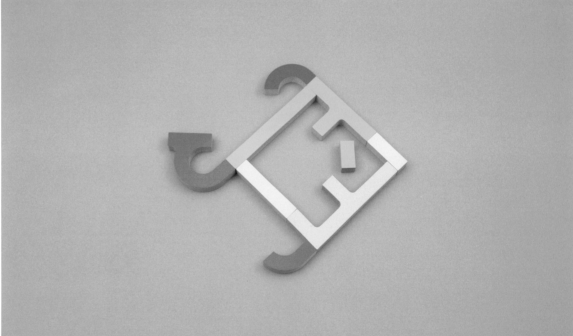

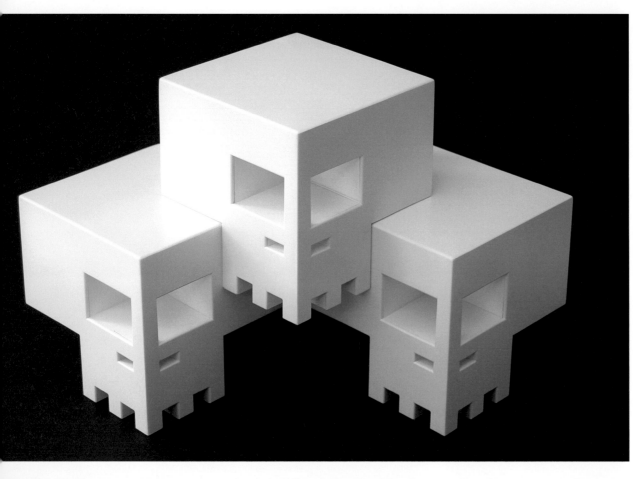

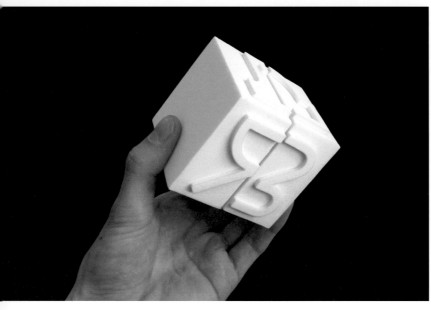

02

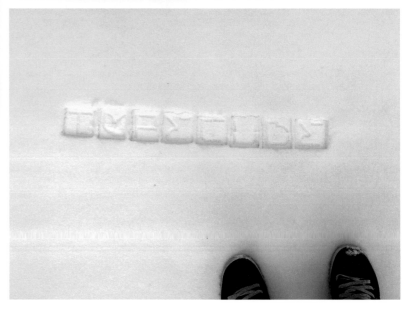

JAMUNGO
01 FERG
 Sqube
 ©Jamungo, 2006

MANUEL KIEM
02 Typecube
 2007

CARSTEN GIESE
03 WITH JANA PATZ
 Auflösung im Raster
 FHTW-Berlin , final work project.
 Study with shapes, colors and mathematics, 2003

03

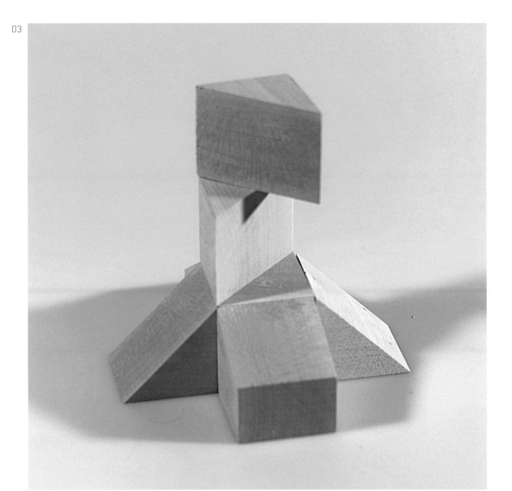

- 131

CARLO GIOVANI
WITH CAMILA LISBOA
01 **The Meat Point**
 for Vida Simples Magazine
 art direction by Fernando Noiqeborin
 photos by Invan Shupikow, © Editora April, 2005

JENNIFER MAESTRE
02 **Imp**
 Photo by Logan Hufford, 2006

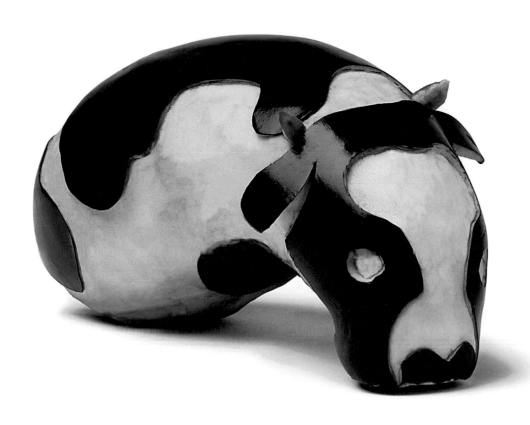

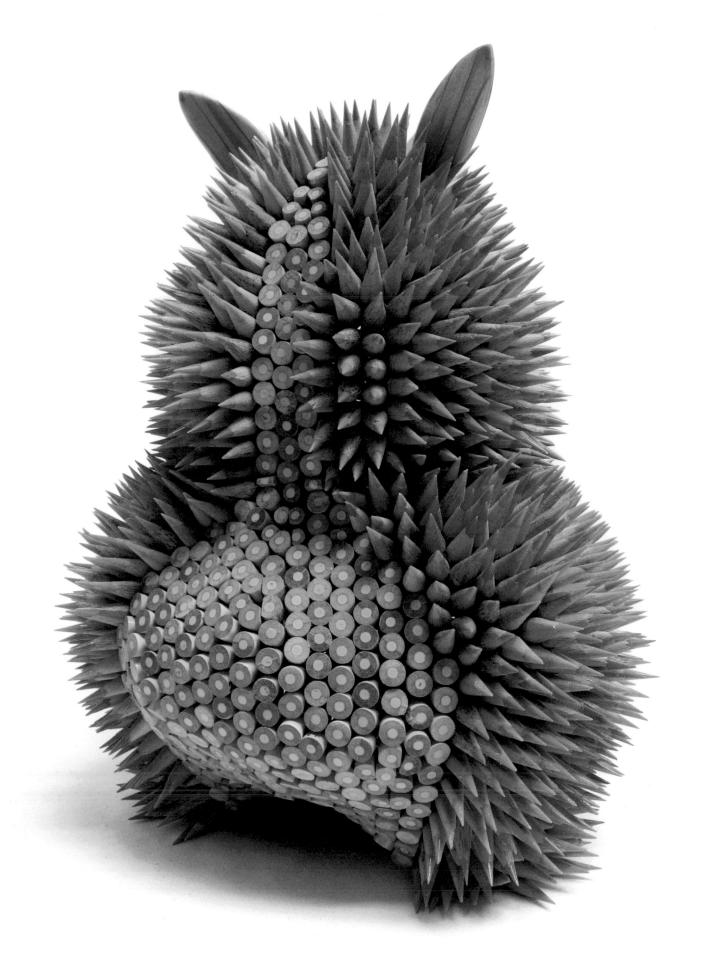

01

02

04

03

SANDRINE PELLETIER / MASKARA

05 **Untitled (back)**
Ecole cantonale d'art de Lausanne,
(ECAL), courtesy Galerie Frank Elbaz,
Paris, 2002

06 **W (back)**
Ecole cantonale d'art de Lausanne
(ECAL), courtesy Galerie Frank Elbaz,
Paris, 2002

07 **Battlefield III**
Courtesy Villa Grisebach, Berlin, 2004

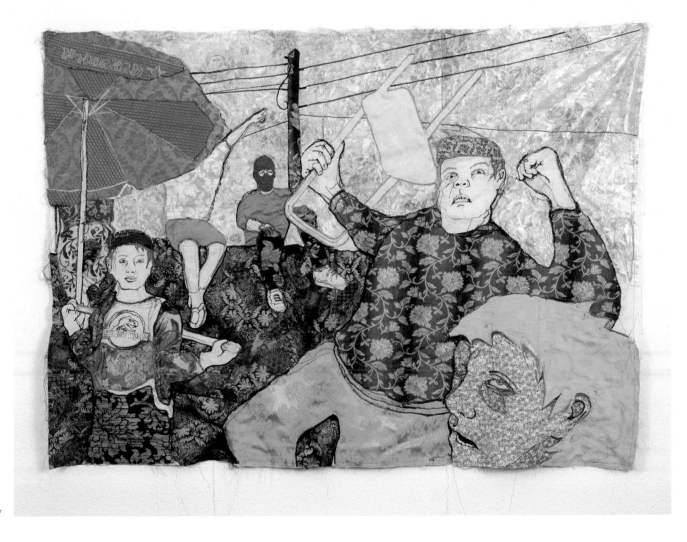

07

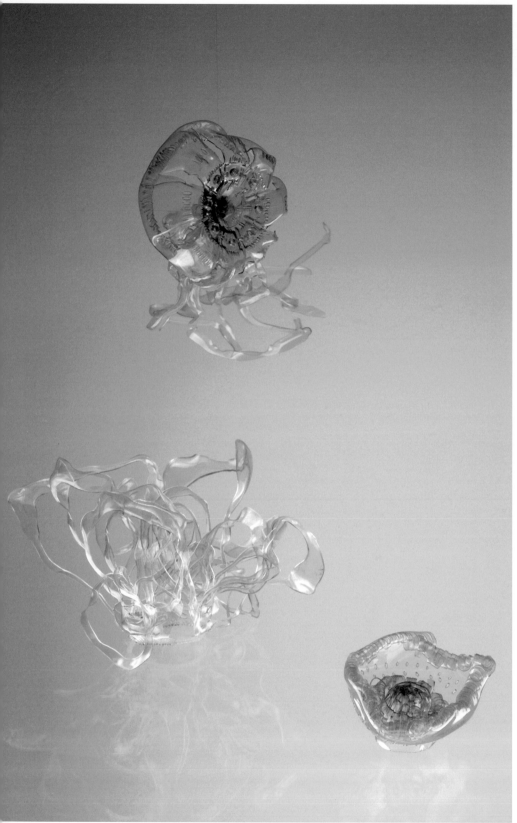

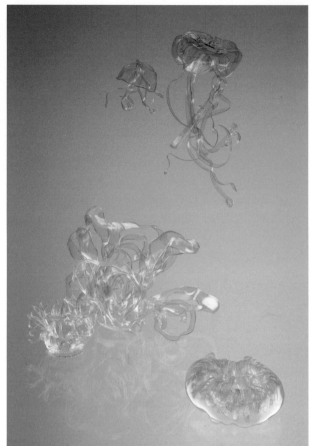

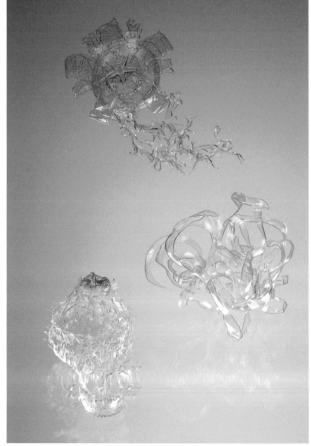

01

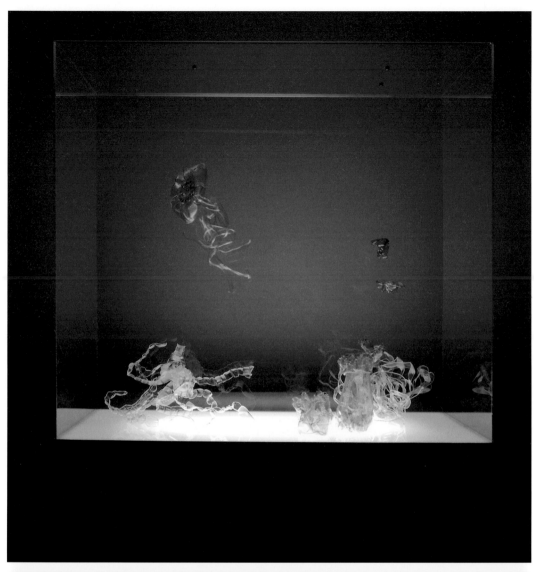

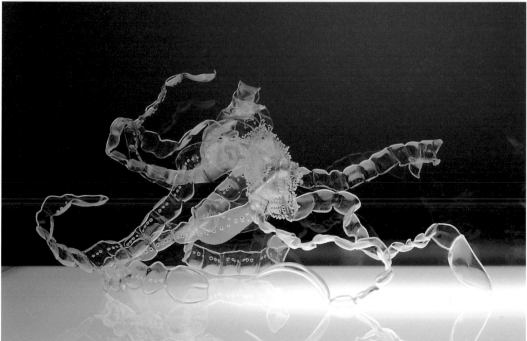

MIWA KOIZUMI
01 **PET**
20"x24", material : pigment ink print, 2006
02 **PET Aquarium**
24"Wx14"Dx28"H, Material: Pet (Polyeth-
ylene Terephthalate) Volvic, San Pellegrino,
Poland Spring Water bottles, light box,
photo by Miwa Koizumi 2007

..............

*With her fragile menagerie of aquarium resi-
dents, Miwa Koizumi takes recycling to a new
level. From terminal melt-down to inspired
resurrection, her aptly named translucent
pets give discarded PET bottles a new lease of
life in their own ecosystem.*

"Since I moved to NY, I have started to see
garbage as small creatures. Back in Asia, we
accept that there are many spirits in eve-
ryday life. So, even when an object doesn't
have a life of its own, its spirit affects me.
With this in mind, I pick up on natural
phenomena to reveal simple facts about
our existence. One of the things I remem-
bered was that, like most animals, we used
to be foragers. So, I decided to head outside
to look for materials and ideas. This is how
my PET project came about."

*Bizarrely beautiful, Koizumi's fleeting shape-
shifters inhabit a new taxonomy between jel-
lyfish, anemone and a range of mysterious,
alien species caught unawares in the depth
of the ocean. And while each bottled brand
adds its trademark – and thus commercial
– tint, the glistening structures might even be
said to return to their natural habitat.* "PET
(polyethylene terephthalate) is not only
highly recyclable, but in fact very natural:
it is made from oil, which in turn is a prod-
uct of ancient organic decomposition proc-
esses. All that aside, I simply loved the idea
of using liquid containers to make aquatic
animals. And I really wanted some pets ..."

01

02

06

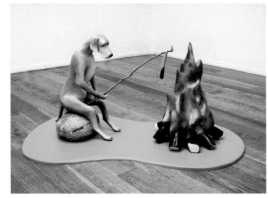

03

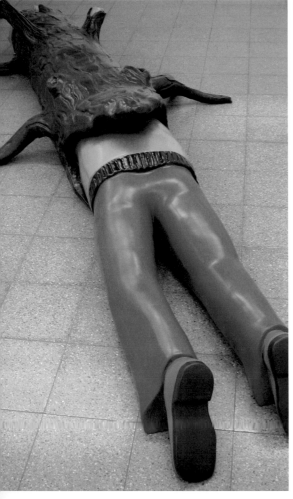

04

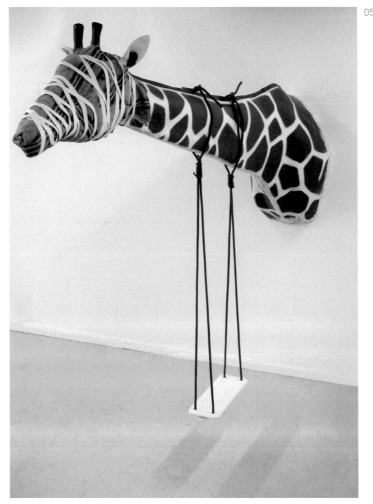

05

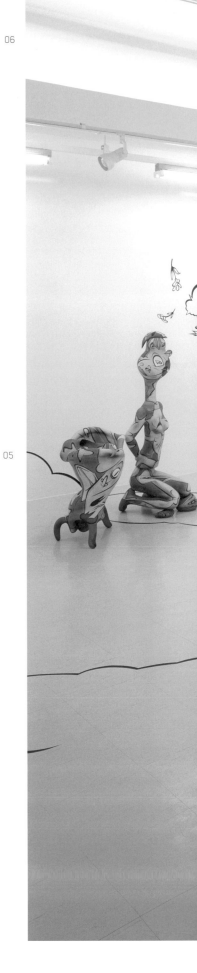

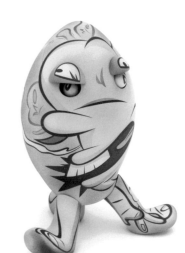

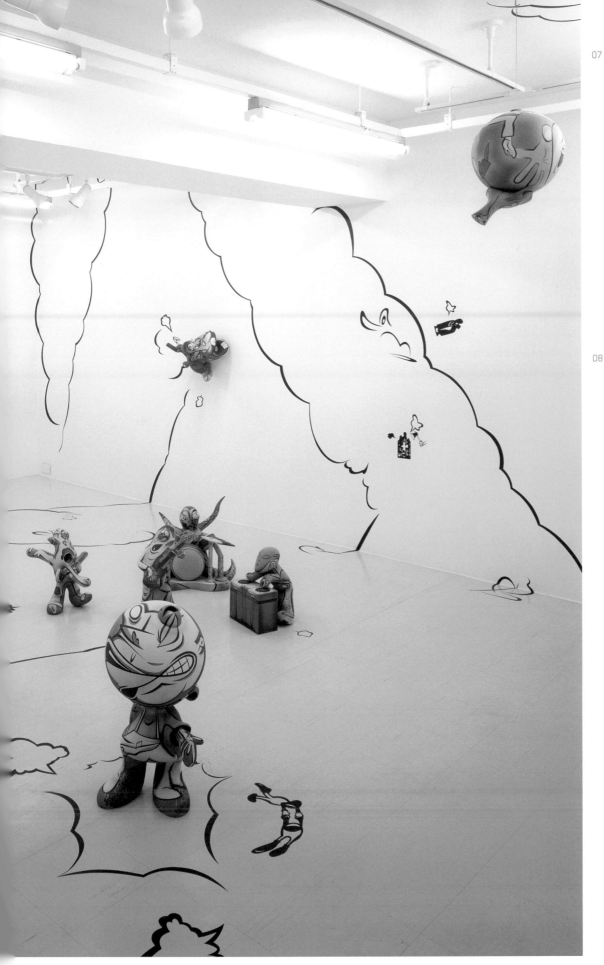

FREDRIK RADDUM

01 **Hanging Man**
© Public Art Norway, 2006

02 **Flying Dog**
© Galerie Albrecht, München, 2003

03 **Dog with Fire**
© Galleri Brandstrup, Oslo, 2002

04 **The Tree Trunk**
© Martin Asbæk Projects, Copenhagen, 2006

05 **The Swing**
© Galleri Brandstrup, Oslo, 2005

TAKASHI HINODA

06 **Installation View**
for solo exhibition at Galerie 16, Kyoto, Japan
Photo by Kazuo Fukunaga,
Image Copyright by Takashi Hinoda, 2006

07 **It's uneasy even being in the World**
Ceramic 58x45x32cm,
Image copyright by Takashi Hinoda, 2005

08 **White Fang**
Ceramic 55x33x21cm, Photo by Shigehumi Kato,
image copyright by Takashi Hinoda, 2007

- *Indoor Installations* -

With cues from photography, typography and graphic design, "Indoor Installations" take the concept of scenes to a loftier scale. Imbued with a tangible, sensual appeal, they relinquish the safe haven of wall-based murals to venture into space itself.

In their blend of graphic design elements and conceptual approaches, the heterogeneous group of artists assembled under this heading might pursue entirely different goals, might favour narrative or abstraction, ostentatious kitsch or pared-down minimalism, yet all delight in their new-found freedom to fill this space with the unexpected. Progressing from organic, ornamental wall adornments, statement exhibits and pod-like store environments to increasingly complex, overpowering abstraction, this chapter takes us from clear-cut wall and floor installations to increasingly elaborate, encompassing productions that describe and define the space they inhabit.

A nod to most artists' 2-D origins, paper serves as the obvious staple, transporting signs, icons and characters into the three-dimensional realm. In addition, cardboard – its unassuming sturdier cousin – makes a strong reappearance. Perfectly suited for 3-D "sketches", this cheap and flexible material resurfaces in a huge variety of applications, from faux everyday fixtures to entire rooms caught between architect's nightmare, fanciful playground and poetic statement. Because of the material's flat, makeshift appeal, expect plenty of surreal cut-outs referencing Hollywood's gloriously fake town facades in their deliberate juxtaposition of real life and constructed reality.

Furthermore, keep your eyes peeled for some frighteningly life-like, painstaking miniatures. Untangle yourself from a homespun web connecting everyday chaos with thin threads of order or marvel at a range of light-weight creations with substantial appeal.

Inbetween all these elaborate clusters, staggering stacks and curious characters – poised to invade a gallery near you soon – don't miss the intriguing forays beyond the tactile, visual and cerebral. Throwing sound into the (media) mix, these multi-sensory projects add yet another dimension and ensure there is plenty left to explore.

GINA MÖNCH & JOHN RUSSO
WITH ROMERO STEINHAUSER,
SEBASTIAN ESCHE, MICHAELA DECHERT
LUKAS BREITKREUZ, MATHIAS BIEGEL
Titel der Dinge
Hochschule Darmstadt, design department,
supervised by Prof. Sandra Ellen Hoffmann
Robbiani, 2007

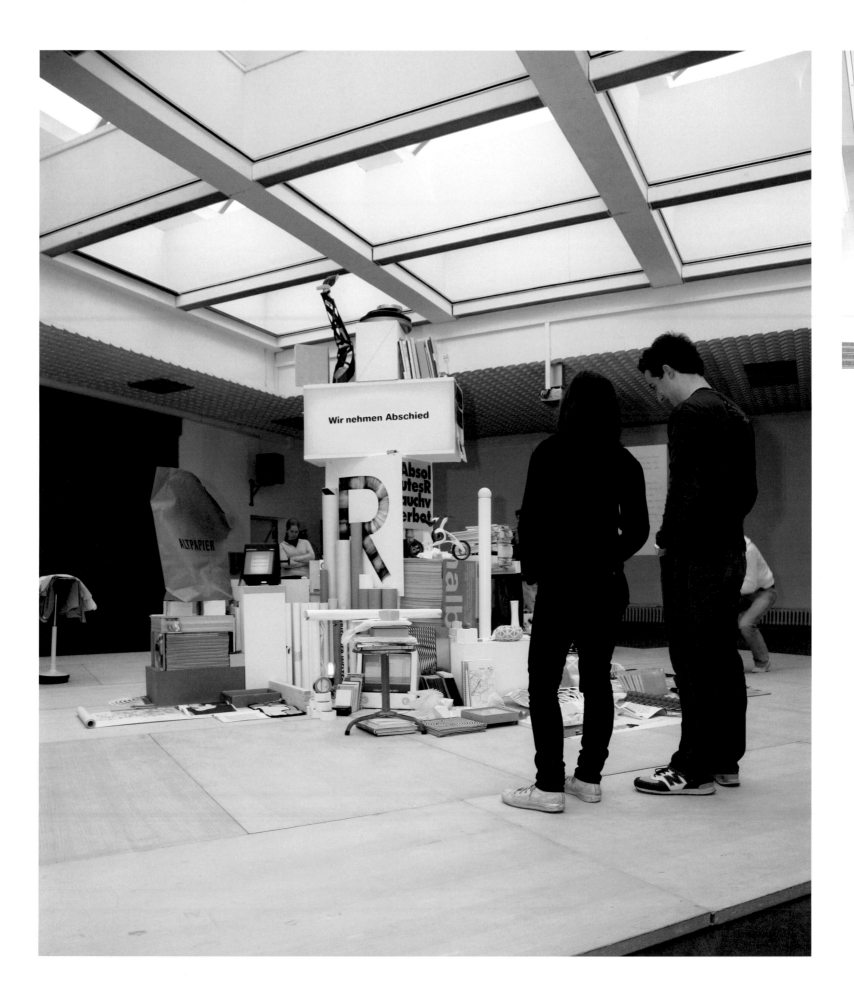

01

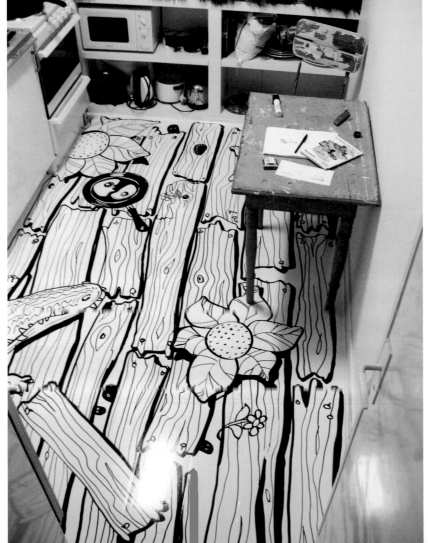

02

03

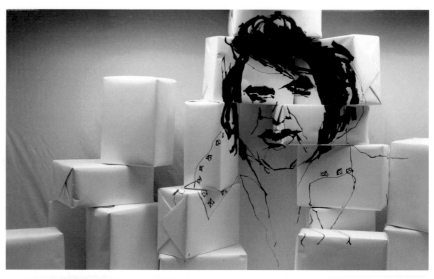

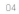

FL@33
01 AGATHE JACQUILLAT & TOMI VOLLAUSCHEK
Customised Rubber Floor Design For FL@33 HQ
A self-initiated Fl@33 project, 2007

OLLE HEMMENDORFF
02 My Kitchen
Permanent marker on vinyl-covered floor, Olle Hemmendorff, 2007

ANNE-LI KARLSSON
03 Moving Target
Gallery Ether-Gram, Elvis Presly, 2007

BAS LOUTER
04 Octagon 2007
Pakt, Amsterdam, charcoal, ink, paper, plywood
05 -
Rijksakademie, Amsterdam, ink,paper, silksreen, paper,
cardboard, 2003

04

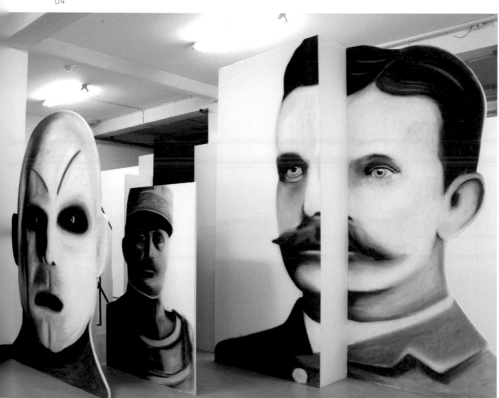

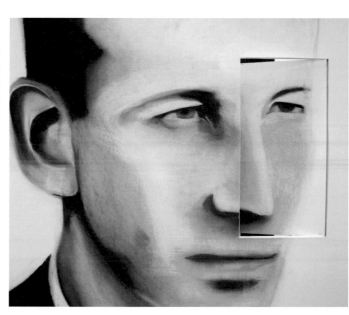

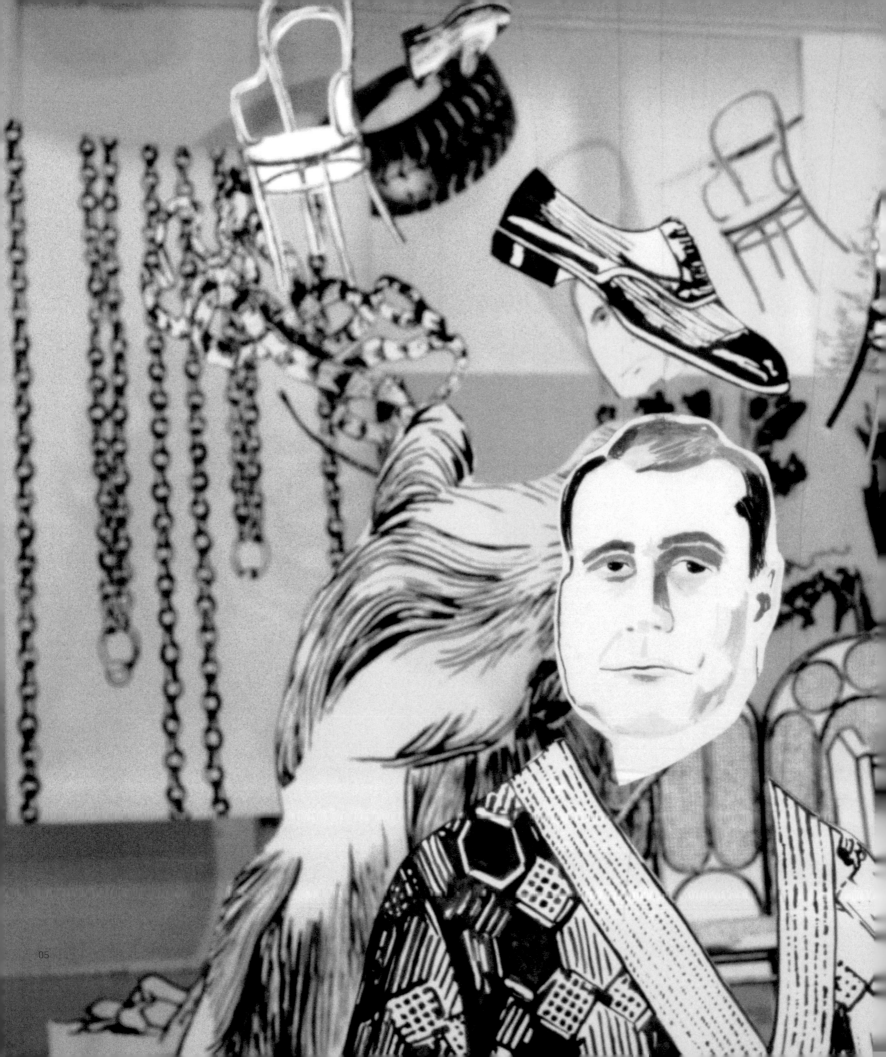

05

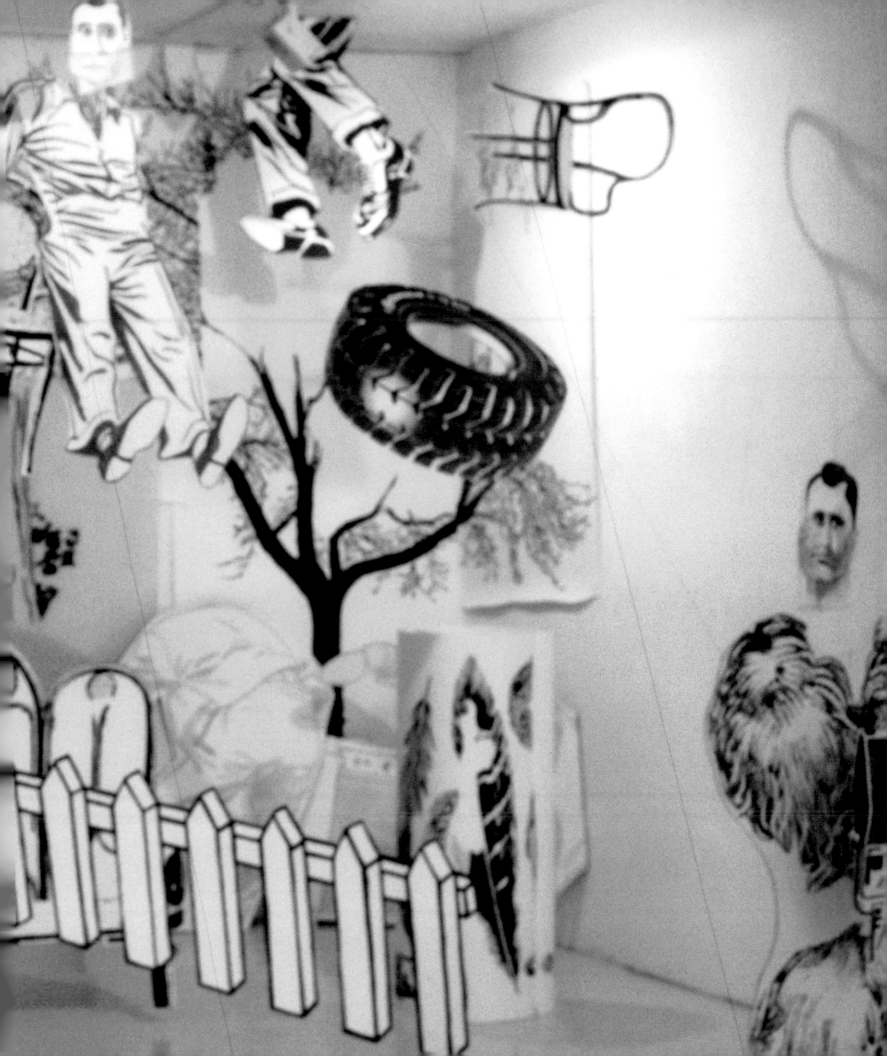

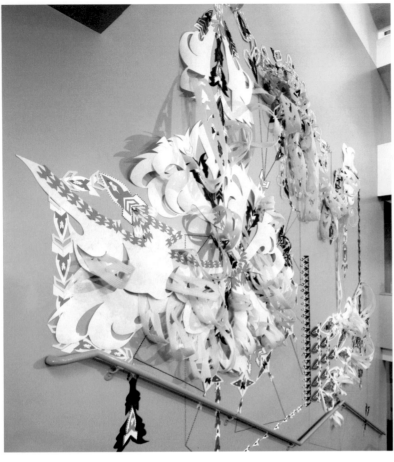

01

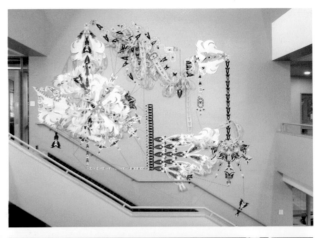

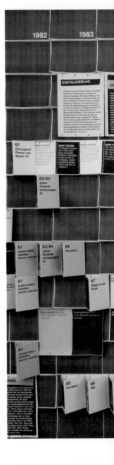

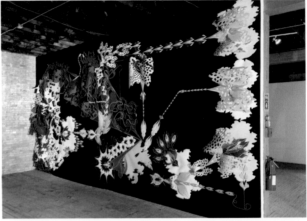

02

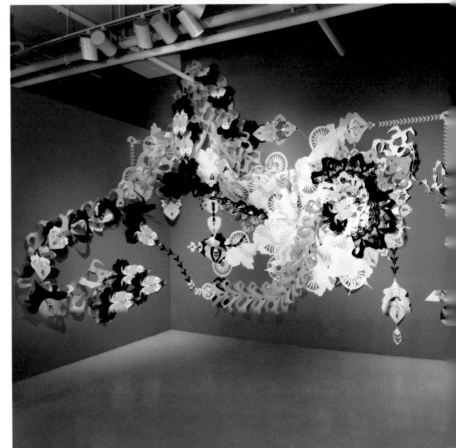

03

LIZ MILLER

01 **Impudent Instant Message**
Installation view, Carleton College, Northfield,
MN, photo by Rik Sferra, 2006

02 **Vociferous Transmission**
Installation view, The Soap Factory, Minneapolis,
MN, photograph: Rik Sferra, 2006

03 **Errant Ecosystem (Revisited)**
Installation view, mixed-media installation,
Minnesota Museum of American Art, St. Paul,
MN, photo by Rik Sferra, 2007

ONLAB ETC.
NICOLAS BOURQUIN & SVEN EHMANN
WITH MURIELLE BADET, CATHY LARQUÉ,
MÉLANIE SCHNEIDER, MARIA TACKMANN,
KASPER ZWAANEVELD

04 **The Making of Your Magazines**
forarchplus - zeitschrift für architektur und
städtebau, © onlab etc., 2006

JOHAN HJERPE

05 **Happy Room**
Mossutställningar, 2006

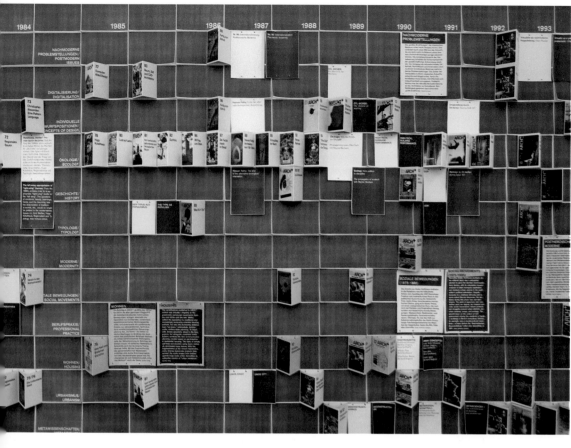

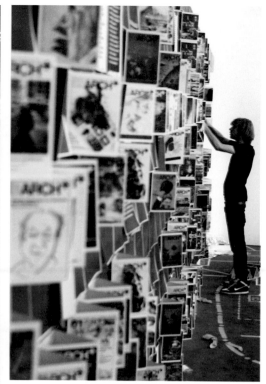

04

05

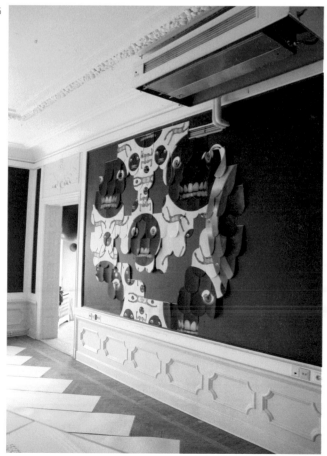

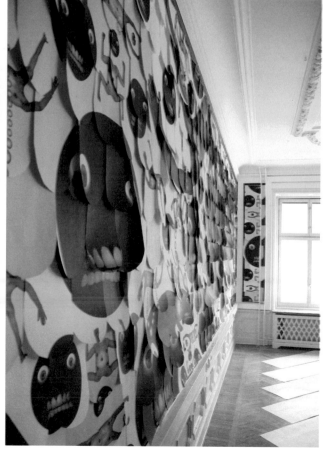

01

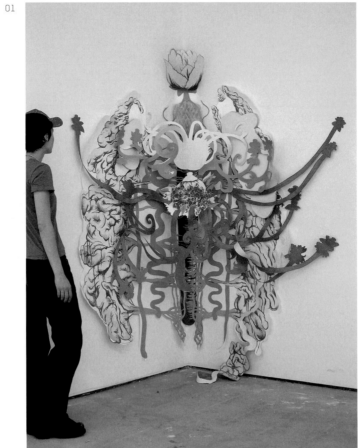

02

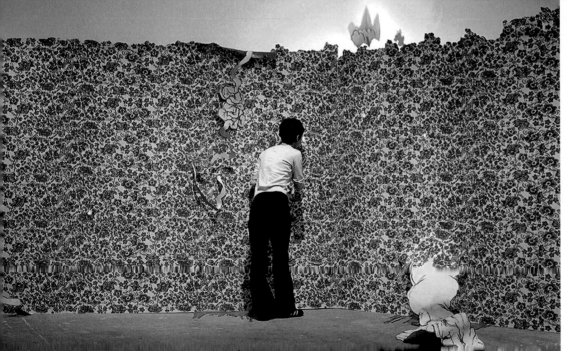

03

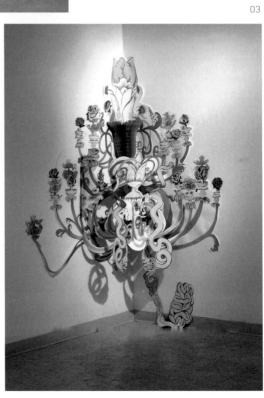

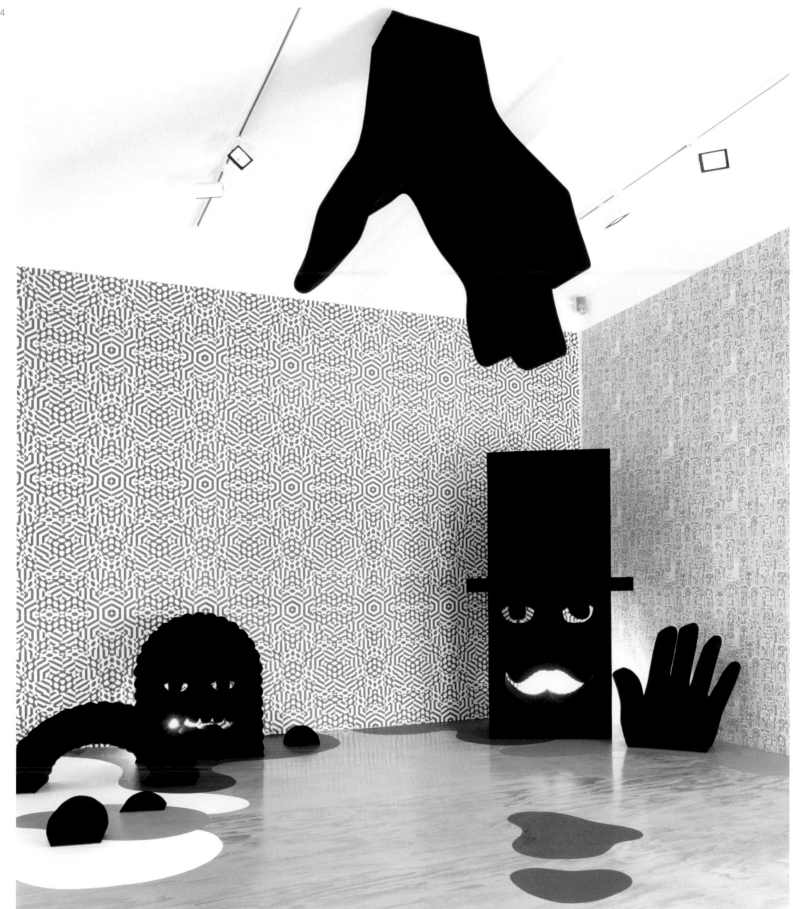

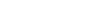

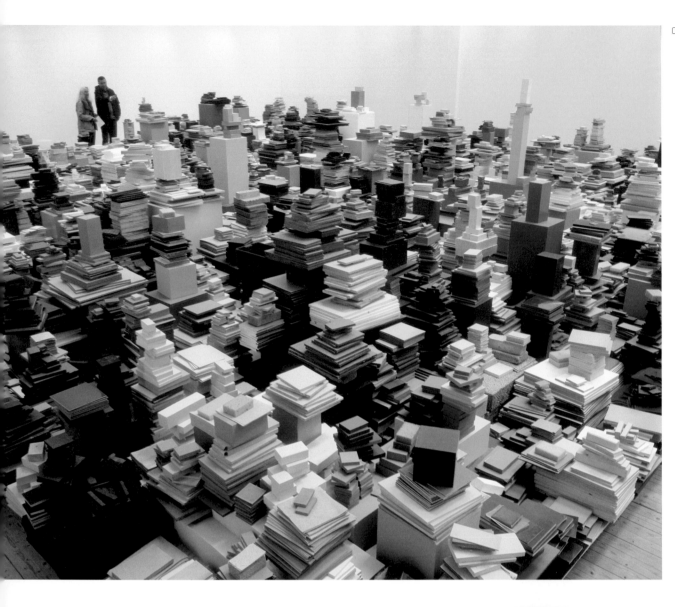

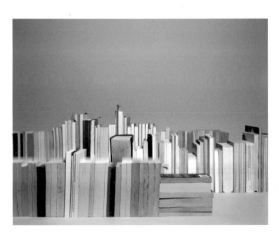

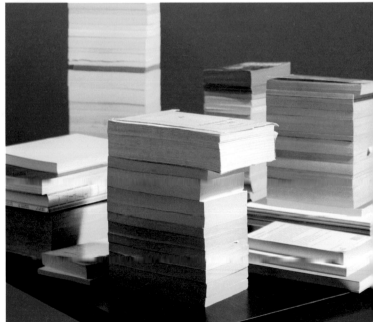

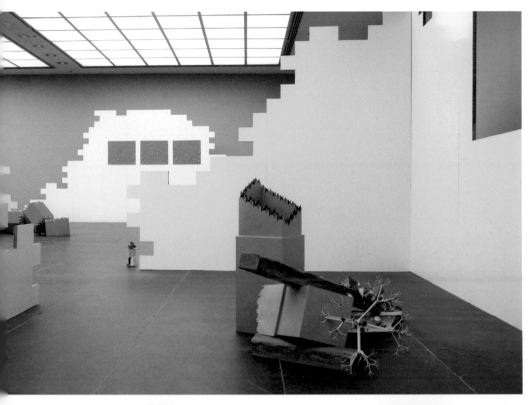

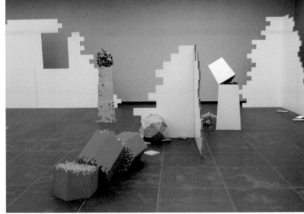

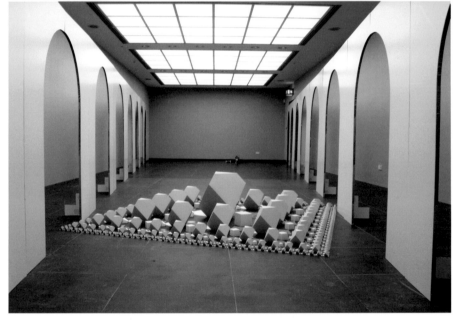

JACOB DAHLGREEN
01 Colour Reading and Contexture
Photo by Vegar Moen, 2005

FULGURO
02 YVES FIDALGO + CÉDRIC DECROUX
Journee du Livre - Program
Lausanne University Library, image © fulguro, 2007

TOMMY STØCKEL
03 Ist das Leben nicht schön?
Installation view, Frankfurter Kunstverein 2000-06,
wood, acrylic, paper, foam decoration beam,
courtesy Helene Nyborg Contemporary, 2006

04 **BRUNO PEINADO**

 04

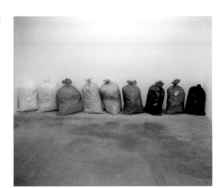

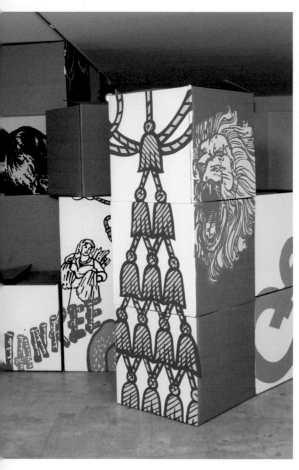

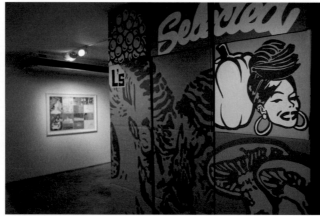

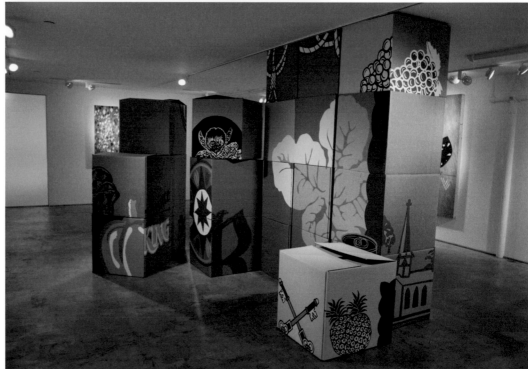

02

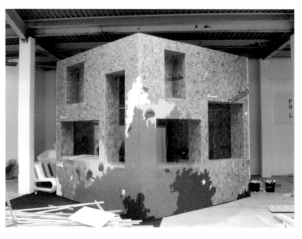

MATTHEW HOLLISTER

01 Desiderata
An installation at the Proposition Gallery.
New York, NY, photo by Luke Barber-
Smith, 2006

JAWA AND MIDWICH

02 100% East Furniture Exhibition - Bar
Installation
for 100% East, graphics by Jawa and Mid-
wich, structure by Ryan Frank, 2006

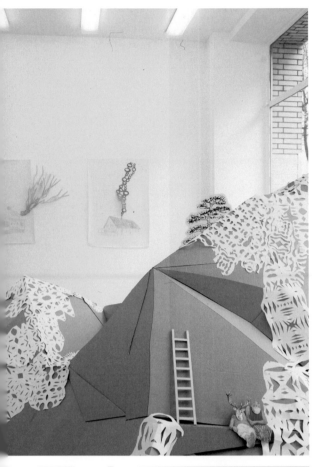

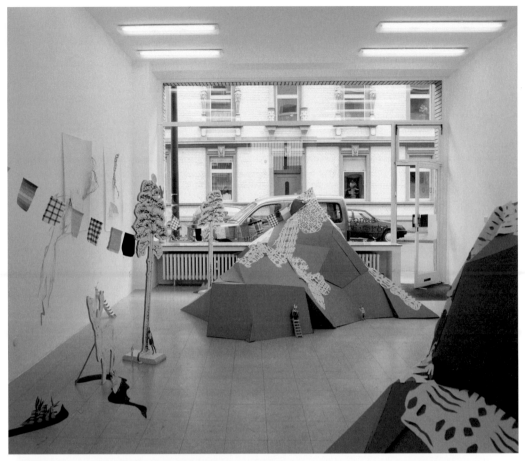

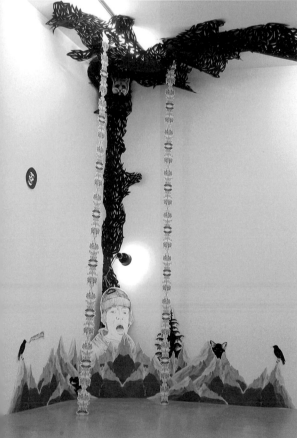

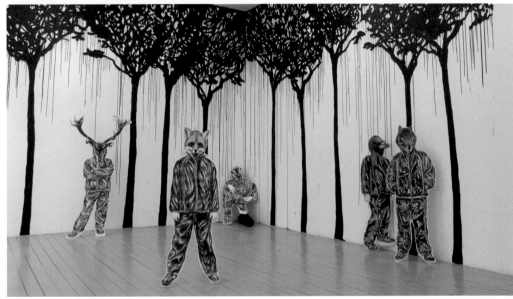

04

JONAS LIVERÖD

03 **Behind the Mountain there is Another Mountain**
for Kunstbüro, 2004

04 **Endless Bummer**
for the Remix Project, 2005

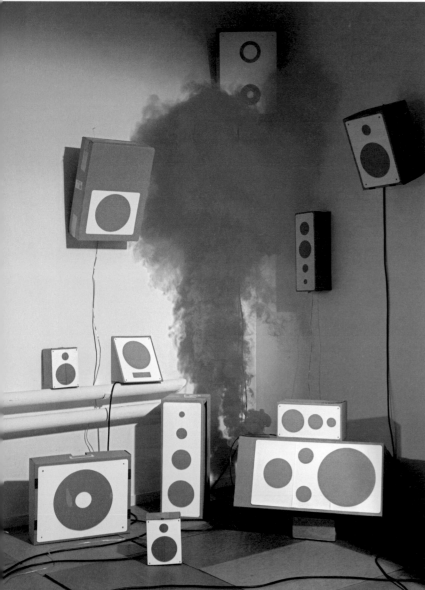

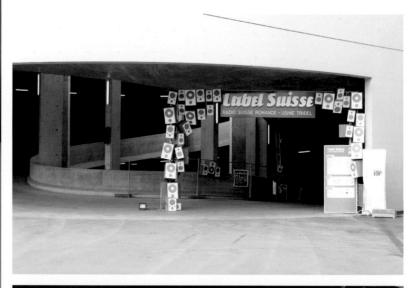

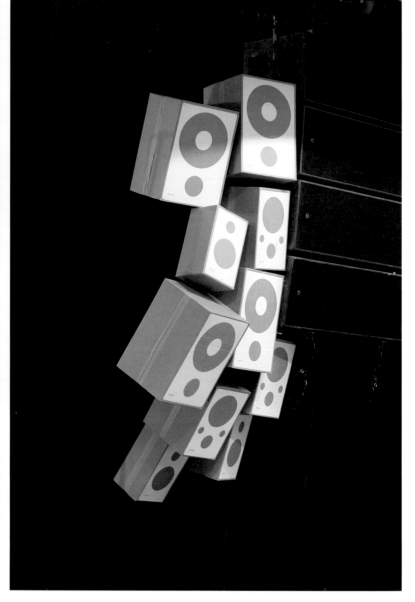

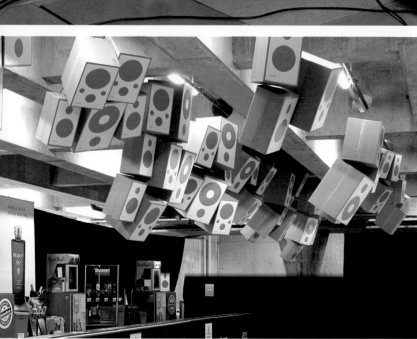

FULGURO

01 YVES FIDALGO & CÉDRIC DECROUX &
GEOFFREY COTTENCEAU
Label Suisse - Music Festival
for Radio Suisse Romande, image ©
Fulguro & Geoffrey Cottenceau, 2006

JONAS LIVERÖD

02 Videostills
Air Bureau, Massive Management,
© Jonas Liveröd & Peter Reinholdsson,
2006

02

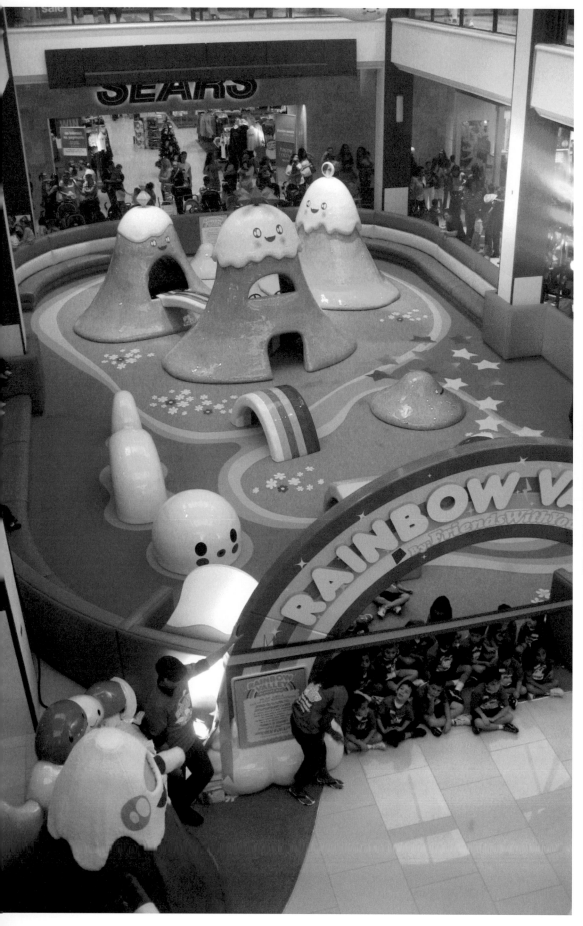

FRIENDSWITHYOU
Rainbow Valley
for Aventura Mall, photos by Chris Cutro

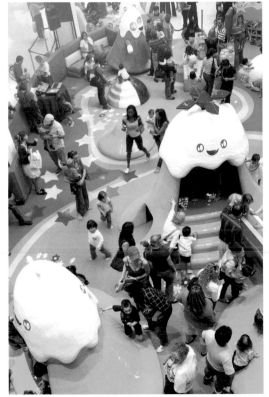

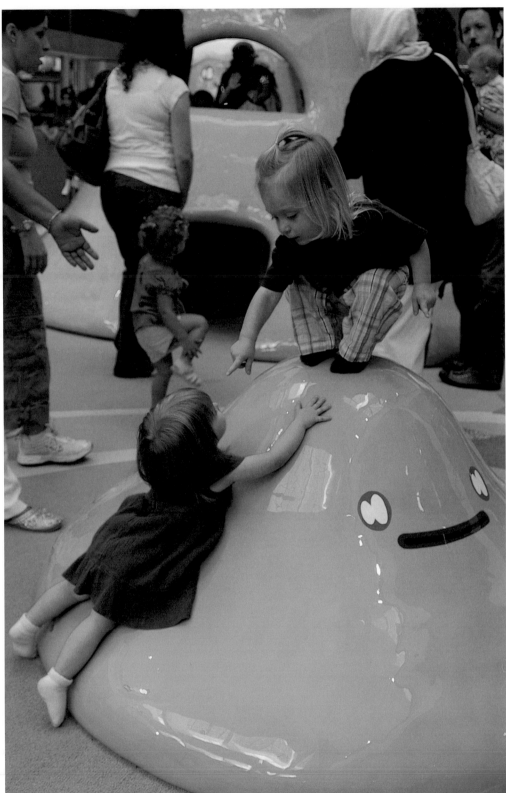

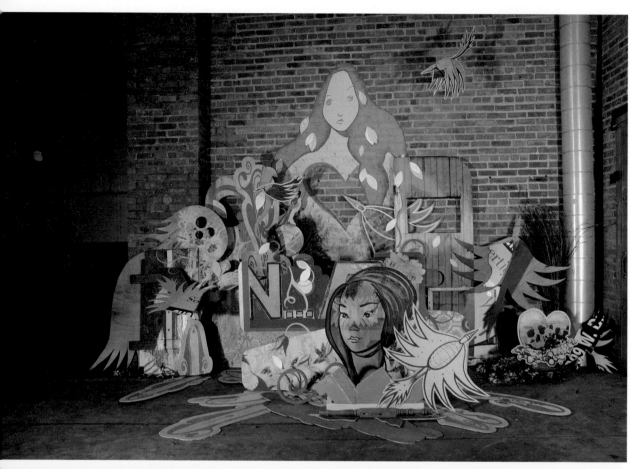

CHRISTOPHER TAVARES SILVA
01 WITH LAUREN FEECE
Open Hearts Urgery
for Version Fest 2006, © Christopher
Tavares Silva & Lauren Feece, 2006
02 **No Snowflake in an Avalanche
Ever Feels Responsible**
Installation at Walker's Point Center
for the Arts, Milwaukee, Wisconsin,
USA., 2006

DAVID ELLIS
03 **Drum Painting Project v3.0 /
Smackmellon, Brooklyn, NY**
2005
04 **Granny**
2005

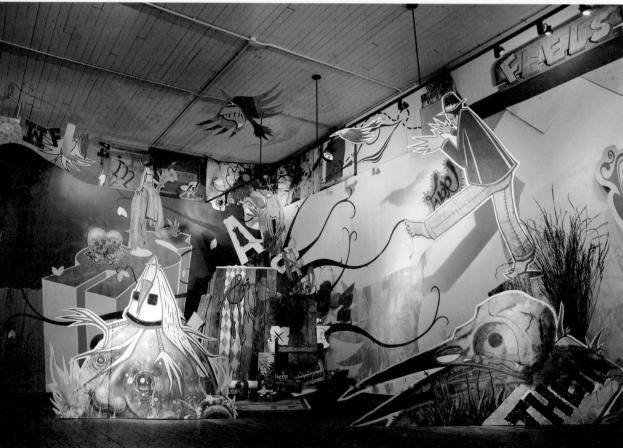

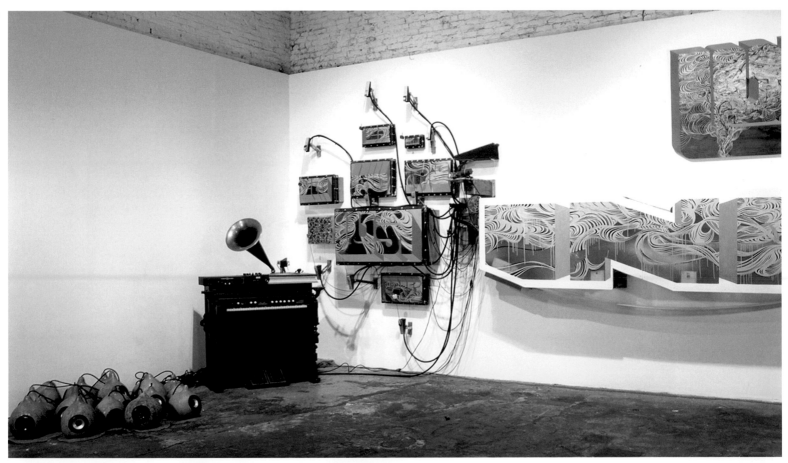

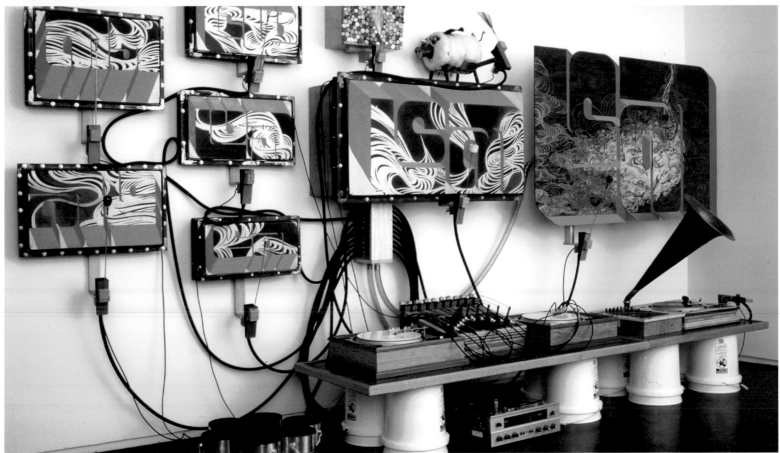

ANTONIA LOW
Unterm Sofa
Material: studio objects, nylon string
size: 4,5 x 3,6 x 6m,
courtesy of Klara Wallner Galerie,
Berlin, 2000

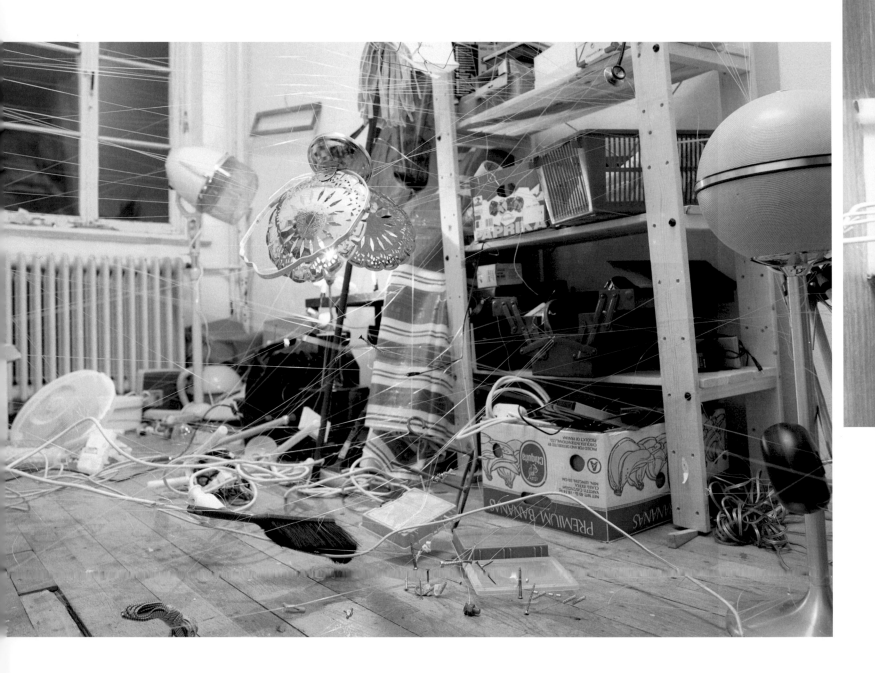

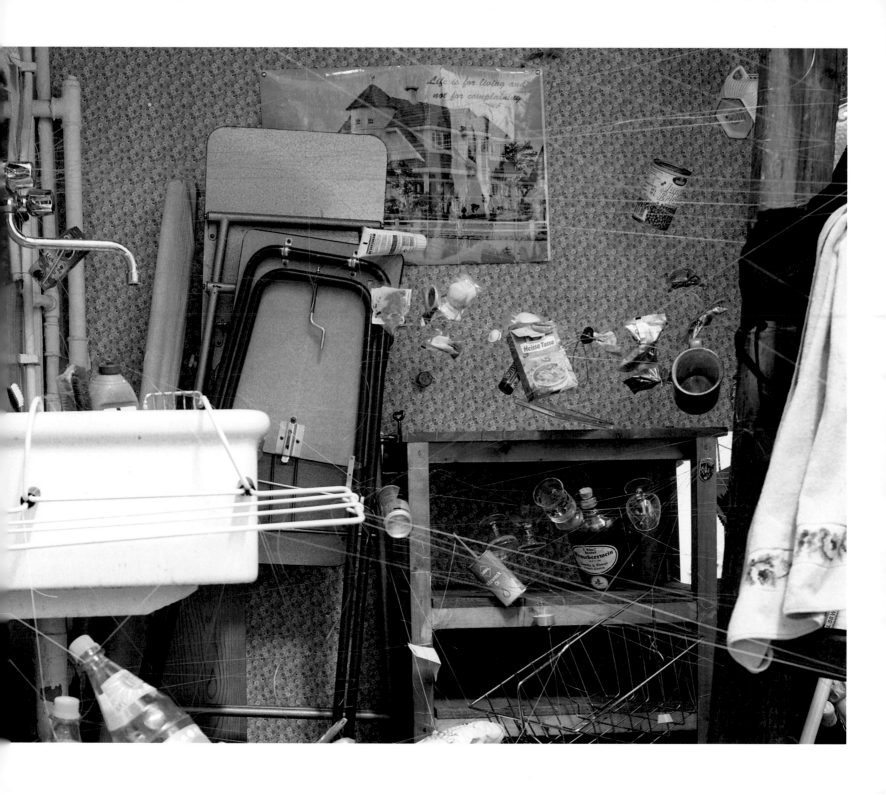

Well-versed in different media, trained gold- and locksmith Thomas Raschke applies the principles of his trade to sculpture, film-making and beyond. Unafraid to use whatever comes to hand and mind, the avid model builder has yet to come upon a material unsuited for his endeavours – so far, he has worked with cardboard, wood, bread rolls, play dough, beeswax, foam, gypsum, sponge, rubber, fabric – and iron wire. Pared down to the bare essentials, these welded wire frames throw a light on the interior workings of everyday objects and provide a transparent engineer's view of what makes a vase, a power drill or a washing machine.

Raschke himself traces the origins of this project back to his early cardboard sculptures. "In order to generate an amorphous form from a rigid material, I had to understand the underlying principles of inner structure and external cover – of skeleton and skin. As in technical drawings, clothing patterns, floor plans and blueprints, the essential edges are depicted with lines. So I asked myself: just how many lines do we need to describe the edges and surfaces of an object in space? There is always a compromise between the sum of lines and plasticity, the ideal balance lying somewhere between an austere economy and the luxury of detail."

The resulting sculptures, created entirely without the aid of 3-D computer modelling, not only inspire a new respect for the old-fashioned art of model building, but also surprise casual viewers with the realisation that what appears to be a digitally generated image constitutes a real, tangible and probably weighty object in space.

01

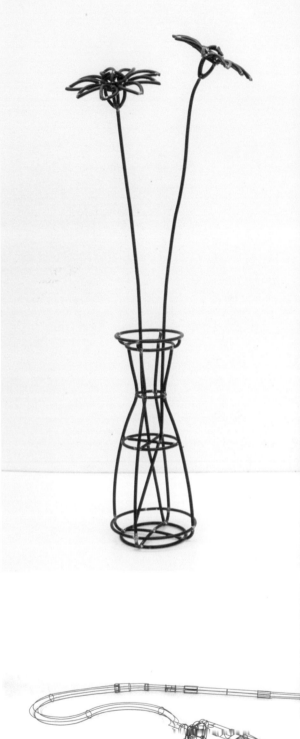

02

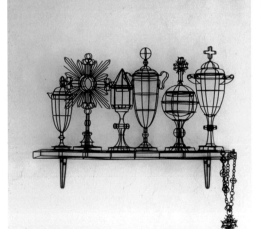

03

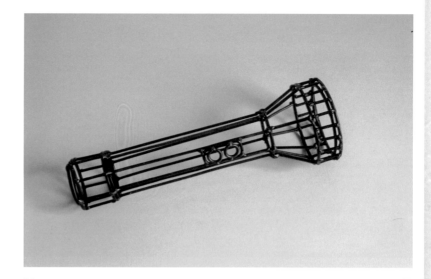

04

05

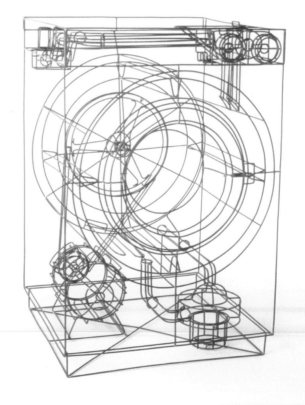

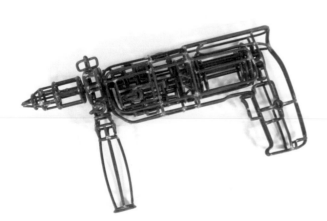

06

07

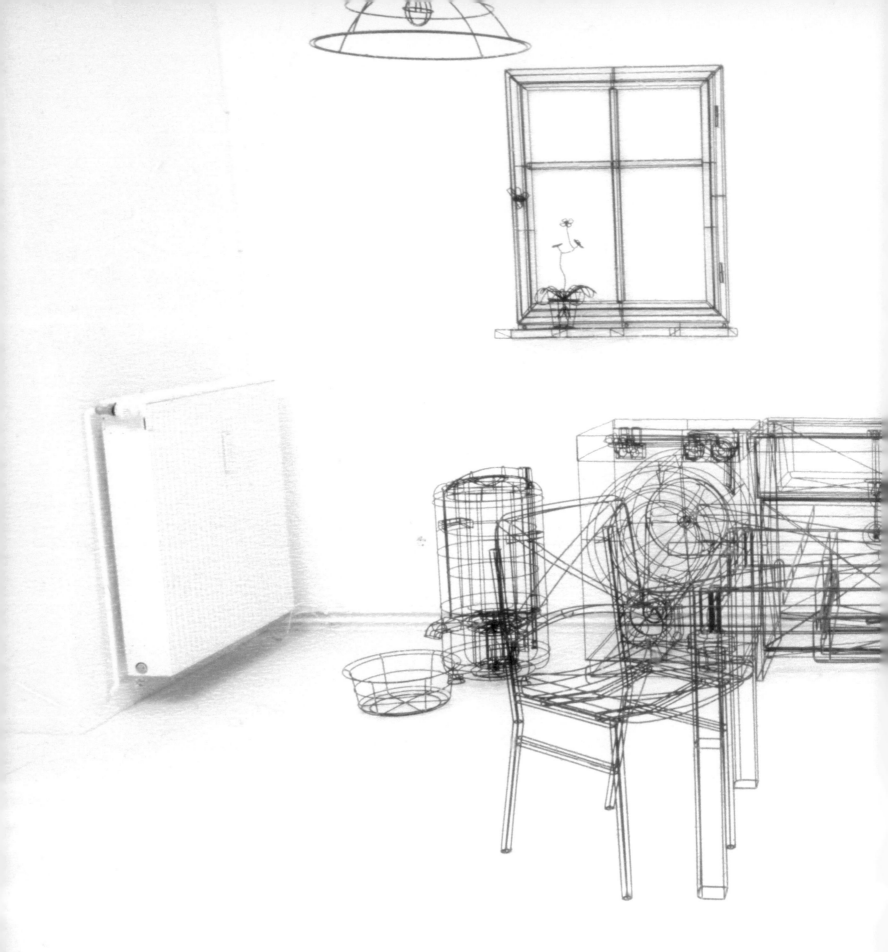

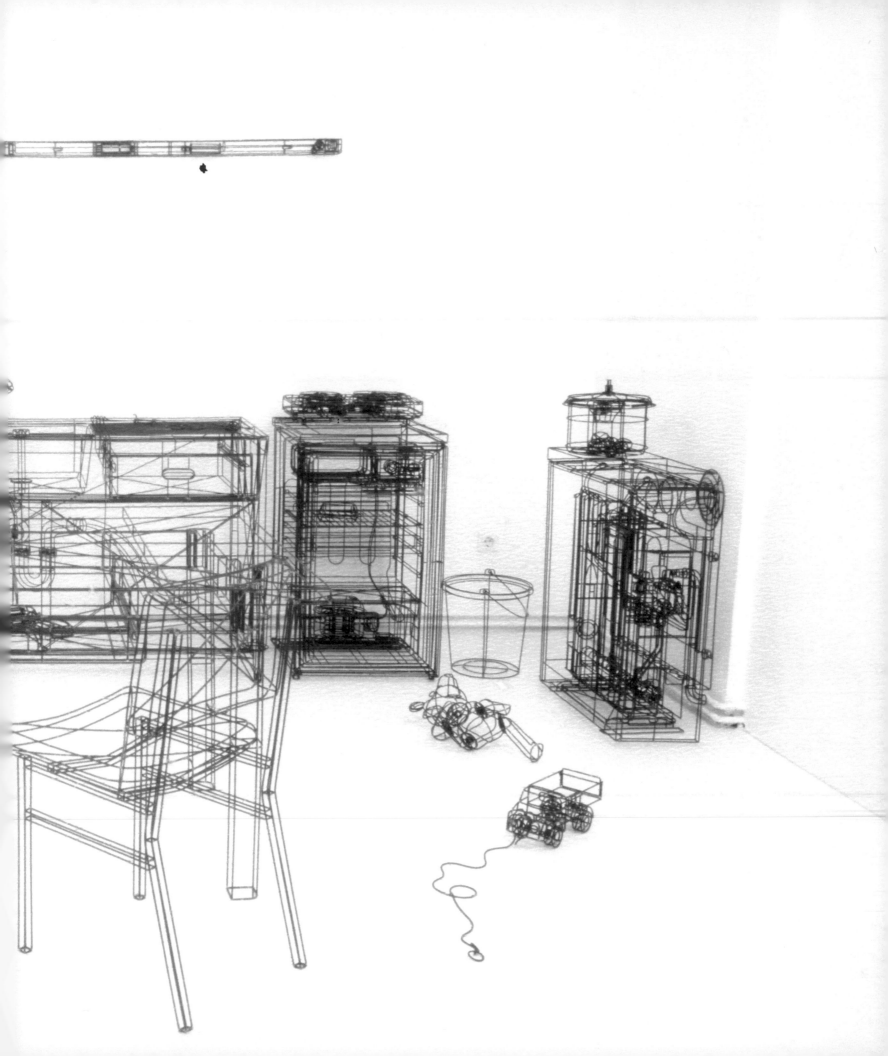

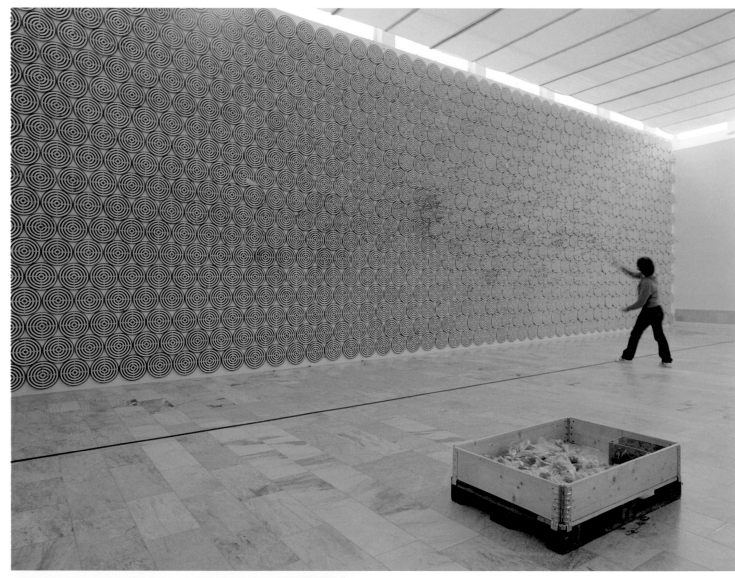

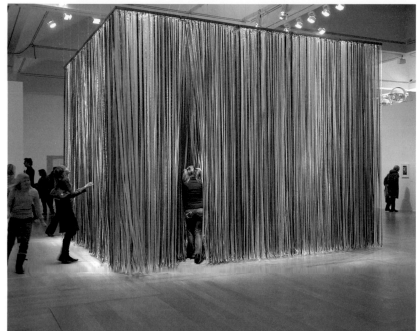

JACOB DAHLGREEN

01 **I, the World, Things Life**
Photo by Tedd Soost, 2004

02 **The Wonderful World of Abstraction**
Photo by Per-Anders Allsten /
Moderna Museet, 2006

JULIA RYSER

03 **Der Mond tut nichts**

For most a distant, shameful memory of our teenage past,
Julia Ryser's multi-layered tale "Der Mond tut nichts" (the
moon does nothing) picks up on the long-neglected art of the
photo love story and tweaks the medium's characteristic,
formulaic storylines and visual markers into a non-linear
narration on relationships, perceptions, falsehoods – and a
corpse in the woods. Far more than a backdrop for the dead
body, the forest reflects the story's underlying notion – the
precarious boundary between the familiar and the unknown.
Divided into four flexible brochures, "Der Mond tut nichts"
not only encourages readers to blaze their own trail through
Ryser's thicket of deception, but also traverses more than one
boundary, flitting back and forth between past and present,
fiction and reality.
Photo by Daniel Kaufmann, 2006

03

04

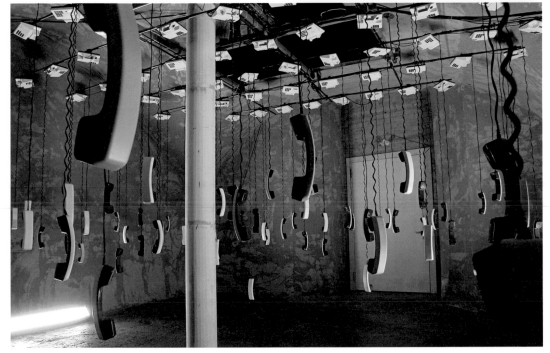

!MEDIENGRUPPE BITNIK

04 Opera Calling! - Arien für alle!

If you can't get people into the opera, take the opera to the people!

Invading one of the last remaining bastions of "high culture", !Mediengruppe Bitnik installed an audio bug in Zurich's opera house, thus giving the public access to these exclusive performances. Never ones to take the easy route (see their strenuous climbing wall/computer input device), Bitnik decided to broadcast the performance by phone, calling Zurich's residents one by one to play them the live transmission. An exploration of the usefulness of hacking as an artistic device for redirection and criticism, this mixed-media intervention provoked equally mixed reactions.

Media performance and installation
Cabaret Voltaire Zürich, photo by Florian Bachmann, 2007

YUKO TAKADA KELLER

01 **Between the Air**
© Allan Hansen, 1996

02 **Air Pyramid**
© Yuko Takada Keller, 2000

03 **Spring Breeze**
© Allan Hansen, 2005

01

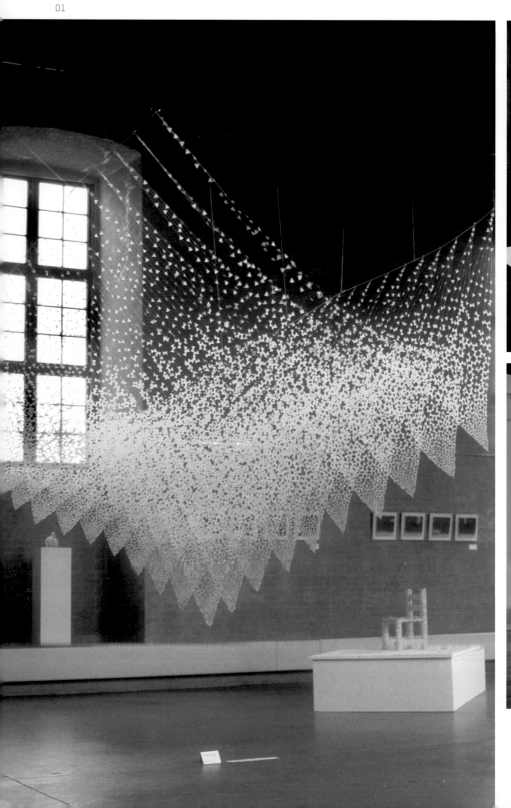

02

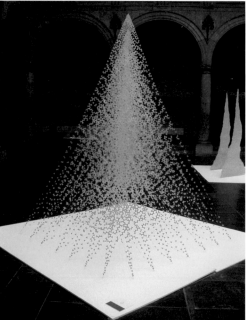

03

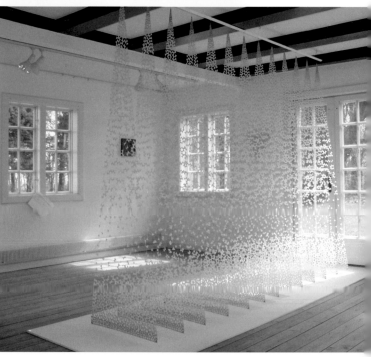

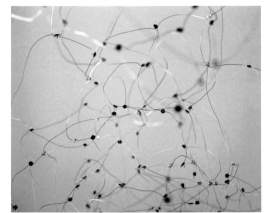

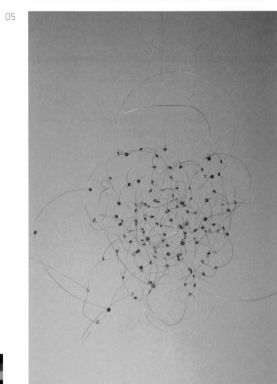

ANTONIA LOW

04 **Mittwochs bis Sonntags**
 Material: single-cored cable,
 cable binder, lamp, bulb,
 Size: 3,8 x 1 x 0,8m, courtesy of Klara
 Wallner Galerie, Berlin, 2005

05 **Konfettimaschine**
 material: drawing pins, wire, motor,
 size: appr. 2m x 1.40m,
 private collection, Berlin, 2005

06 **Atome unter sich**
 material: drawing pins, wire,
 size: appr. 80cm x 100cm x 85cm,
 © KfW Bankengruppe, Frankfurt, 2007 06

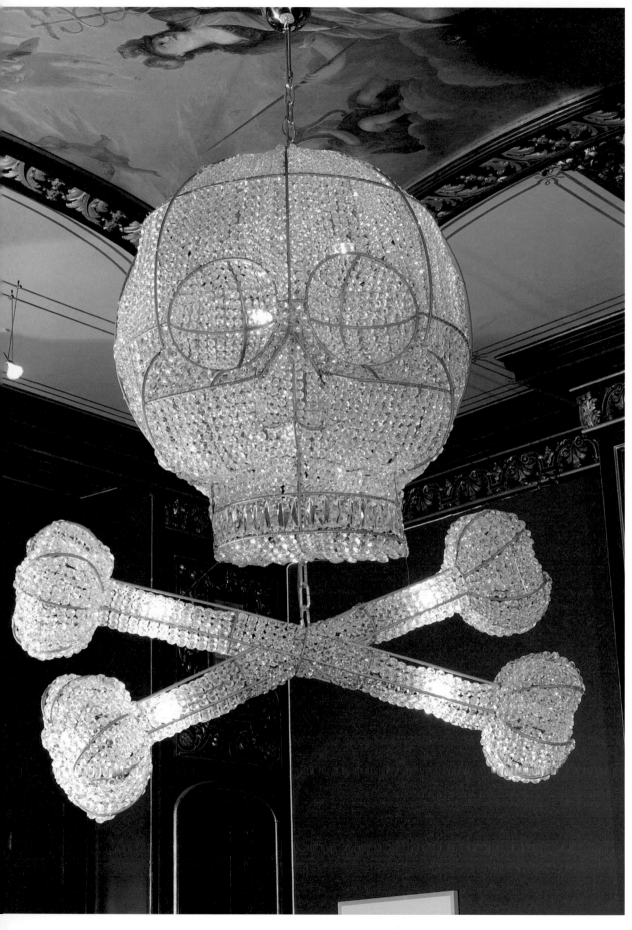

HANS VAN BENTEM
01 **Escher In Het Paleis**
Chandeliers for Museum Escher in
Het Paleis. The Hague, materials:
metal, crystal, lamps & wiring

PATRICK JOUIN
02 **Van Cleef & Arpels**
Store, Place Vendome Paris, 2007

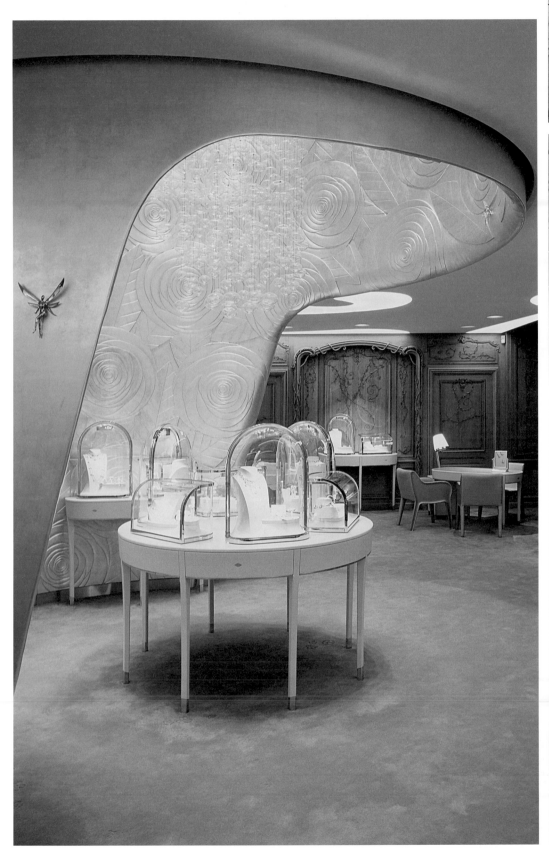

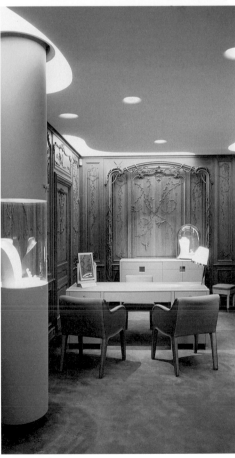

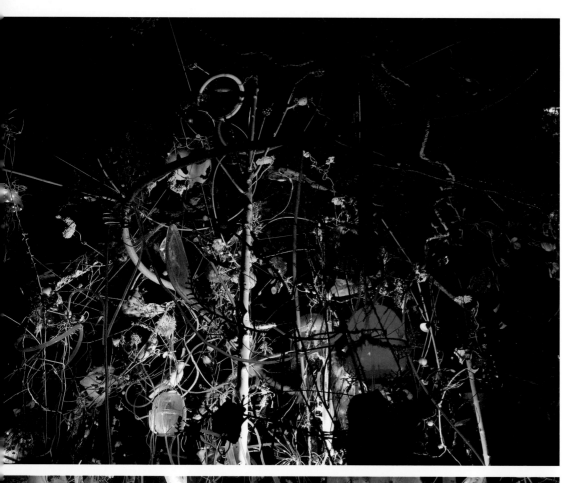

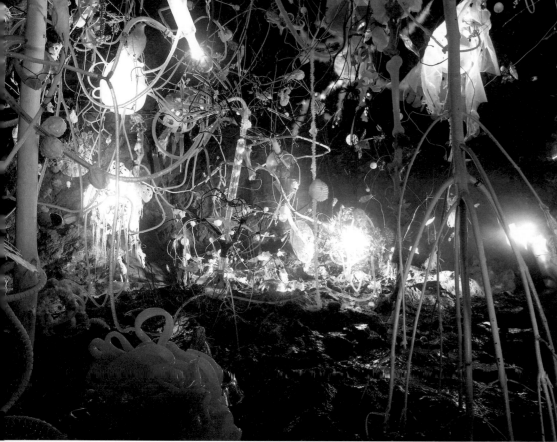

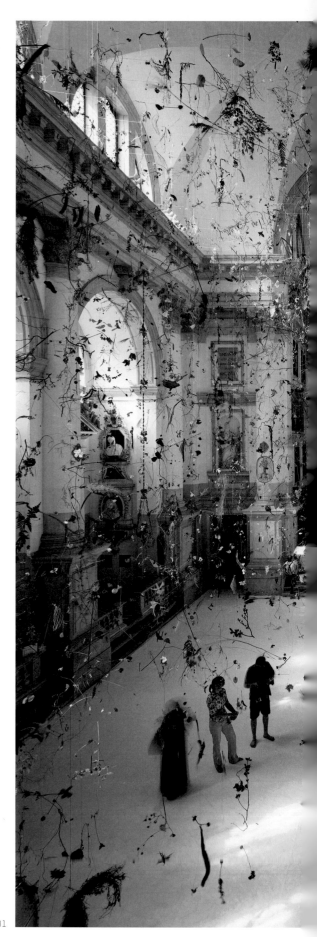

01

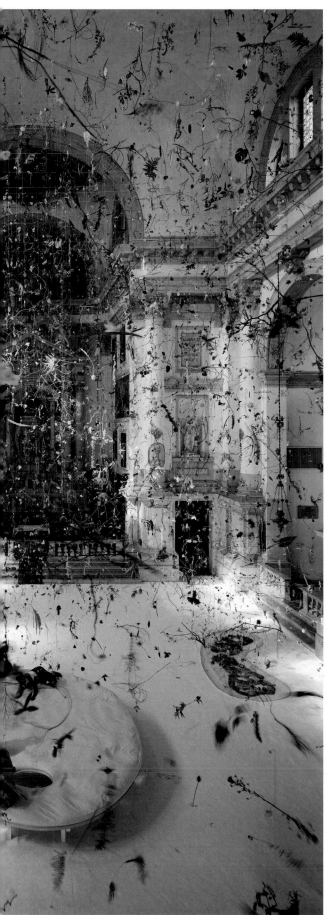

**GERDA STEINER &
JÖRG LENZLINGER**

01 **Jardin de Lune**
Sainte-Marie-aux-Mines,
France, May 2007 – May 2008
Photo by Gerda Steiner & Jörg
Lenzlinger

02 **Giardino calante**
Chiesa San Staë,
Venice Biennale, 2003
Photo by G.Rehsteiner

03 **Das vegetative
Nervensystem**
Museum Kunst Palast, Düssel-
dorf, © Gerda Steiner & Jörg
Lenzlinger, 2006

04 **La Fuente de la Juventud**
1. Bienal de Sevilla, Chapel
Santa Ana, Cartuja,
© Gerda Steiner & Jörg Len-
zlinger, 2004

*Not averse to tackling the great mysteries of life, Gerda Steiner
and Jörg Lenzlinger turn the debate of nurture vs. nature into
one of nurturing nature, of self-organising systems and mini-
ature wonderlands brimming with life.*

*To this end, the artist couple, who have been working together
since 1997, conjure up gardens of earthly delights filled with the
tiniest of delicate creatures and myriads of fragile, flowering,
airborne wonders. And while their grand, encompassing instal-
lations might restage a natural evolution in space, a visualisa-
tion of all things unseen in the great wide world around us, they
tend to resound with staggering narrative complexity.*

*Steiner and Lenzlinger's Vegetative Nervous Systems, for exam-
ple, reinterprets the nutritional cycle as a sensitive, large organ,
a network of tubes, cables and coloured tracks to provide stems
and blossoms with nourishing liquid and nervous impulses.
Branching out into pillars, railings, walls and ceilings to feed
the museum's "body" with the necessary stimuli, the installa-
tion invites visitors to roam the entrails of this wondrous organic
environment and follow its nerves and arteries to where they
explode in a vivid splendour of exotic plants and flowers. With
a wide array of materials referencing subject matter and loca-
tion, their Fountain of Youth takes bones from a Seville abattoir,
dried plants from the monastery garden, parts from various car-
repair workshops, abandoned television sets and dinosaur eggs
as well as artificial plant parts and weaves them into a stunning
display of natural exuberance – a glorious, overwhelming con-
fusion to leave us breathless.*

03

- Outdoor Installations -

While urban art, by its very nature, sidesteps the traditional value chains of client/product or curator/gallery, it is has long left the underground confines of the hip-hop and graffiti scene. And although these roots continue to be a rich source of inspiration, the works assembled in this section – from retuned street furniture to subversive statement, from Cattelan-inspired intervention to FriendsWithYou's theme parks – add a further dimension to street art's original means of expression.

In their quest to defend public space against the ubiquitous appropriation by branded messages, the scenes current protagonists have developed a keen sense of humour and intelligence. Picking up on graffiti's original premise of subversive irritation, they expand its visual language by physical complexity and a social component, actively encouraging direct encounters, interaction and reactions to the art in question.

To this end, the works in this chapter shrug off the shackles of a controlled environment, leave the museum and materialise in the street to redefine and re-appropriate public space.

Hailing from a huge variety of disciplines, some still rely on oversized letters or giant speech bubbles for a truly public statement, while others unleash their diminutive heroes onto the outside world, ready to brave the great unknown between kerbside and urban (weed) jungle, or, like the Austrian Mediengruppe Bitnik, experiment with (mis)communication, civilian disobedience and new means of data entry.

Less overtly political, yet equally stunning are a range of examples that emphasise an equal, symbiotic relationship with their surroundings, customising their environment with anything from painted trees to distinctive geometric abstractions that populate facades like self-propagating, alien entities. In their coexistence with the idiosyncrasies of the space they invade, these public interventions prove once and for all that graphic design, free from all commercial and advertising constraint, can indeed have a purpose.

JACOB DAHLGREEN
World of Abstraction
Linköpings Kommun,
Photo by John Håkansson, 2005

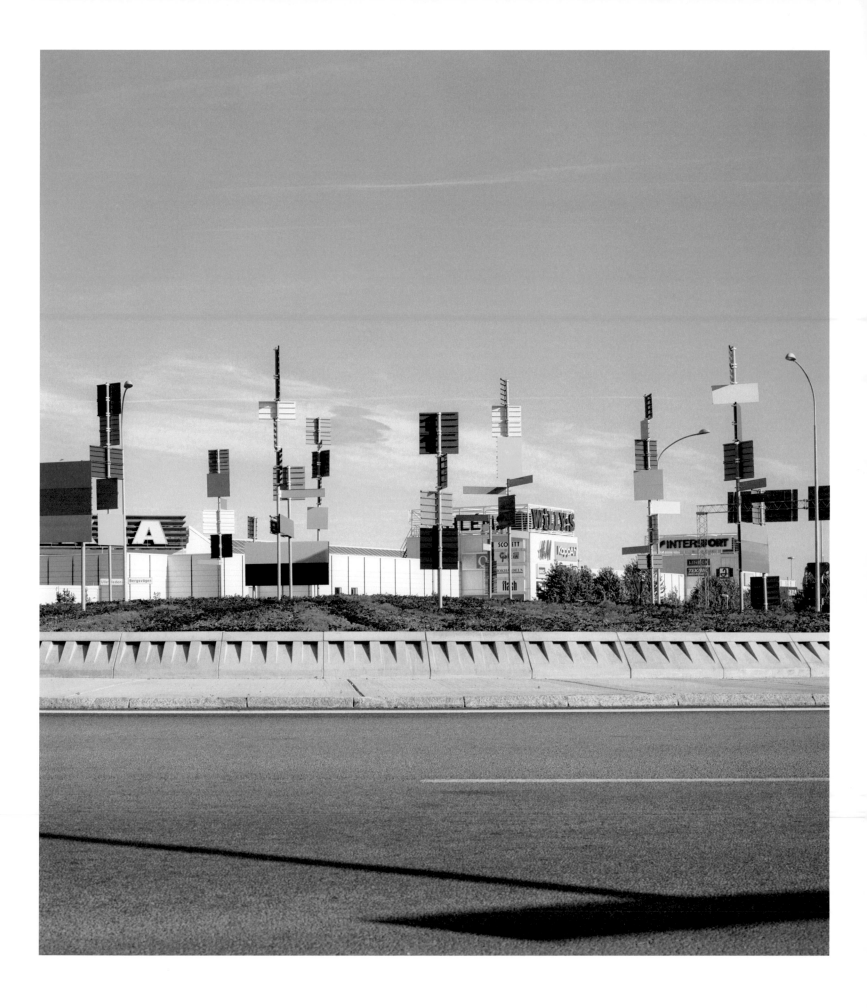

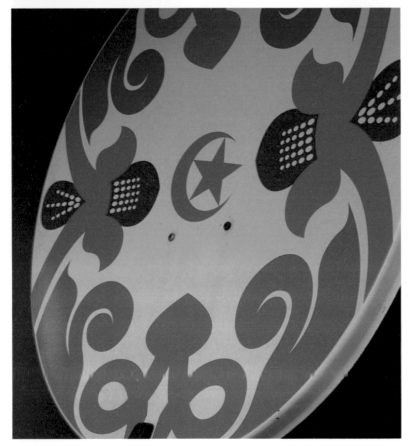

JULIEN CELDRAN
01 Paraboles Custom
City of Bourges, for Bandits-
Mages, © Julien Celdran, 2003

WAYNE HORSE
02 Cute Jeep
2005
03 Tel Aviv Roofs
2006

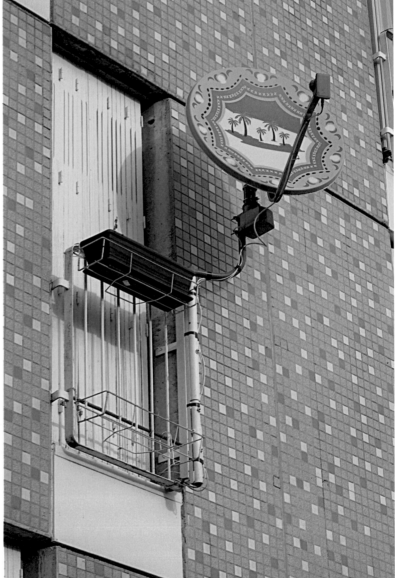

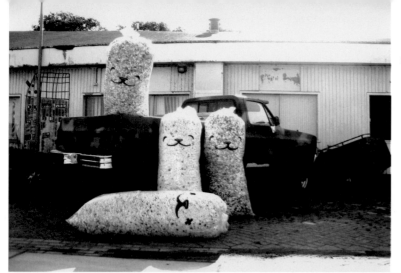

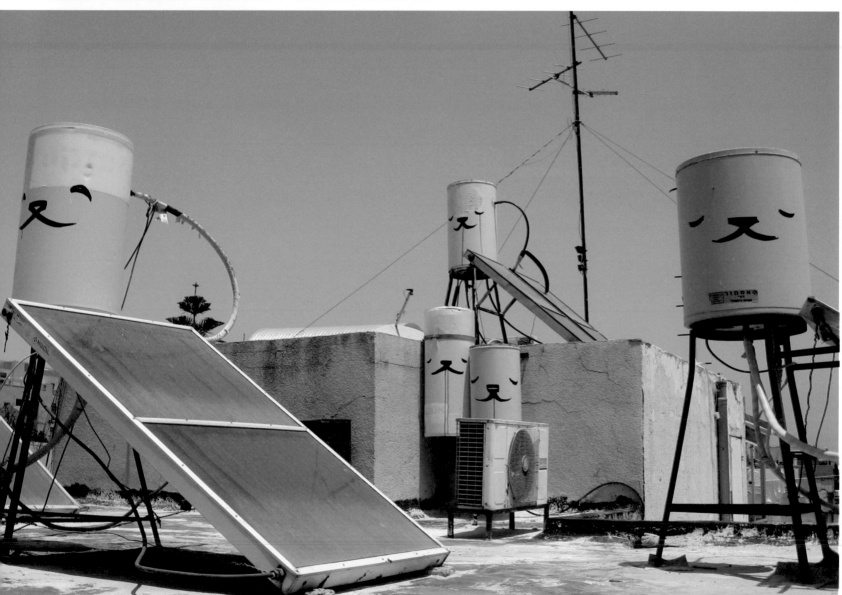

03

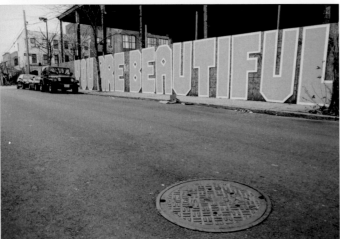

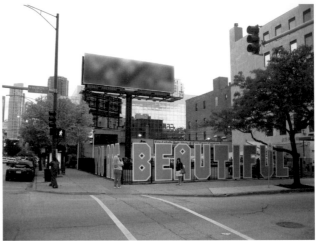

02

01

01 YOU ARE BEAUTIFUL

A simple, powerful statement among today's deluge of mass media and consumerist culture, You Are Beautiful appropriates the cues of advertising to spread a positive message. Reduced to its simple slogan, the Chicago-based project soon took on a life of its own: From rough tag to lovingly crafted installation, variants of this self-perpetuating, non-profit urban intervention are making a splash all over the globe. Everyone is encouraged to get involved, order stickers, start their own project and tell the world that we are, indeed, beautiful. Or, in the words of the project's instigators

"We are just attempting to make the world a little better." 2006

MATHIEU MERMILLON

02 **WITH YANNIS PEREZ**

La Jetée

© Mathieu.mermillon & Yannis Perez, 2006

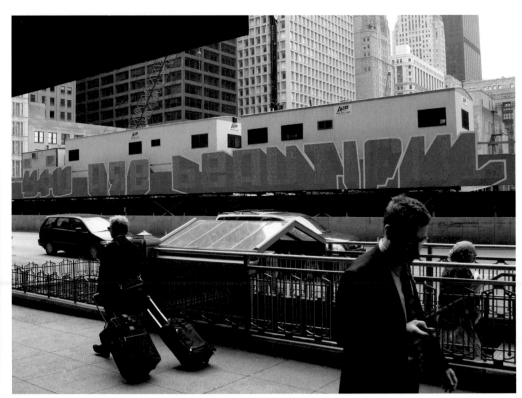

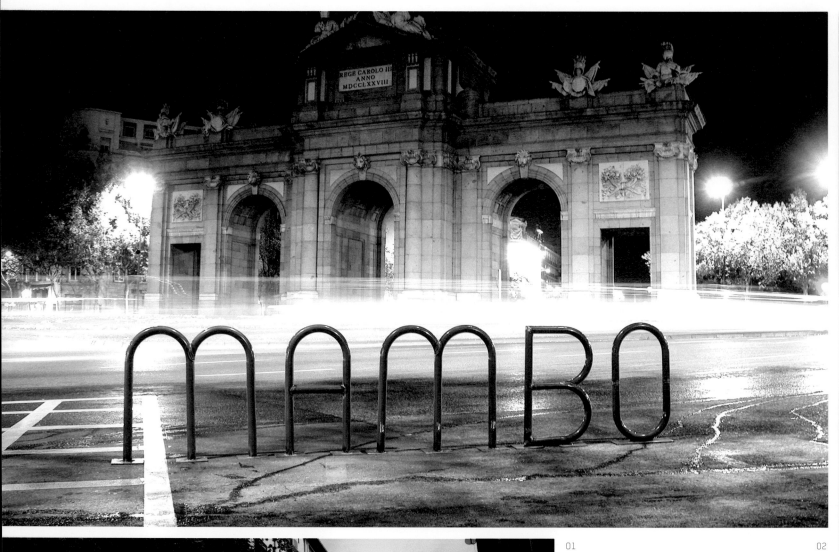

01

02

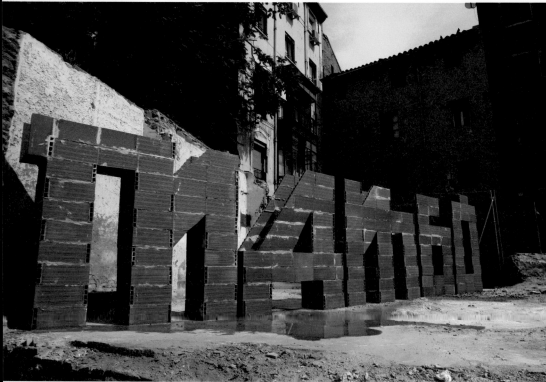

SPY
01 Bricks
02 Green Fence
03 Flower Sign

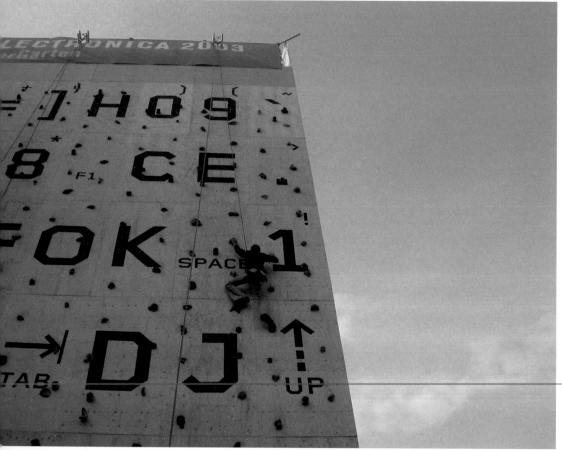

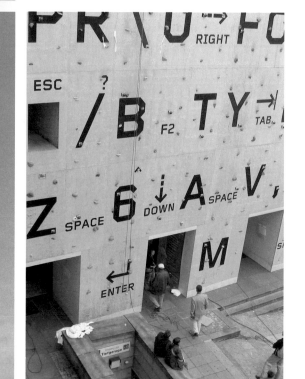

!MEDIENGRUPPE BITNIK
01 WITH M. PURKATHOFER & GRUPPE FOK,
Teleklettergarten

For Ars Electronica 2003, Bitnik and FOK transformed the façade of Linz's Art University into the world's largest keyboard, inviting members of the audience to scale and explore this impressive piece of information architecture. After a brief introduction to the ground rules of climbing and software development, climbers and programmers joined forces to input a range of codes, scripts and tools. While it turned the largely cerebral act of programming into a physical experience, the "remote climbing garden" also made a stand against the arbitrary awarding of software patents for core functions of everyday computing routines. With all actions performed by an anonymous collective, no individual could be held responsible for the illegal execution of patented code.

Interactive installation / CODE - Ars Electronica Festival 2003, Mario Purkathofer Gruppe FOK !Mediengruppe Bitnik, 2003

NENDO : OKI SATO
02 ILLOIHA OMOTESANDO
© Daici Ano

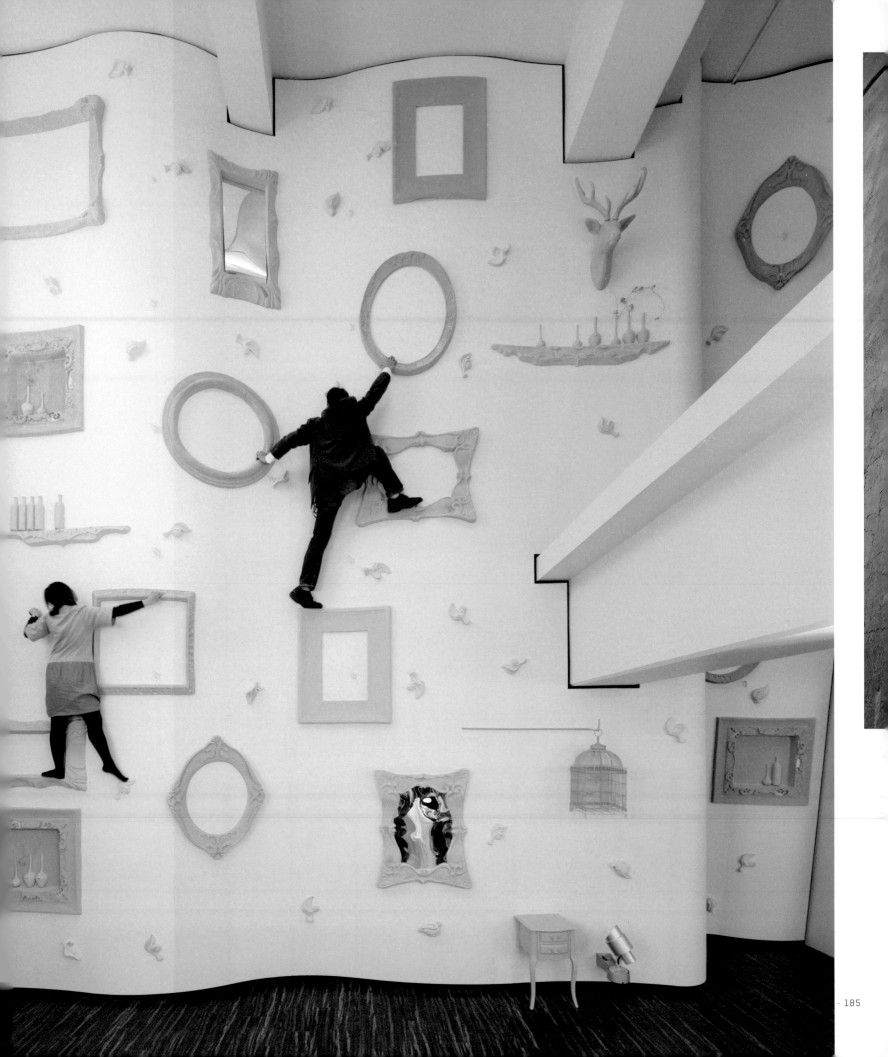

SAMUEL FRANÇOIS
Pattern
2005

INOUT DESIGNERS
01 EMANUELLE JAQUES
 Tree's Stool
02 DAMIEN REGAMEY
 Bead Necklace
03 DAMIEN REGAMEY
 Bling-Bling
 for INOUT, config. 01
 Curator : Francisco Torres
 Photographers : Yann Gross
 & Emilie Muller, 2006

INOUT, a Lausanne-based platform for emerging designers, takes a new look at urban furniture. To this end, the Lausanne Museum of Design and Contemporary Applied Arts (MUDAC) gave the floor to 12 recent graduates of ECAL (Ecole cantonale d'art de Lausanne) set on (re)designing their city's urban landscape.

Aesthetic, surreal and surprisingly functional, the group's exhibits amaze with their sheer inventiveness in reappropriating public fixtures for private use. Besides the examples on display in this book, INOUT's visual stumbling blocks encompass aesthetically pleasing manhole covers, clever hanging gardens, a discreet pigeon deterrent disguised as the city's gently undulating skyline, thought-provoking bicycle stands, outdoor parquet flooring and the missing link between drainpipe and a pet-friendly water bowl.

Reflecting on themes as varied as ecology, social life, cutting-edge technology and the problems inherent in management of the urban world, INOUT's urban interventions invite residents and visitors alike to linger, explore and examine their own expectations of the city around them.

01

02

03

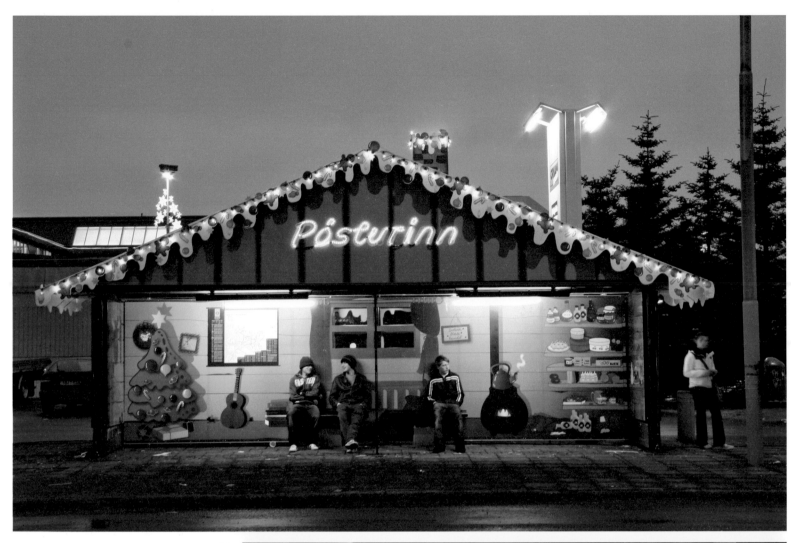

04

SIGNY KOLBEINSDOTTIR
04 **Christmas House - Bus Stop**
The Icelandic Post Office, Íslenska,
December 2005

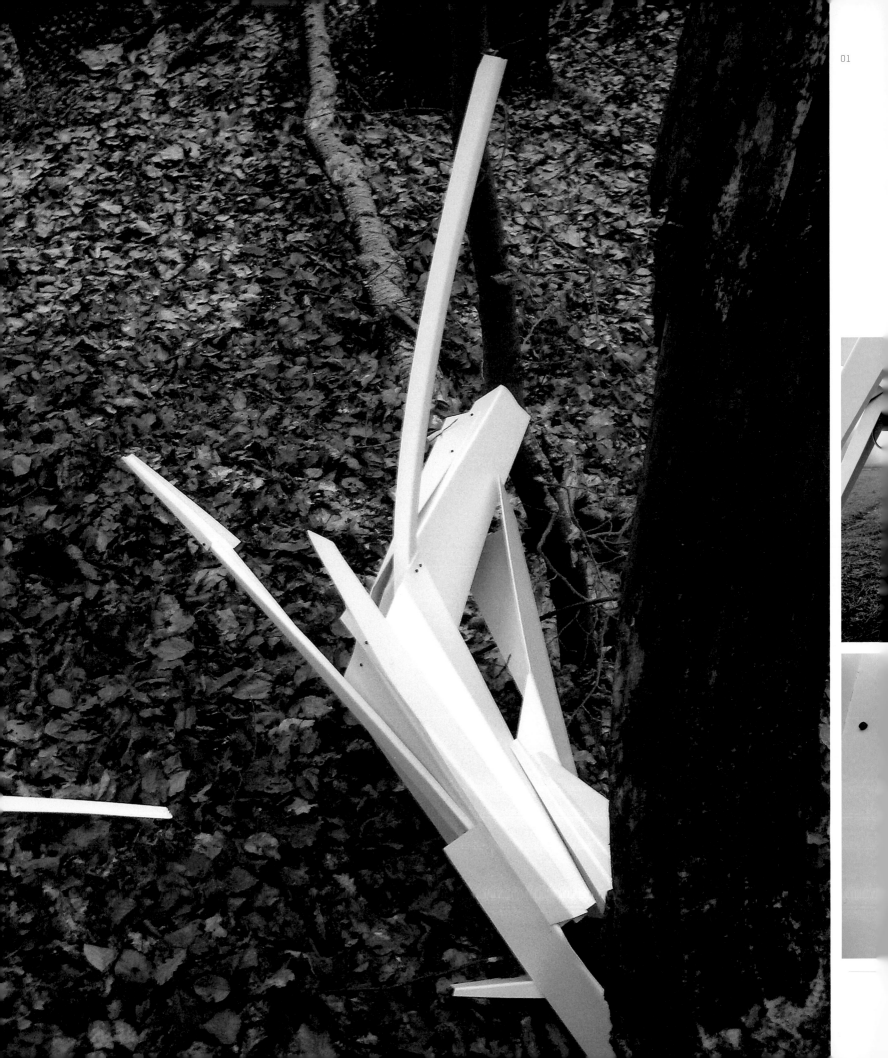

VIA GRAFIK
ROBERT SCHWARTZ
01 6
02 -
03 Sukker™
04 LEO VOLLAND
Grafik, Tragbar

All un-commissioned, 2006

02
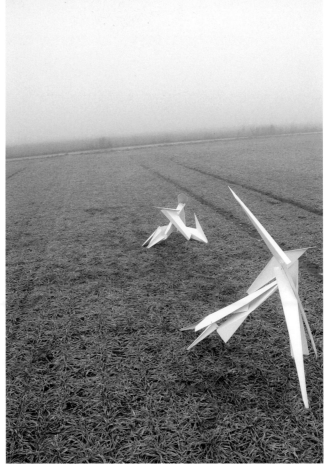

03

04

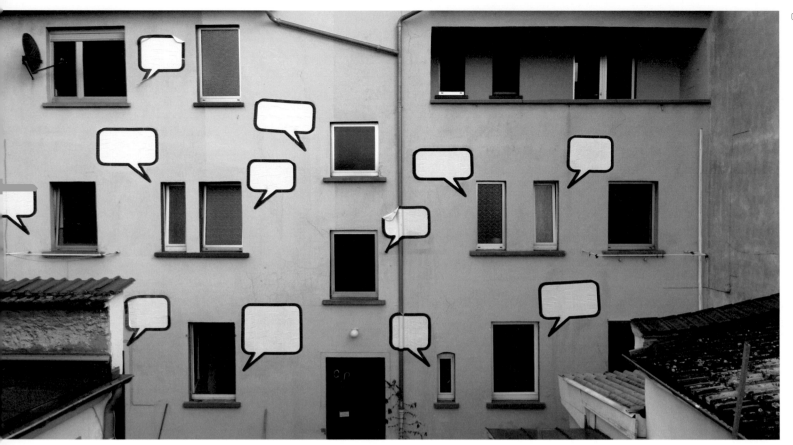

VIA GRAFIK
01 LARS HERZIG, ANDRÉ NOSSEK,
LEO VOLLAND
Speechless
Un-commissioned, 2006

JESSE SHAPINS

02 Yellow Arrow
 The Secret New York
 for Counts Media, project
 concept by Brian House,
 Christopher Allen
 © Jesse Shapins and Michael
 Counts, photos by Jesse
 Shapins, 2005

Part game, part urban installation, the Yellow Arrow project shows there is more to things than meets the eye. A simple, yet ingenious means to share insider tips and personal musings connected to specific locations, Yellow Arrow's eye-catching stickers have started to pop up on pavements, lamp posts and benches across the world to highlight monuments of historic and personal significance.

Distributed at concerts and art openings – or available from their website for a mere 50 cents – the stickers invite anyone with a story to share to tag a site and upload their related insights to yellowarrow.org. Akin to geographical blogging, each arrow comes with a unique code, allowing passers-by to "browse" the physical space around them by texting the company for the lowdown on their current location.

"When you're placing yellow arrows, you pay more attention to little details, you notice paradoxes and curious moments," claims Jesse Shapins, project director and co-creator of this global interactive urban storytelling project. And with more than 50,000 registered arrows scattered across the planet, Yellow Arrow has evolved into a global treasure hunt of personal points about public spaces. The result: a truly subjective map of the world's hidden histories.

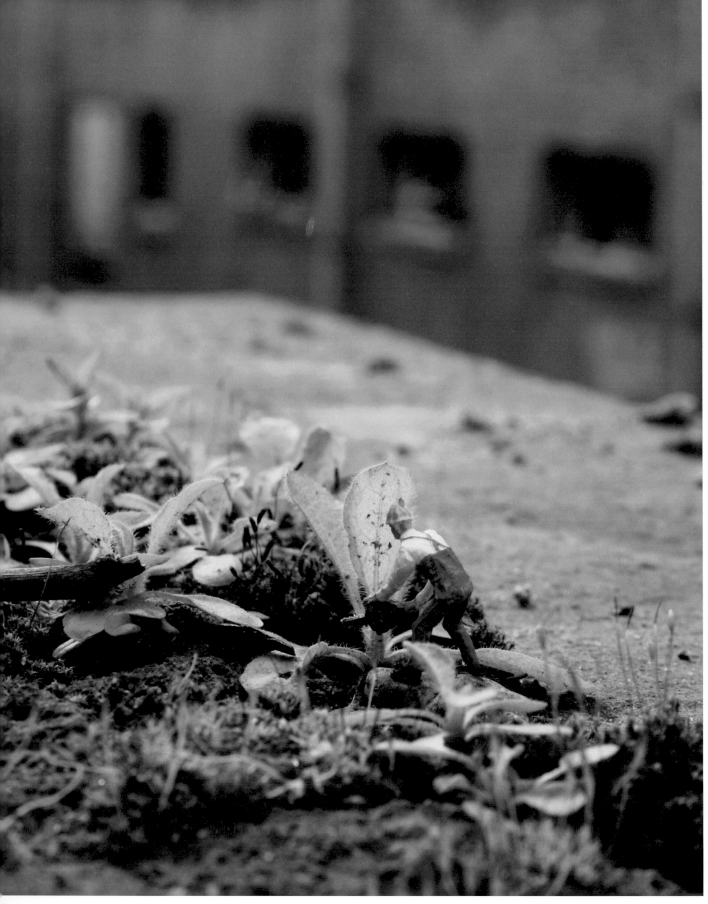

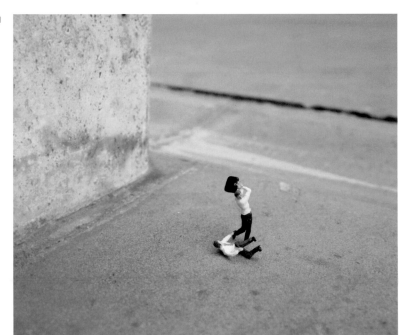

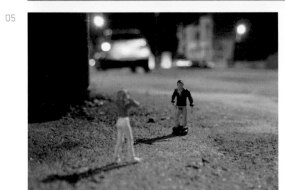

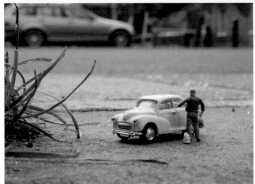

SLINKACHU

01 Weed Surgeon, 2007
02 The Feast, 2006
03 Office Politics, 2006
04 I Can't Actually Graffiti, 2007
05 Indecent Proposal, 2006
06 Shopping for One Again, 2006
07 Tox
 Eleven exhibition, Leonard Street
 Gallery, 2007

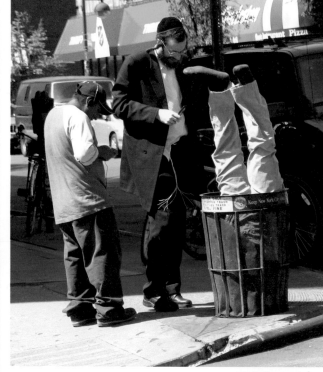

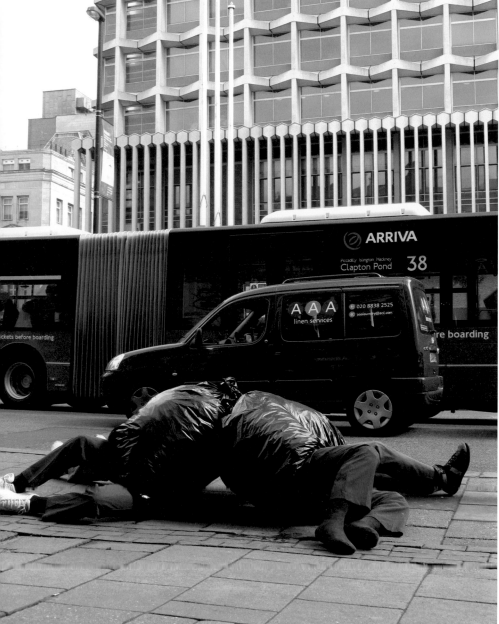

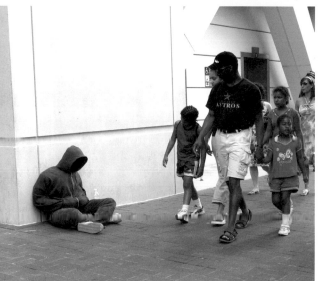

MARK JENKINS

© Mark Jenkins, 2006 & 2007

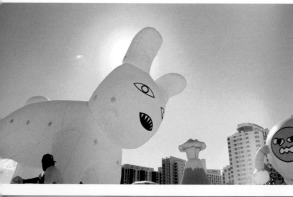

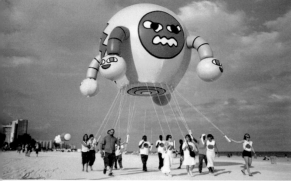

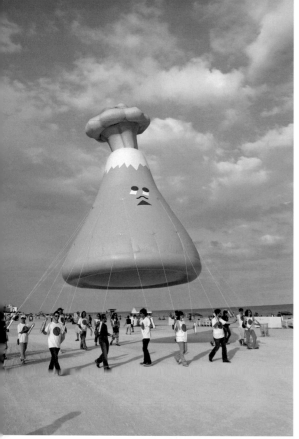

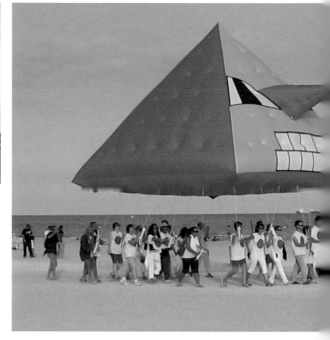

FRIENDSWITHYOU
WITH PAPERRAD, ARA PETERSON, MISAKI KAWAI,
DEVILROBOTS, MUMBEBOY, DAVID CHOE
Skywalkers
for Scion, photos by Abraham Kalili, Sebastian Angy
& Ray Caragher, 2006

Work Index - 0123 - K

Work Index -L-Z

Imprint

TACTILE

HIGH TOUCH VISUALS

Edited by Robert Klanten, Sven Ehmann & Matthias Hübner
Layout by Matthias Hübner for dgv
Cover by Pixelgarten / Catrin Altenbrandt & Adrian Nießler
Text by Sonja Commentz for dgv
Preface and art direction by Robert Klanten
Layout assistance by Sabrina Grill for dgv
Production management by Martin Bretschneider & Janni Milstrey for dgv
Proofreading by English Express
Font: Blender by Nik Thoenen, www.die-gestalten.de/fonts/
Printed by SIA Livonia Print, Riga

FSC
Mixed Sources
Product group from well-managed
forests and other controlled sources
Cert no. SW-COC-002883
www.fsc.org
© 1996 Forest Stewardship Council

This book was printed according to the internationally accepted FSC standard for environmental protection.
The FSC logo identifies products which contain wood from well-managed forests certified in accordance with the
rules of the Forest Stewardship Council.

Published by Die Gestalten Verlag, Berlin 2007
ISBN 978-3-89955-200-3

2nd printing, 2008

None of the content in this book was published in exchange for payment by commercial parties or designers; dgv selected all
included work based solely on its artistic merit.

Bibliographic information published by the Deutsche Nationalbibliothek.
The Deutsche Nationalbibliothek lists this publication in the Deutsche Nationalbibliografie;
detailed bibliographic data is available on the Internet at http://dnb.d-nb.de.

For more information please check: www.die-gestalten.de

Respect copyright, encourage creativity!